Step • by • Step

CALLIGRAPHY

A Complete Guide with Creative Projects

Step • by • Step

CALLIGRAPHY

A Complete Guide with Creative Projects

SUSAN HUFTON

Sterling Publishing Co., Inc.
New York

Library of Congress Cataloging-in-
Publication Data Available

10 9 8 7 6
First Paperback Edition
Published in 1997 by
Sterling Publishing Company, Inc.
387 Park Avenue South,
New York, N. Y. 10016

Published in Great Britain 1995 by
George Weidenfeld & Nicolson Ltd.
Orion House, 5 Upper St. Martin's Lane,
London, WC2H 9EA

Text and line drawings
© 1995 by Susan Hufton

Projects and artworks
© 1995 by individual calligraphers

Photographs © 1995 by George
Weidenfeld & Nicolson Ltd

Distributed in Canada by
Sterling Publishing
c/o Canadian Manda Group,
One Atlantic Avenue, Suite 105
Toronto, Ontario, Canada M6K 3E7

Printed in China

ISBN 0-8069-3986-9 Hardcover

ISBN 0-8069-3987-7 Paperback

ACKNOWLEDGEMENTS
I would like particularly to thank the following people:

John Woodcock, whose valuable initial work on the
synopsis provided the basic framework of this book.
Richard Middleton for writing the Foundational and
Italic pages and exemplars and for spending many
hours checking my work and giving honest criticism
and advice. Christopher Haanes for his work on the
Flourished Italic pages. Ann Camp for her encourage-
ment and Tony Curtis, Sam Somerville and my
Tuesday students, and Sue Green, who helped me
willingly when needed. The individual calligraphers
whose projects were carefully and beautifully done
especially for this book and Anna Ravenscroft for her
kindness and support to us all when photographing the
step-by-step processes. Tessa Clark and Graham Davis
for the great deal of work they have done to bring this
book together. My patient family for their support.

The publishers are grateful to publishers and copyright
holders for permission to use the following quotations:
Page 24: Extract from Psalm 131 from the Revised
Standard Version of the Bible, copyright © 1946, 1952,
1971 by the Division of Christian Education of the
National Council of the Churches of Christ in the USA.
Used by permission. Page 59 (right) quotations starting
'All round the ivied bank . . . ', 'To no part of England
. . . ', 'Upon St Valentine's Day this year . . . ' from *A
Country Calendar* by Flora Thompson (1979); by
permission of Oxford University Press. In the same
illustration the quotation starting 'For he's bewitched
. . . ' from THE LAND, copyright © 1927, Vita
Sackville-West, reproduced by permission of Curtis
Brown, London, on behalf of the estate of Vita
Sackville-West. Pages 100-101: 'The wind has stopped
. . . '; Kenneth Rexroth: *100 Poems from the Japanese*. All
Rights Reserved. Reprinted by permission of New
Directions Publishing Corp. Pages 120-21: 'Barn's
burnt down . . . '; from *The Penguin Book of Zen Poetry*
translated by Lucien Stryk and Takashi Ikemoto. Page
136-37: First two verses from Michael Quoist's 'The
Sea' from *Prayers for Life*, copyright © 1954; published
by permission of Gill & Macmillan, Dublin, and Sheed
& Ward, Kansas City.
 While every effort has been made to trace all
copyright holders of quotations used in this book, we
would like to apologise should there have been any
errors or omissions.

CONTENTS

INTRODUCTION

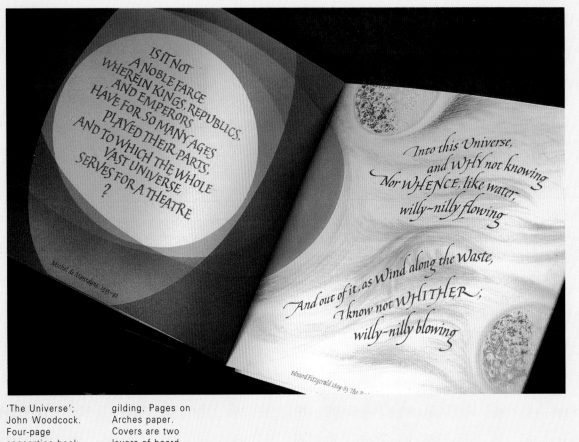

'The Universe'; John Woodcock. Four-page concertina book. Cover, endpapers and pages in a variety of media: marbling, resist, airbrushed stencils, colored crayons and gouache, watercolor, gilding. Pages on Arches paper. Covers are two layers of board covered in Ingres paper, the upper marbled, with ribbons between, the whole in a leather pouch. Page size: 18.2 x 18.5 cm (7 1/8 x 7 1/4 inches)

The modern interest in calligraphy began about a hundred years ago in 1898 when Edward Johnston, the British calligrapher, began studying early manuscripts in the British Museum. He then passed on the results of his research — and his excitement and enthusiasm — to his students at London's Central School of Arts and Crafts where he was teacher of calligraphy. Through his teaching began the revival of the ancient skills of writing with a broad-edged tool. This was not a mere copying of what had been done a thousand years previously; rather, it was using these skills to develop calligraphy into a craft that was relevant to the early twentieth century.

Today the boundaries of calligraphic communication and expression are being pushed to new limits as people explore the enormous potential of the craft. And traditional beautiful writing is highly valued as a vehicle for communicating words and ideas in a classical way and as a formal skill for producing documents.

At the root of all good calligraphy is a thorough understanding and appreciation of letterform that comes through the mind and the eye, both of which work together through the hand to produce co-ordinated, structured writing that, as skill develops, has life and spirit.

This understanding and a study of calligraphy's historical forms are both essential in the learning process and are the underlying themes of the first part of this book. There is no substitute for writing and writing. Practice controlled by critical appraisal helps to co-ordinate the mind, eye and hand and this in turn builds confidence and an ability to write fluently and freely. But endless practice is not enough. When you have a controlled grasp of the tools and materials and are willing to commit time and effort to your work your next step will be to begin working on projects. The second part of the book is designed to help you do this in a structured way, beginning with relatively simple pieces of work and progressing to more complex designs. Doing finished pieces like these will help you to consider aspects of design and use of materials — and encourage you in the making of good letters.

Each of the pieces of calligraphy in this book is unique. Everyone writes differently even though they may have started with the same information. And although the exemplars — letters with stroke directions — in the first part of the book have been written as carefully as possible to give a good consistent basis for understanding letterform, the letters and words in the other writing may not be uniformly consistent. This is natural: we are human beings not machines programmed to achieve perfection. However, because we are human, we can allow life into our work and, providing understanding lies behind the letterforms, imperfections can be tolerated and not even be noticed. The spirit of the work is the over-riding factor.

Remember, too, that the exemplars in the Getting Started section are just one person's interpretation of each script. For example, Italic and Foundational minuscules are explained in particular detail. However, in the project section Italic and Foundational letters have been interpreted and adapted in ways that are different and individual. Do not be afraid to let this happen in your own work; what is important is that your writing is carefully considered, structurally sound and consistent — not that it slavishly follows one particular interpretation.

Finally, here is a guide to some calligraphic do's and don'ts.
• Do take time to read the text carefully rather than just looking at diagrams and illustrations.
• Do keep your tools and materials clean and make sure that you have everything you need before beginning work.
• Do make yourself comfortable and give yourself space to work.
• Do work carefully and thoroughly. Cutting corners can lead to bad — and discouraging — results.
*Don't try to run before you can walk; work at your own level. If you do not understand something immediately, persevere with what you do understand and find your own ways of resolving a problem.
• Don't be afraid to develop your own ideas. Try varoius different ways of working and use this book as a tool, not as a set of rules.

This chapter highlights the most frequently used calligraphic scripts, their historical roots and the ways in which they are used today.

• The equipment and materials you will need are summarized and the basic techniques involved in calligraphy are described.

• Detailed illustrations show how to begin writing the different scripts and appreciate their letterforms.

• The last part of the chapter deals with the various elements of calligraphic design from layout to finished work.

EQUIPMENT

Calligraphers cannot make good letters with sharp, controlled pen strokes unless they are sitting comfortably and working against a firm, sloped surface. The drawing board, its preparation and position are therefore critical factors.

The board should be at least the size of an A2 (23 1/4 x 16 1/2 inch) sheet of paper. Commercially made boards are expensive but a piece of plywood at least 5mm (3/8 inch) thick, with its edges sanded smooth, is a satisfactory substitute. The diagrams on the right show how it can be used. In all three cases the board extends beyond and below the table top so that it will not slip away from you.

The angle at which the board is held is determined by your comfort and by the work you are doing. However, it also affects the flow of ink to paper (see far right).

The surface of the board will be too hard for the whole edge of a lightly held broad pen to write smoothly and make proper contact with the paper and it will therefore be necessary to pad it when setting it up (see top right).

Cut a section of cardboard tube and tape it to the bottom of the board to prevent paper creasing, or tape a heavy piece of card so that it hangs free from the bottom.

You must be able to sit upright and rest the whole of your forearm comfortably on the board with your hand and pen on a line about two-thirds of the way up. Keep your back straight, the chair well tucked in and your feet on the floor. Sitting uncomfortably will cause backache and create tension in your writing arm and shoulders which will show in your writing.

A good light source will ease any strain on your eyes. Daylight is the best and should come from the left if you are right-handed and from the right if you are left-handed. A north-facing window provides an even light. This is important when mixing and matching colors as artificial light produces varying results. An adjustable lamp provides the best kind of artificial light as it can be adjusted to shine exactly where it is needed.

Positioning a board
The plywood sheet is rested on your knee against a table to make a simple and effective board. It is stable, can be positioned at any angle and you can easily reach the top of the board.

Two boards are hinged together. Heavy blocks such as cloth-covered bricks hold the upper board at the desired angle and also anchor the base board.

The hinged boards have hinged supports which slot into grooves in the base support, and pegs to stop the board from slipping away.
This shows the cardboard tube attached to the board.

The right angle

The angle at which the board is positioned is as important a factor in the ink flow as the nib or reservoir you are using. Steepen the board for work that requires a slow, carefully controlled flow of ink and flatten it if you want a speedy and plentiful ink flow.

Setting up a drawing board
Tape a pad of 20 newspaper sheets covered with a sheet of cartridge paper on to the board, or use several large sheets of blotting paper or the reverse side of thick, smooth-surfaced wallpaper. Finally, tape a guard sheet across the board. This will help to hold the writing paper in position and protect its surface from any grease and dirt on your writing hand. Position the guard sheet at about two-thirds the height of the board so that your hand and eye are in line as you write and your arm fully supported.
Left-handed calligraphers may prefer to tape the writing paper and guard sheet so that they are at an angle (see bottom diagram).

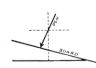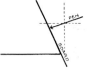

Ink flow
Hold your pen at an angle of about 60 to 90 degrees from the board whatever the slope of the board. When the board is sloped at a shallow angle the pen is held almost vertically and the ink flow is much faster than when the pen is held nearer to the horizontal on a board positioned at a steep angle.

Keep the whole of your arm supported to ensure that your wrist and fingers are able to move your pen freely. If only the wrist is supported and the forearm and elbow lift off the board, the movement in the hand, wrist and fingers is reduced and less controlled.

Basic equipment

The equipment shown here will be useful for the projects in this book. Where necessary, additional tools and materials are included in the lists at the start of each project.

1,2. Set square or protractor 30 degrees and 45 degrees are useful for drawing angles when practising letters and making margins.

3. Ruler 45 cm (18 inches) or longer.

4. Metal straight edge For cutting paper. Clear plastic rulers with one metal edge are available.

5. Scissors Good sharp ones are useful for doing paste-ups but not for trimming finished work as they will not give an accurate line.

6. Knife With disposable blades or blades that can be sharpened. Scalpels have different-shaped blades but these can snap if too much pressure is applied. Craft knives are good for cutting card or many layers of paper but are not suitable for detailed cutting.

7. Compass For drawing circles.

8, 9. Dividers For marking points for ruling lines. Springbow dividers (8) have a screw for fine adjustments and remain at the measurement set. Some come with pencil point or ink (9) attachments.

10, 11. Pencils HB and B for drawing lines and making double pencils (see page 26). Soft pencils blunt easily and will give a wider line, leading to inaccuracies when ruling up, unless they are kept sharp. Fine propelling pencils (11) can take a softer lead and remain sharp.

12. Bone folder For scoring and folding paper. Folders are available from suppliers of bookbinding materials.

13. Eraser A good soft one will not smudge.

14. Cow gum Not a permanent glue, it enables layouts to be repositioned.

15. PVA glue Preferably acid-free so that it will not eat into the paper. A white glue that dries clear, it can be diluted.

16, 17. Brushes Inexpensive brushes (17) can be used for mixing paint and loading nibs. Use pointed 00, 0 or 1 fine sable brushes (16), or their synthetic equivalent, for fine work.

18. Masking fluid A rubber-like solution (see page 12) that can be used with a pen or brush for work where a resist fluid is required.

19. Gum arabic A few drops in gouache paint mixes helps to 'fix' the paint on the paper.

20. Cutting mat Cuts heal and knife blades blunt less quickly when one is used. Alternatively, cut paper on the thickest possible piece of card.

21. Ruling pen For lines in paint or ink.

22. Masking tape Secures paper firmly and can be lifted off again.

PENS AND FLUIDS

The oldest writing tool is a quill, hardened and cut to size by hand. Writing with one takes practice and most calligraphers use manufactured pens. Writing fluids include paints as well as inks. Masking fluid can be used for special effects.

PENS

Fountain pens These are available with calligraphy nibs and can be useful for quickly noting down ideas or practising when time and space are limited. However, they do not give as controllable a sharp line as quills and other pens. They take cartridges of colored ink but the consistency these produce is not very good and color mixing is not easy.

Dip pens The commercially made tool that gives the best results is a dip pen with metal nibs. Square-edged metal nibs are inserted into pen holders and used with or without reservoirs to hold the ink. They are available in ten sizes. Examine them carefully and do not buy any that are crooked or split or which are badly formed or not clearly cut out. These nibs can be used with bottled and stick inks and gouache and watercolor paints as well as with other writing fluids and media for gilding. Left-handed calligraphers can buy oblique-left nibs for ease of writing. Pen holders come in various shapes. Find one that you feel comfortable with and buy several so that you have a holder for each of the nibs you use in a piece of work.

Automatic pens These come in a variety of shapes and sizes and make many different types of line. They can be used successfully with either ink or paint. Feeding several different colors into a wide automatic pen, using a brush, creates interesting effects.

WRITING FLUIDS

Bottled ink This is the easiest writing fluid to use and the most widely available. Use non-waterproof Indian ink. The waterproof version contains shellac which, if left to dry on a nib, cannot be removed by simple washing. Ordinary fountain pen ink is too thin to use with a dip pen as it will not give a good, even cover. Colored inks are often too thin.

Drawing acrylics and colored fluids These can be used straight from the bottle, but they vary in consistency and cover. It is always important to wash pens and brushes thoroughly after use.

Paints Gouache paints mixed with water to the consistency of single cream write well in a dip pen and endless color variations can be created. Mix the color the day before you need it and let it stand overnight. It will flow more freely and evenly and be less sticky. Watercolor paints can also be used but are less opaque than gouaches.

Chinese stick ink This is very good to work with. It comes in stick form and is ground with water on a slate ink stone to the density of black that is required. The blackness of ink sticks varies. Some, even when ground to a thick ink, produce a greyer tone than others. Generally speaking, better quality ink sticks produce blacker inks. Matt black ink sticks are usually better than shiny black ones. Cut down on the grinding time to make watery greys.

MASKING FLUID

This is a rubber-like solution that is used in a pen and left to dry. A wash is then applied over it. When the wash is dry the masking fluid is rubbed off, leaving the paper to show through. If the fluid solidifies in the bottle it can be dissolved by adding strong ammonia (available from pharmacies).

Writing tools
1 Automatic pen.
2 Square-edged nibs are sold individually or in sets and have a protective coating so always lick the nib before use so that it holds the ink. These nibs can be used with or without detachable reservoirs which clip under the nib. Right-handed nibs are cut straight across the top; nibs for left-handed calligraphers slope away obliquely to the left (5).
3 Reservoir. 4 Nibs with reservoirs; the reservoir can be removed to make the pen more flexible.
6 Pen holders.

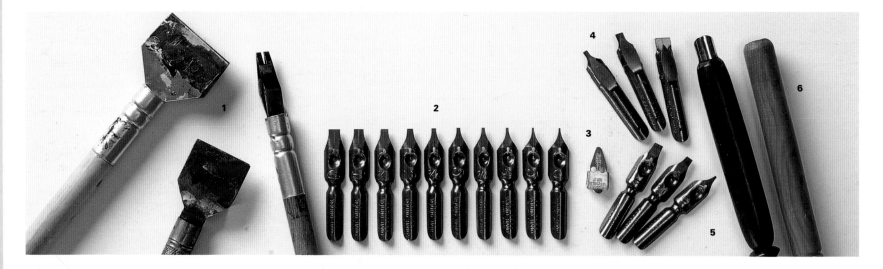

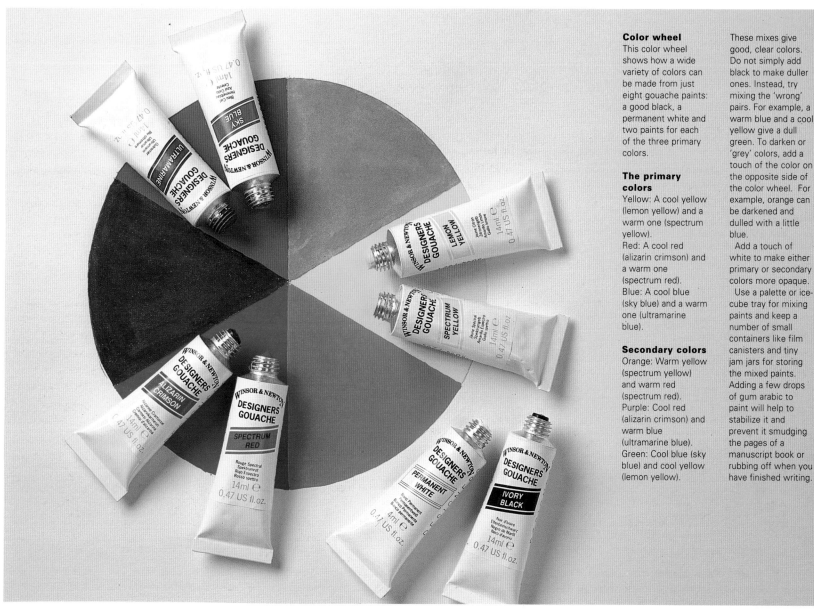

Color wheel

This color wheel shows how a wide variety of colors can be made from just eight gouache paints: a good black, a permanent white and two paints for each of the three primary colors.

The primary colors

Yellow: A cool yellow (lemon yellow) and a warm one (spectrum yellow).
Red: A cool red (alizarin crimson) and a warm one (spectrum red).
Blue: A cool blue (sky blue) and a warm one (ultramarine blue).

Secondary colors

Orange: Warm yellow (spectrum yellow) and warm red (spectrum red).
Purple: Cool red (alizarin crimson) and warm blue (ultramarine blue).
Green: Cool blue (sky blue) and cool yellow (lemon yellow).

These mixes give good, clear colors. Do not simply add black to make duller ones. Instead, try mixing the 'wrong' pairs. For example, a warm blue and a cool yellow give a dull green. To darken or 'grey' colors, add a touch of the color on the opposite side of the color wheel. For example, orange can be darkened and dulled with a little blue.

Add a touch of white to make either primary or secondary colors more opaque.

Use a palette or ice-cube tray for mixing paints and keep a number of small containers like film canisters and tiny jam jars for storing the mixed paints. Adding a few drops of gum arabic to paint will help to stabilize it and prevent it smudging the pages of a manuscript book or rubbing off when you have finished writing.

Grinding Chinese stick ink

Choose a large ink stone rather than a very small one. This will allow the rhythm of grinding to be established. If you use a lot of stick ink the slate will eventually wear smooth and will not produce black ink however long you grind. Roughen the slate with 400-600 grit wet and dry paper. Ground ink does not keep, so it is best to grind it afresh whenever you use it.

To grind stick ink, add a little water to the ink stone and rub the ink stick into it with rhythmic, circular movements. Keep testing the ink on paper — use a nib to do this — and keep grinding and adding water until you have a good black pool of ink. Measuring how much water you use and noting down the time it takes to reach the blackness you require will help if you have to grind ink for the same piece of work in the future.

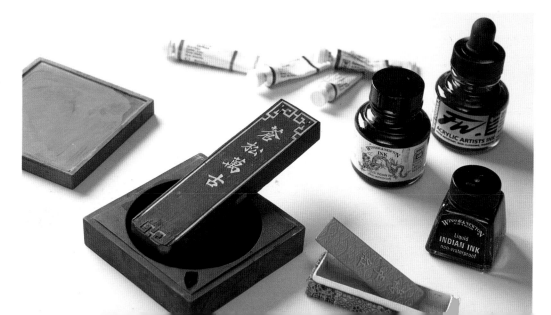

Writing fluids

Clockwise from top: Watercolor paint mixed with water can be used for writing or painting letters; liquid acrylic ink is useful for writing or painting when a waterproof medium is needed; bottled, non-waterproof Indian ink is the most convenient writing fluid for achieving good results; vermilion ink stick is ground with water to give a rich, warm color; black ink stick and grinding stone for black and greys.

PAPER

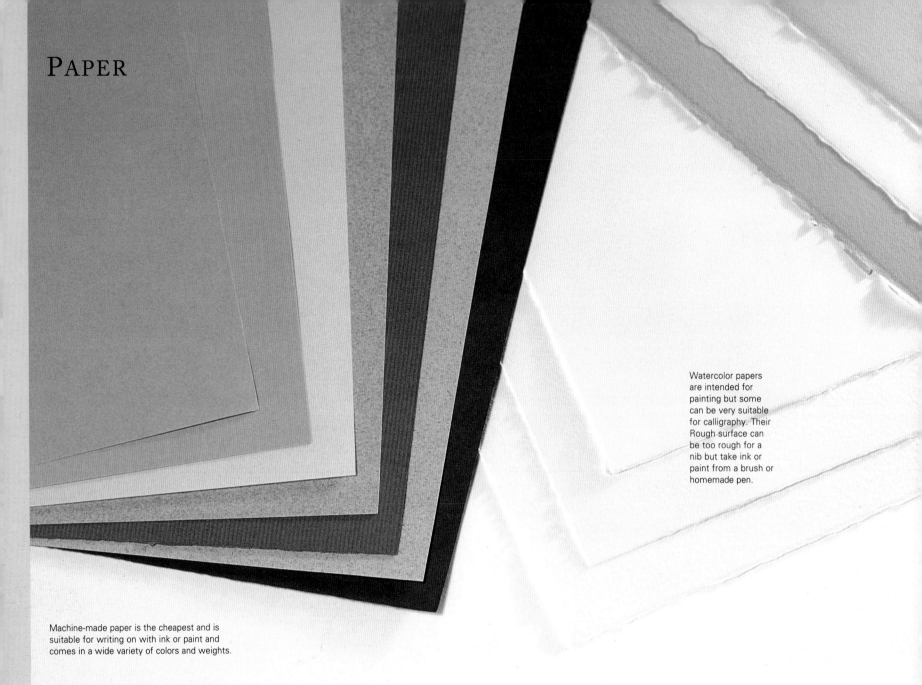

Watercolor papers are intended for painting but some can be very suitable for calligraphy. Their Rough surface can be too rough for a nib but take ink or paint from a brush or homemade pen.

Machine-made paper is the cheapest and is suitable for writing on with ink or paint and comes in a wide variety of colors and weights.

Books and charters were traditionally written on animal skin that had been expertly cleaned, scraped and prepared to give strong, flexible, durable sheets. Vellum made from cowskin is still used today by calligraphers, but it is expensive and not easily available. Furthermore, careful preparation is necessary to make the surface suitable for writing on. Good handmade paper is a fine alternative. If it is acid-free it can last a long time.

There are three categories of paper:
Machine-made paper Continuous lengths of paper made by machine and cut into sheets.
Mould-made paper Individual sheets made by machine.
Handmade paper Individual sheets made by hand.

Various substances can be made into pulp for papermaking. Good quality European paper was traditionally made of cotton and linen rags but is now usually made of short cotton fibres rejected by the textile industry. The rags or fibres are beaten and pulped in a vat so that the fibres are in suspension. Size, which enables the paper to be written on, and sometimes color is then added. A flat, rectangular mould is dipped into the vat so that the pulp collects in a layer on top of a mesh in the mould. The water then drains through to leave a sheet of wet paper which is sandwiched between woollen felt blankets and pressed to remove excess water.

The surface of the finished paper is affected by how it is dried.
Rough Sheets of paper dry naturally and the paper is as rough as it was when it was removed from the blankets.
Not Sheets of paper are piled together and then pressed again. The result is a slightly rough surface.
Hot pressed Sheets of paper are passed between heated metal rollers to give a smooth surface.

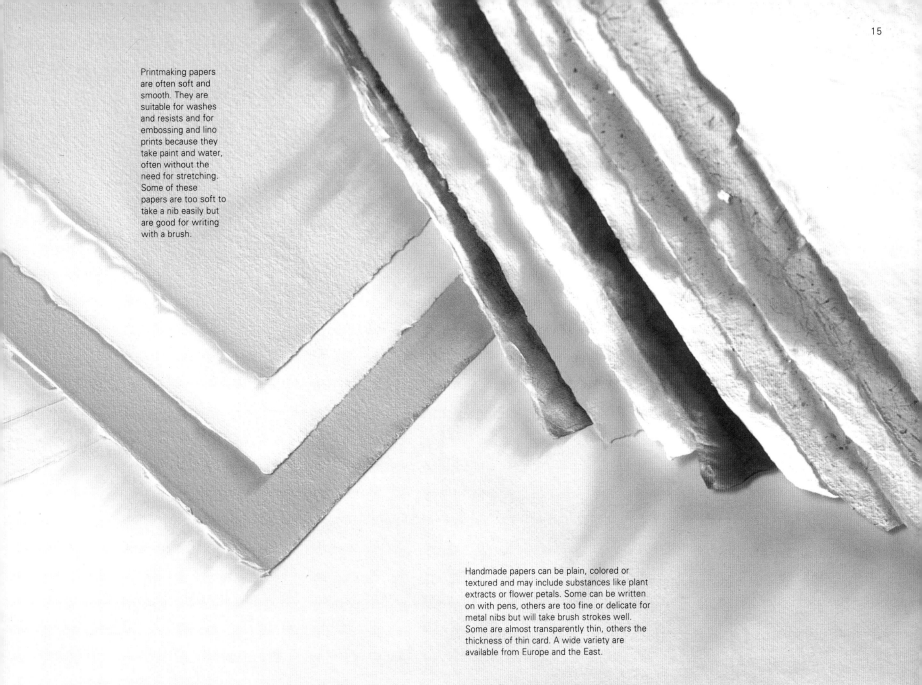

Printmaking papers are often soft and smooth. They are suitable for washes and resists and for embossing and lino prints because they take paint and water, often without the need for stretching. Some of these papers are too soft to take a nib easily but are good for writing with a brush.

Handmade papers can be plain, colored or textured and may include substances like plant extracts or flower petals. Some can be written on with pens, others are too fine or delicate for metal nibs but will take brush strokes well. Some are almost transparently thin, others the thickness of thin card. A wide variety are available from Europe and the East.

Paper weight is measured in grams per square metre (gsm) or pounds. Generally, the smaller the number the lighter the weight of the paper.

An enormous range of papers is available and many paper suppliers will provide samples of the papers they stock, for a fee. These are useful if you are ordering by mail and enable you to try out the papers with your nibs and brushes before buying. Art shops tend to stock what they know they can sell

for painting and drawing, as well as for calligraphy, but specialist paper shops stock a wide selection of papers for all purposes, and often offer a mail order service.

Paper for finished work is better bought in large sheets than small pads. Be sure to buy enough paper for the work you are doing. Buying one sheet puts you under enormous pressure to get it right first time. Remember, too, that you will want to do trials on the paper before starting on the finished

piece and just one sheet may limit the number you can do. Some handmade papers can be expensive, but it is worth balancing this against the amount of work you are putting into a piece. You may well consider that the extra expense is justified.

Layout paper is good to use for practice work and roughs. It is lightweight but strong and has the advantage of being partially transparent, which is useful for making roughs and layouts. Try to

buy a good quality paper. Poor quality paper often causes the ink to bleed — sharpness of line is as important in practice work as in the finished piece. Layout paper is available in pads. Buy an A2 (23 1/4 x 16 1/2 inch) pad if possible, or at least an A3 (16 1/2 x 11 5/8 inch) one. Anything smaller than A3 can restrict your writing and the way you see your work on the page. Space gives the freedom to write without being interrupted by short lines and the edge of the paper.

BEGINNING TO WRITE

These two pages deal with the most basic skills of calligraphy: how to put a nib and reservoir together and then how to load the nib with ink and start to write.

ATTACHING A RESERVOIR

Attaching a reservoir to the underside of a nib needs practice. If it is put on too tightly it will split the tip of the nib apart or prevent the ink from flowing on to the tip. If it is attached too loosely the ink will blob or the reservoir itself will fall off.

Always remove the reservoir from the nib after using it and clean it with a toothbrush to avoid rust building up.

APPLYING INK

Use a brush to apply the ink under the reservoir or on the top of the nib if you are not using a reservoir — if you dip the nib straight into the ink it will be totally covered in the fluid and it is essential that the ink stays only on one side of the nib to help keep the writing sharp.

Clean the nib at regular intervals using a tissue or, ideally, a cloth that does not shed fibres. This will prevent dried ink building up on the nib as you write. Always wash and dry nibs after use.

STARTING TO WRITE

When the nib is loaded you may find that getting it to write on the page is difficult at first. It is perfectly acceptable to start the ink flow by making side-to-side movements on the paper at the point where you are intending to write.

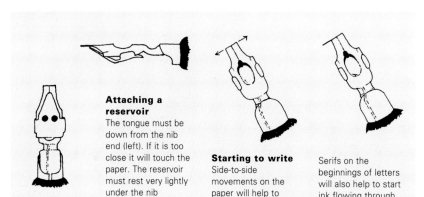

Attaching a reservoir
The tongue must be down from the nib end (left). If it is too close it will touch the paper. The reservoir must rest very lightly under the nib (above).

Starting to write
Side-to-side movements on the paper will help to start the ink flow.

Serifs on the beginnings of letters will also help to start ink flowing through the nib.

Applying ink
Apply ink into the space between the reservoir and the nib using a small or medium paint brush. If you are using a nib without a reservoir brush on the ink so that it covers the opening on the top of the nib.

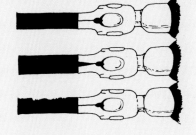

Pen angles and pressure

If the width of the strokes in your writing is inconsistent it could be because the pen angle — the angle at which the nib is held to the writing line — has changed or the pressure on the nib is uneven. Always be aware of your pen angle and how your hand and fingers move — they must remain consistent throughout the writing process.

Apply only light pressure. This will make writing quicker and easier. Work steadily and evenly and be aware of a feeling of rhythm as you make the strokes.

Try to relax as you write.

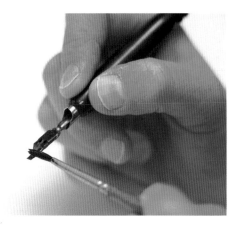

Top: Always keep the full square edge of the nib in contact with the paper. Centre: The stroke may be wider than the nib. This happens when heavy pressure on the nib causes its tines to splay.

Above: Uneven strokes are the result of the nib not making full contact with the paper so that you apply more pressure to one side than the other. This happens when the writing surface is too hard.

If the ink flow is still a problem check the following points:
• Is the surface of the nib too smooth to conduct the ink on to the writing edge? This can happen with new or very shiny nibs, especially wide ones. If you hold the nib in the flame of a match for a few seconds or lick its surface the deposits will help the ink to flow.
• Has the reservoir been attached too tightly?
• Has the paper picked up grease from your hands or arm? A guard sheet (see page 10) will prevent this happening.
• Is there enough water in the ink? Add distilled water if the ink seems too thick or creamy.

HOLDING THE PEN

Two right-handed pen holds are either between the first two knuckles of the forefinger or between the thumb and forefinger. The first 'hold' allows the pen to move flexibly between the fingers. There is less flexibility with the second hold but many people find it more comfortable and that it gives them greater control. This hold can be adapted for left-handed calligraphers.

The hold affects the way the nib makes contact with the paper and the flow of ink from the nib to the paper. The angle of the board is also important. The first pen hold may work well at a shallower board angle while the second one requires the board to be positioned at a steeper angle so that the underneath of the nib is lifted clear of the paper.

SETTING LINE SPACES

The space between the upper and lower guidelines for your writing is the body height of the letters — known as the x-height because it is the height of the x — and is set by the width of the nib you use.

Always draw the bottom guide-line first. Then, with the nib held at 90 degrees to the line to give its widest stroke, make a series of horizontal steps to the required number of nib widths. Each step must begin exactly at the top of the previous one — accuracy is vital. Draw the top guideline when all the steps are marked.

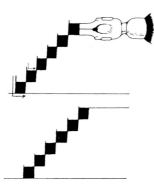

Setting line spaces
Top: Draw the bottom guideline. Keeping the nib at a 90 degree angle and holding it vertically make accurate horizontal steps from the line.
Above: The top point of the steps sets the top writing line for the x-height of the letters.

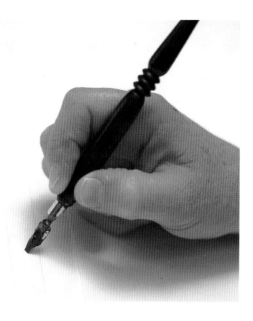
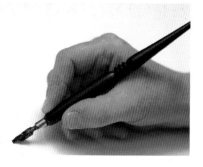

Two alternative pen holds
Left: The pen is held resting between the first two knuckles of the forefinger. This is a steep hold which allows the pen to move flexibly between the fingers.

Above: The pen can be rest between the first knuckles of the thumb and forefinger. This shallower pen hold may be more comfortable and you may feel you have greater control.

Basic strokes

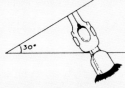

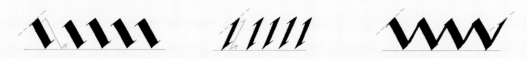

Hold the nib at an angle of 30 degrees to the writing line — draw a 30 degree angle at the beginning of the line as a check. Make sure you keep this angle consistent while you write and that your upright strokes are upright and do not slope backwards.

Concentrate on spacing the strokes evenly. Look at the spaces between the strokes as well as the strokes themselves, so that an even pattern is made. Look at the width of the strokes along the line to see if they are consistent.

Hold your pen at a steeper angle, nearer to 40 degrees, to make diagonal strokes.

Look at the beginnings and endings of strokes to check that you have kept the pen angle consistent.

Curves should balance and appear to sit upright. When straight strokes lead into curves, and arches, the straight strokes should be upright and parallel.

Draw lines across the page and use these as a base line.

Straight strokes should form a series of parallel lines with even spaces between them. Thick diagonal strokes and thin strokes should be parallel to give triangles of white space that are equal and symmetrical.

STARTING-POINT

Edward Johnston, the father of the modern calligraphy revival, wrote on the first page of *Writing & Illuminating & Lettering:* 'Nearly every type of letter with which we are familiar is derived from the Roman capitals, and has come to us through the medium, or been modified by the influence of, the pen.' The fine examples of consistent letterforms that can be found among Roman inscriptions are therefore a sound starting-point for looking at good lettering. They have the understanding of a mathematical origin, but the life and visual balance that only a trained eye can add.

The example on the right is from the Trajan Column in Rome. It is likely that the letters were first written on the stone with a square-ended tool — possibly a brush — and then chiselled into it. Because they are larger at the top of the inscription than at the bottom all the letters seem to be the same size to anyone looking up at it.

Relationships of form, shape and size can be clearly seen and the careful spacing of the letters gives an even flow along the line. Legibility was vitally important to the inscription makers but they also produced aesthetically pleasing letters. Appreciating the knowledge of letterforms that is embodied in this and other Roman inscriptions helps to train the eye to recognize and judge good letters; and is the first step to making them.

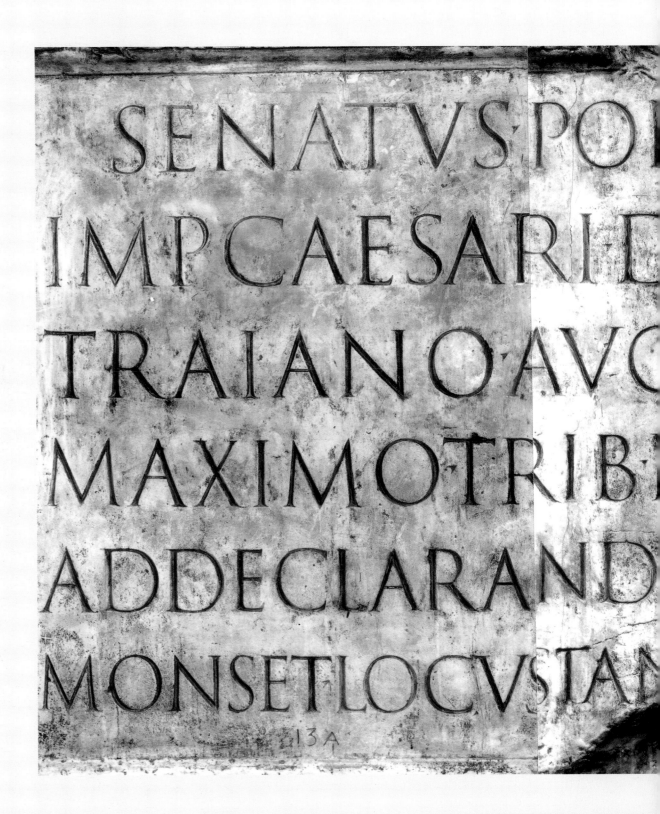

The Trajan Column,
from the cast in the
Victoria & Albert
Museum, London.
 Size of inscription:
114 x 274 cm (3 ft
9 in x 9 ft).

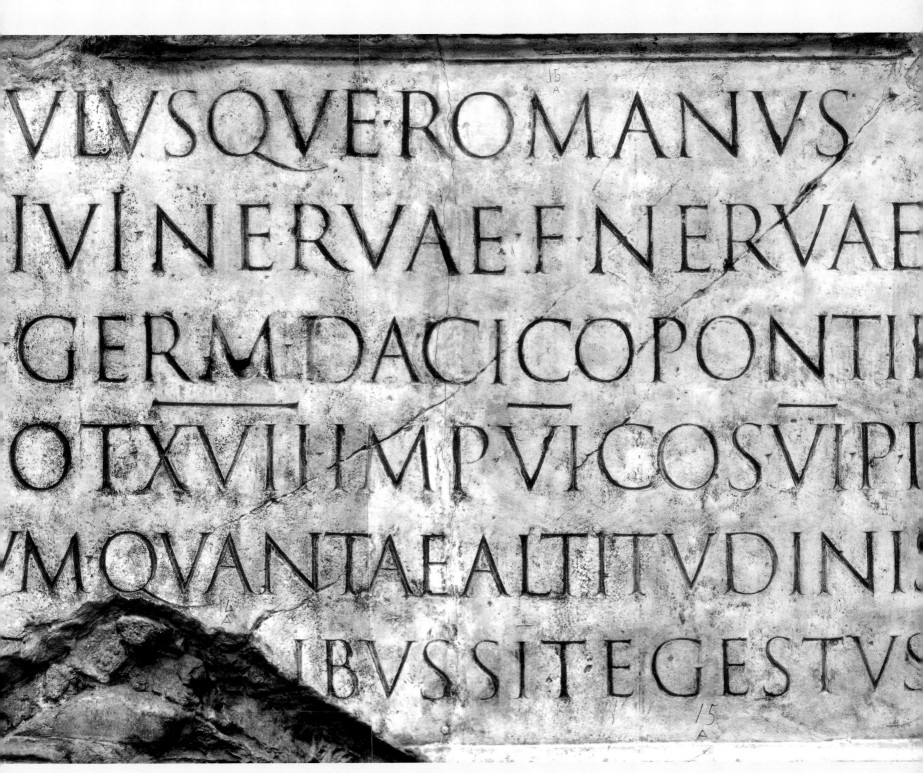

SKELETON LETTERFORMS

It is not known for certain whether Roman inscriptional letters are geometrically based. However, the carved letters are so well proportioned that it is conceivable that the inscription makers used some method that ensured consistency of shape and form.

Edward Johnston, as a result of his research into early manuscripts and inscriptions, used a geometric model to introduce his students to Roman capitals and the forms based on this are known as skeleton letters — the bare bones of letterform.

Skeletons are a useful framework within which to work. They provide a foundation on which to build fine letters and, when written with a certain amount of optical adjustment and finish, can be very beautiful in themselves. An understanding of them is as essential to a calligrapher as the learning of scales is to a musician. However, just as mastering scales is only the first step towards a musician's proficiency in his or her art, skeletons form the basis of a calligrapher's work but not its sum total. The importance of skeletons is that a thorough knowledge of the relationship between their shapes and forms allows him or her the freedom to write and design good letters — capitals and lower case letters — and to apply the principles that he or she has learnt to all scripts.

The diagrams on the following pages explain the geometrical basis of skeleton letters and their spacing and how to use them.

The basic geometric grid is a

Family groups

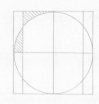

Basic grid
A circle within a square is the starting-point. One-eighth of the square is cut off each side to give a rectangle and the 1/8 lines cut portions off the circle so that the area of the rectangle is visually equal to the area of the circle.

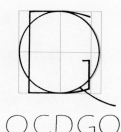

OCDGQ

Round letters:
O, C, D, G, Q
O and Q follow the circle. D occupies the same visual area as O.
C and G follow the circle, but the top and bottom strokes are flattened to allow the eye to move along the line to the next letter.

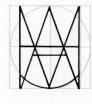

HAVU

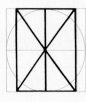

NTXYZ

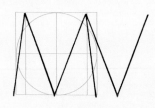

MW

Rectangular letters:
H, A, V, U, N, T, X, Y, Z
H sits on the rectangle and occupies the same visual area as O. Place the crossbar slightly above centre or it will appear to drop below centre. U follows the lower section of the circle. T's crossbar sits between 1/8 lines, as do Z and N. Y has a central downstroke. The crossbar of A is lower than centre so that the top and bottom spaces visually balance.

Wide diagonal letters:
M, W
W is as wide as two Vs; V sits within the rectangle so W is therefore as wide as two rectangles side by side. The centre section of M is the same as V; the legs extend to the corners of the square.
M is not an upside-down W.

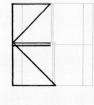

EFLK

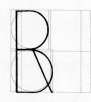

BPR

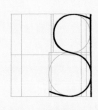

SJI

Narrow letters:
E, F, L, K, B, P, R, S, J, I
These are based on diagrams which occupy half the area of the large square. The 1/8 line is also divided in half to become, in effect, 1/16 of the large square. The top square is slightly smaller and the bottom one slightly larger than 1/4 of the large square, but both are true squares. E, L, F, and K's upright strokes sit on the outside of the squares. The upper and lower strokes of J and S are flattened for the same reason as those of C and G. I is a straight line. The bowls of B, P and R follow the circles.

Using the theory

The strict geometric diagrams on the left provide a useful theory from which to discover letterform. As the diagrams stand they give letters that technically relate in shape and form. Aesthetically, though, some letters can look rigid and even uncomfortable when they are together.

The narrow letters B, P and R are good examples of this. Drawn geometrically, their bowls look small; indeed, the internal spaces of the top bowls are less than a quarter of the area of a D. And the bowl of P, and to some extent the bowl of R, needs to be enlarged a little in order to balance visually with the space below it.

However, the geometric diagrams for the narrow letters B, P and R are useful to show how the shapes of the bowls should relate to the circle and square and are a first step towards understanding their form. But do not be afraid to modify the letters — it is what they look like that is ultimately important.

Optical adjustments that need to be made to these letters are shown on page 22.

Edward Johnston wrote that, 'The tension lies in the difference between an exemplar and the free interpretation of it — spontaneous writing is dependent on the free movement of the hand.'

Spacing

The starting-point is the space between two upright strokes: 5/8ths of the height of the letters.

When a diagonal letter follows an upright, the diagonal stroke is moved closer so that if were upright it would sit upon the 5/8th space guideline.

When two diagonals are adjacent they are positioned similarly so that the visual area between them is the same as the two upright strokes.

When a circle and an upright stroke are adjacent the circle comes closer to the upright by overlapping the 5/8th line. The area between remains visually the same as the space between two upright strokes.

Adjacent round letters come closer to compensate for the space around the curves, ensuring that the visual area between them remains the same.

To check spacing

Begin your analysis by looking at the space between two upright strokes and work from that until you have looked at the whole word.

Look at three letters at a time. The balance of the two spaces between them will be much more noticeable. Too small a space between two letters will pull them together; too large a space will push them apart.

Visual balance

The letters should balance visually so that neither holes nor dark patches are created. In closely spaced letters O stands out as a hole. In evenly spaced letters it takes its place and should not be any more noticeable than other letters.

circle within a square — an easy starting-point because both shapes are constant and vary only in size. They are also easily constructed and recognized. The letters sit within this grid and are based on the shape and area of the letter O which follows the circle. In the exemplar on the left — as in all family group exemplars in this book — the letters are grouped according to their shapes rather than the order of the alphabet so that the relationships between them can be clearly seen.

Spacing the letters ultimately depends on visual judgement but actual measurements are a tangible starting-point as they help to train the eye. Basic rules for combining letters are given in the diagrams above; follow these and then judge the overall balance of the spaces in your writing. Look at the shapes of the spaces inside the letters together with the shapes of the spaces between them.

Evenly spaced letters are crucial to the smooth reading of a piece. More often than not lettering is too closely spaced which is uncomfortable to the eye because it hinders legibility and destroys the pleasure and ease with which the eye receives good letters. Judging good spacing comes with both doing and looking at well-spaced, good lettering.

Learning the basics of skeleton capitals

Take time to construct the capitals geometrically so that you fix the proportions in your mind. Use a 4 cm (1 1/2 inch) grid.

• Rule horizontal lines 2 cm (3/4 inch) apart then write the letters between the lines. Pay very close attention to their shapes and proportions. Write the letters in their groups, first in pencil and then with non-waterproof Indian ink and a narrow nib.

• Notice the white shapes inside the letters as well as the black letter shapes themselves.

• Remember the circle — natural handwriting tends to be narrow and making circular-based skeletons can be difficult when you start to write skeleton letterforms for the first time.

ABCDEFGHIJKLMN

OPQRSTUVWXYZ

USING SKELETON LETTERS

Far from being written solely as an exercise, skeleton capitals can be used in themselves as elegant and graceful letters. Once you have become thoroughly familiar with their shapes and at ease with writing them you will find they have many uses. Knowledge of their form will give you a valuable foundation and basis from which to develop and will help you to examine the relationships between letters and any particular script in terms of form and shape.

The diagrams on this page show how to write skeleton capitals and the various ways in which they can be used. Remember that the letters are spaced visually and that it is essential to ensure that there is an equal visual balance of space inside and around them. You may need to make optical adjustments to the letters so that they sit together in a visually pleasing way.

When you are confident about writing skeleton capitals and sure in your mind of their related forms you will be able to use them in a freer, more relaxed way. Try using a centre guideline, which allows movement, instead of writing letters between lines. With prac-

tice, the shapes of the letters will become second nature and you will find it easier to get their shapes right with even spaces between letters. As you relax, your writing speed may well increase and result in your letters sloping slightly forwards. This is quite acceptable — and adds vitality to your work. Just let it happen naturally.

The diagrams on the opposite page show how to construct minuscule, or lower case, skeleton letters. Although they are not as commonly used as the capitals, understanding their construction and related forms will prepare you for looking at and understanding Foundational letters.

Learning to use skeleton capitals

It is worthwhile working hard to master skeleton capitals. When you feel confident of your ability to write individual letters practise them in their family groups, then progress to writing out a quotation.

This is valuable practice as it will encourage you to sustain the form and flow of skeletons in a continuous piece of writing. Write the letters at a comfortable size with a fine nib.

Optical adjustments

Adjusting widths
B, P and R tend to look very narrow when placed with round letters.

To help them relate more comfortably the Os can be narrowed very slightly and the bowls of narrow letters widened slightly.

The adjustments must be slight so that the Os give the illusion of being circular, and so that the bowls of P and R are round and their shapes still relate to each other. Overdone adjustments give noticeably oval bowls to the letters.

Protruding letters
The points of A, V, W and M must protrude very slightly above and below the writing lines so that all letters appear to be the same size. The top and bottom curves of O and Q may need to protrude beyond the lines instead of just touching.

Widening letters
The bottom of Z and lower points of X need to be slightly wider than the rectangle to give them a stable base. The legs of A and V may have to be extended to look the same width as the rectangular letters.

Reducing space
Leaving less space between lines of writing will also affect the look of your work — interlinear spacing is discussed in more detail on page 58

Creating texture
Reducing interlinear space produces a texture rather than a series of lines. Because capitals have no ascenders and descenders they are ideally suited to this technique.

Adapting skeleton capitals
Use a fine nib held at an angle of approximately 30 degrees.

The easiest way to make the letters more 'finished' is to add small serifs — endings at the top and bottom of the strokes (above right)

— with the nib moving from left to right so that it produces a small, thin stroke at an angle to the main strokes. Serifs should

be light and fine: too much ink or a damaged nib will result in heavy serifs. Serifs also provide a useful lead in to the main strokes.

Creating movement
Using a centre guideline is difficult at first but do not worry if the letters vary in height slightly — this will actually add vitality. But do not make the letters jump and down deliberately. This is disturbing to the eye. Let them move naturally, taking on the rhythm of your writing.

Checking heights
If you are aware that your letters get noticeably much smaller or larger as you write, mark the height you wish to maintain in pencil on a scrap of paper and keep this nearby to check the letter heights every now and then.

Family groups

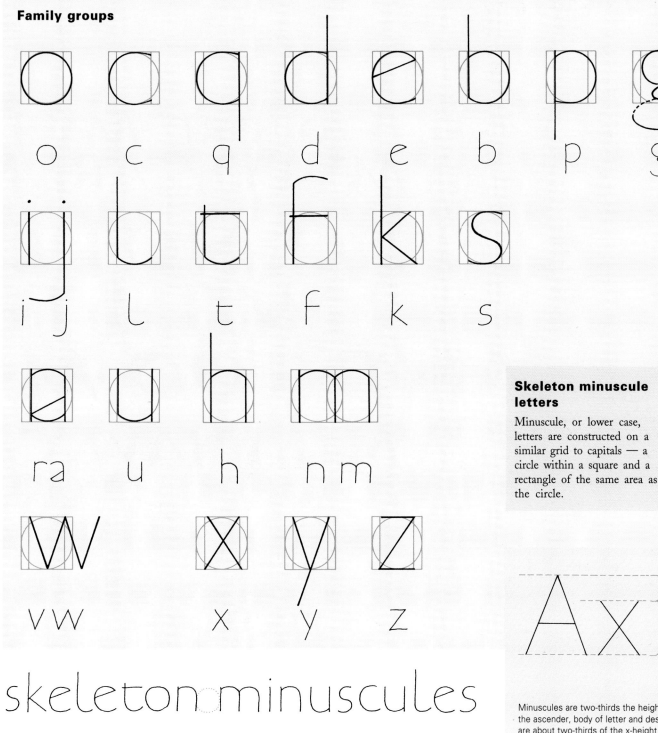

Round letters:
o, c, q, d, e, b, p, g
Round letters follow the circle. The top curves of c, q and d are flattened, as is the bottom curve of p, to avoid disturbing eye movements or making heavy joins. g is made of a circle between the 1/8 lines and a lower open or closed oval-shaped bowl. The back curves of c and e follow the circle but are often slightly straightened.

Straight letters:
i, j, l, t, f, k, s
The bottom curves of l and t follow the curve of o but i does not have a curve at its base. The top curve of f is a slightly flattened curve. s is hard to draw diagramatically but the bowls should have a circular feel.

Arched letters:
r, a, u, h, n, m
These follow the top curve of o. m is twice the width of n. u follows the lower part of o.

Diagonal letters:
v, w, x, y, z
w is twice the width of v. The top of x is inside the rectangle and its base just outside it. The base stroke of z is just longer than the top one.

Skeleton minuscule letters

Minuscule, or lower case, letters are constructed on a similar grid to capitals — a circle within a square and a rectangle of the same area as the circle.

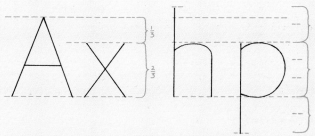

Minuscules are two-thirds the height of capitals. Letter parts consist of the ascender, body of letter and descender. Ascenders and descenders are about two-thirds of the x-height of the letter.

skeleton minuscules

Letters are spaced visually with even spaces inside and between the letters and an O space between words.

abcdefghijklmnopqrstuvwxyz

ROMAN LETTERS

Letters whose forms are based on inscriptional letters carved on capitals — the blocks of stone on top of columns — are known as Roman capitals. Today their shapes are based on skeleton letters and their forms are influenced by the use of a square-edged nib rather than a brush and chisel. The movement of the pen on paper gives the written letters a life of their own that distinguishes them from carved ones.

When Roman capitals are written fluently with a thorough understanding of the skeleton forms they are beautiful, clear letters. Because they are easily read they can be used in all parts of the design of a calligraphic work. Edward Johnston said, '. . . in regard to lettering generally, a very good rule to follow is: When in doubt, use Roman Capitals.' He considered it necessary that his students should understand their fundamental importance in calligraphy.

The writing on the right is a good example of their use with letters written at different weights which provide contrast and emphasis. The writing is spirited and rhythmical with a unity of form and clear concept of shapes and spaces that springs from a clear concept of the underlying skeletons but which does not adhere slavishly and rigidly to them.

O LORD, MY HI
MY EYES ARE N

I DO NOT OC

WITH TH

AND TOO MA

BUT I HAVE CAI
LIKE A CHILD QUI
LIKE A CHILD T

O ISRAE
FROM THIS TIME

Psalm 131, Revised
Standard Version of
the Bible; written by
Richard Middleton.
Quills on plain cream
laid paper.
Enlarged by 163%.

ART IS NOT LIFTED UP,
T RAISED TOO HIGH;

CUPY MYSELF PSALM 131
NGS TOO GREAT
RVELLOUS FOR ME.

MED AND QUIETED MY SOUL,
TED AT ITS MOTHER'S BREAST;
AT IS QUIETED IS MY SOUL.

HOPE IN THE LORD,
ORTH AND FOR EVERMORE.

ROMAN CAPITALS

Like all written pen capitals, Roman capitals are based on skeleton capitals — a relationship that becomes clear when a double pencil is used for writing.

The diagrams on these two pages show the 'family' likeness between various groups of letters, the numerals and punctuation and serifs used in the Roman alphabet and guidelines to bear in mind when spacing Roman capitals. Letterforms to be avoided are also highlighted.

The first step, however, is to practise writing with a double pencil. Although this is not easy it is a useful exercise that will help you to understand the movement of a pen and the form of written Roman capitals. This is because each side of a broad nib will make the same lines as the pencil points; the only difference will be that the nib will produce a solid ink line while the double pencil creates two lines with space between them. It is worthwhile keeping your double pencil close at hand so that you can reuse it whenever you want to check how you are making a letter in relation to its form.

Once you have mastered the double-pencil technique it will be time to move on to using a pen and ink. There are two points to check while you are writing: the shapes of the strokes as they complete the letters; and the white spaces around the strokes and letters. The consistent shapes of the spaces are as important as the shapes of the pen strokes in checking your letter shapes.

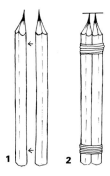

Making a double pencil
1 Take two HB or harder pencils and shave down one side of each of them so that they sit with their points closely together.

2 Bind the pencils tightly together with elastic bands or tape.

3

3 You can keep the points level or, if you are left-handed, slope them to the left. If you are right-handed you could slope them to the right. Always keep the pencil points sharp.

Using a double pencil
1. Draw a pencil line across your page. Then draw another, parallel, line above it at a distance of six times the width of the pencil points.

2. Hold the pencil so that its points are at an angle of 30 degrees to the writing line.
3. The pencil points are the equivalents of the sides of a pen nib.

Family groups

Round letters:
O, Q, C, D, G
The top and bottom of O and Q can very slightly cut the writing lines so that they appear to be the same height as the other letters. Make sure D is wide enough and flatten the tops of C and G to carry the eye to the next letters.

Rectangular letters:
H, U, T, Z
Sit the crossbar of H just above centre or it will seem to drop below the centre. The crossbar of T must not become too heavy. Flatten the pen angle completely for the centre stroke of Z to add more weight than if the angle was 30 degrees.

Narrow letters:
I, J, L, E, F, K
The bottom curve of J is flattened (not a hook shape) or it can stop just below the line. The crossbars of

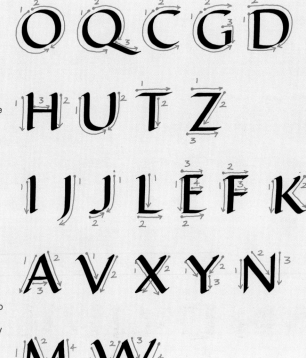

E and F are the same length but the lower crossbar of F is slightly lower than the middle crossbar of E to balance the white space above and below it. The bottom crossbars of E and L are slightly longer than the upper ones. The second stroke of K should only just touch the first stroke.

Diagonal letters:
A, V, X, Y, N, M, W
The pen angle is steepened to give a good contrast between thick and thin strokes. Hold the pen at approximately 40-45 degrees, but flatten the angle slightly for the thin strokes.

Small bowl letters:
B, P, R, S
The arms of S are flattened curves that do not cut into the bowl shapes. Take care to make the internal spaces rounded. Check the inner shapes of the bowls when writing P, B and R.

1 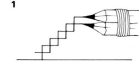 **2** 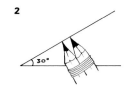 **3**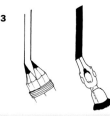

Try writing an H shape first, then an O shape in two strokes. Notice how each pencil point makes a skeleton letter. An O is therefore two overlapping circles. All the letters are made up of two overlapping or parallel skeletons set apart at the angle at which you are holding your double pencil. To examine the shapes of the letters join the skeleton lines together within each letter and color between them with a crayon or pencil. This will help you to see the forms of the Roman capitals as well as the lines of the skeleton shapes.

EVENLY SPACED
WIDE SPACING
MUCH TOO CLOSE

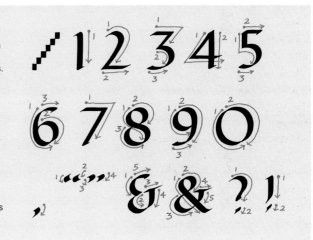

Bad letter forms to avoid

- C's arms curl up and down too much.
- The pen angle has not been flattened for the centre stroke of Z. This results in a weak stroke which is too lightweight.
- The legs of M are splayed out. They must be straighter.
- The second stroke of K cuts into the first stroke which creates heaviness in the middle of the letter.
- The arms of S cut into the bowl spaces. The eye drops as a result instead of continuing to the next letter. In addition, the internal white space is reduced making the letter appear heavier.
- The bowl of R slopes as it moves to join the upright. It must be kept horizontal at that point.
- There is too much contrast between the thick and thin strokes of X. Flatten the pen angle slightly in order to make the thin stroke.

Spacing

Roman capitals are spaced by eye so there are no set rules, only basic guidelines.

Even spacing

Areas between letters must be visually equal with each other and the space inside the letters.
Approximately one O space separates words to ensure they are read separately but that the flow of reading is retained.

Wide spacing

If letters are too far apart they will not connect visually to make words. The eye will not flow easily along the word or line and reading will be slowed down as a result.

Close spacing

If letters are too close dark patches will form and Os will look like holes. Texture will be uneven and legibility may be impaired.

How to check spacing

It is not always easy to gauge the spacing of letters; a useful check is to look back at your work with your eyes half-closed and out of focus so that you are looking at the piece as a whole without concentrating on reading. Spaces that are too close will appear as dark patches within your work. There should be an even pattern of black and white, stroke and space.

Numerals and punctuation

Numerals are written at the same height and weight as letters. Their bowls must be round to echo the letter shapes.
A question mark needs only a small curl underneath the upper curve. Twist the pen as it moves down for an exclamation mark and keep commas and inverted commas small and curved.

Adding serifs

The letters in the family groups have hook serifs, an extension of the letter strokes. Other serifs are:
Top left: Fine lines.
Top right: Slab serifs added as separate pen strokes.
Right: Built-up serifs made with three movements at the tops of strokes and slab serifs at the base of verticals.

Learning to write Roman capitals

Draw a baseline across the page then use a wide nib to mark six nib widths up from this line.

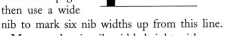

Measure the six-nib-width height with a ruler or dividers and make pencil marks or pin pricks down both sides of the page. Join the marks or pin pricks using a ruler and HB or harder pencil. (Too soft a pencil will make a wider pencil line which is less accurate than a narrow one, especially when the writing lines are close together for smaller writing.)

Write the letters in the family groups on the opposite page between alternate pairs of lines — this will give an interlinear space that will help you to see the letters clearly.

ABCDEFGHIJ
KLMNOPQR
STUVWXYZ

FOUNDATIONAL

The Foundational hand is based on the writing of the Ramsey Psalter (Harley MS 2904) which was written in the south of Britain towards the end of the tenth century. The manuscript is clearly and beautifully written with remarkably well-formed and consistent letterforms. The letters are based on a circle, the o is made of two overlapping circles and, because most of the letters relate to the circle in their shape and form, they are closely interrelated. The pen has been held at a consistent angle while writing so that the thick and thin parts of the letters are balanced and harmonious.

In all, the manuscript is a good starting-point for learning minuscule letters. Furthermore, the related forms of its letters have strong similarities to the forms of Roman capitals and can therefore be used with them.

The clarity of the psalter means that it is a good example to look at when learning how to analyse a manuscript in order to develop a modern hand of writing. Edward Johnston encouraged his students to study manuscripts as he himself had done, and to analyse their various elements.

Learning from a manuscript is not a matter of simply copying letter shapes. In order to be able to form the letters with consistency and understanding it is necessary to ask questions about what you see, in relation to the tool used — in this case a broad-edged pen — and the size and weights of the letters. As you study a manuscript ask yourself the following questions, based on Johnston's seven points for the analysis of historical scripts, and answer them with your eye — and a pen with which to make trials.

• What is the pen angle used and is it consistent or not? If not, how does it change?

• Determine the width of nib used or, if looking at an enlargement or reduction, which nib could be used to make a same-size study?

• What is the height of the letter in relation to the width of the pen stroke?

• Are the letters upright, or by how much do they slope?

• What is the shape of o and how does it relate to other letters?

• Are there any other particular characteristics such as serifs, joins, spaces?

• What is the stroke sequence — how are the letters made?

• Are any changes necessary for contemporary use?

The Ramsey Psalter. Harley Ms 2904, folio F61V. British Library, London.
 Actual page size: 33 x 25 cm (13 x 9 3/4 inches). The writing shown above is a little larger than the writing in the manuscript.

matris tue ponebas scandalum

haec fecisti & tacui

existi masti iniq. quod ero tui similis

arguam te & statuam

contra faciem tuam

ntelligite haec qui obliuiscimini

dnm. nequando rapiat

& non sit qui eripiat

acrificium laudis honorificabit

me. &illic iter quo ostendam

illi salutare dei. In finem psalm

DAUID CU UENIT AD EUM NATHAN PRO

PHETA CU INTRAUIT AD BETSABEE

Miserere mei ds. secundu magna

misericordiam tuam

t: secundu multitudinem misera

tionu tuaru. dele iniquitate mea

mpliuf laua me ab iniquitate

FOUNDATIONAL LETTERFORMS (1)

Calligraphers today impose more of a sense of family likeness on the Foundational hand than did the scribe who wrote the original. This is largely because readers now have become accustomed to equal x-heights — a constraint that arose with the introduction of printing and did not affect scribes in the tenth century. Nevertheless, some variation, imposed by the human hand, is natural and acceptable. The Foundational hand is always written with a square-edged writing tool.

Five basic principles, based on the manuscript on the previous page, underly Foundational:
• The pen angle is 30 degrees.
• The o is a circle.
• The curves in letters echo the o.
• There are equal areas of white space within letters.
• The top third of the x-height is emphasized.

These guidelines enabled the writing of a thousand years ago to be updated to make a beautiful modern alphabet. The diagrams on the following pages show how they are used. The original Foundational did not use capitals in the way they are now used. Today we use Roman capitals at the start of all sentences and for names.

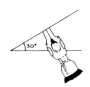

Pen angle
A 30 degree pen angle gives a good contrast between reasonably thin crossbars and thick uprights.

Family groups

Arched letters:
o, n, m, h, r, a, u, l
The top of m is flatter than the top of n so that the second arch also has a strong point of overlap to give strong junctions.
 Both h and m have the same inside shapes under the arches as inside o.
 The top of a is the second part of n so it is bigger than a hooked serif. The thin stroke of its bowl enters the letter halfway up the body height.

Round letters:
b, p, d, q, e, c
The first stroke of the b is like an l. The bottom curve of p and the top of d and q do not follow the circle.
 Because e and c do not have right-hand sides their curved backs are slightly straightened to prevent them seeming to fall over backwards.

Angled letterstrokes:
k, x, v, w, y, z
Although v, w and y are all slightly wider than the n only practice will ensure that the first stroke comes down at the correct angle to make the letter both wide enough and upright.
 Normally the uprights of a letter are about 7/8 of a nib width thick and the thin crossbars are a 1/2 nib width thick. The thicks in the v group are more nearly 1 nib width thick and the thins are thinner than a 1/2 nib width.
 At smaller sizes of writing this is not noticeable but for larger versions changing the pen angle for these diagonal strokes helps to retain the family likeness between them.

Ungrouped letters:
g, s; t, f; i, j
The round part of g is smaller than o so that there is enough room below it for the tail.
 This makes it a bit narrow at the top and since the tail is

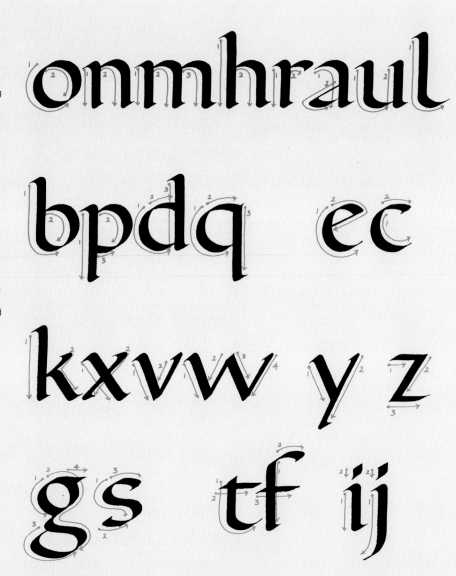

very 'busy' it requires a small 'ear' running along the reading line in order to anchor the eye along the top third of the letter.
 The bottom needs to enclose a lot of white space or it will look like a black blob and draw the eye downwards. The only way to do this without bumping into the line below

is to make the bottom bowl quite wide.
 All the strokes must be sufficiently apart to prevent tight white spaces developing within the letter.
 The crossbar of t sits immediately below, but touching, the top line.
 The crossbar of f can be slightly lower so that the enclosed area

of white space at the top of the letter balances with the open area of white space below the crossbar.
 Historically i and j are the same letter; the longer form (j) was used as the last digit in Roman numerals in order to prevent fraud — for example, vij is seven, viij is eight.

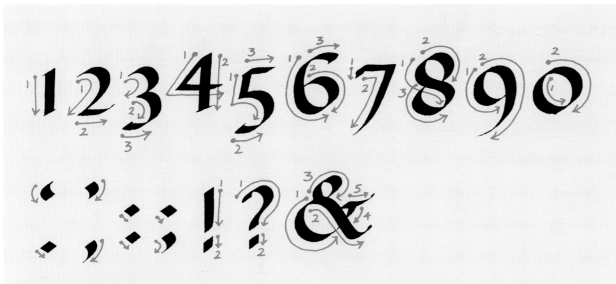

Numerals and punctuation

The 0 has to echo the letter o. The 1 has small serifs that are nothing more than tiny dashes. The 2 has a curve to echo the o and the 3 picks up this curve, its lower white space relating to the white space above. The 4 can be made with a slightly tight triangular bowl in small writing. This is because the thin diagonal tends to have only a small visual impact. For large writing or with Roman capitals the triangular bowl must be bigger. The white spaces in 5 are balanced, the lower curve echoing the 3. The 6 and 9 are mirror images of each other except that while the tail of 9 can be flicked round, the top of 6 cannot be made with such a quick pen movement. The small vertical serif at the top of 7 can be missed off. The centre thin strokes of 8 are offset, unlike the Roman capital numerals (see page 27), because the smaller bowls could become quite tight.

Full stops and commas are placed very close to words leaving very little extra space between them. Colons and semi-colons are the height of an x. The dot under question and exclamation marks echoes their movement and is not angled like a full stop. The ampersand (from the Roman et for 'and') comes straight out of Harley 2904.

Starting to write Foundational

The best way to prepare for writing Foundational is to analyse and look closely at Harley MS 2904 (see page 28) as well as the illustrations on these pages. Notice how the top serifs of letterstrokes are bigger than those at the bottom. This is partly due to the action of the pen as it begins the stroke because of the need to spread the ink from the slit to the whole writing edge. But these larger top serifs also help to hold the eye at the reading line — the top third of the x-height. Harley MS 2904 and the alphabet below also show how close together the letters within a word can be placed. The aim is to have regular, even spacing.

Write the letters at a height of 4 nib widths like the ones on this page.

abcdefghijklmn
opqrstuvwxyz

FOUNDATIONAL LETTERFORMS (2)

Look carefully at the skeleton minuscules on page 23. The whole character of Foundational depends on the points described on those two pages and in the first part of this section. Strong Foundational always shows a clear circular movement of the o and strong arches which start to thicken immediately they leave the left-hand vertical strokes. This is in direct contrast to Italic.

Foundational originated as a book hand and, since page after page had to be read, everthing was sacrificed in favour of legibility. It is slightly slower to write than Italic can be since in a typical letter like the n the pen has to be lifted off the page at the bottom of the letterstroke and put back on the page at the top of that stroke for the second part of the letter. This, however, lends the hand its great strength which lies in the steady rhythmic emphasis that can be put at the reading line, the top third of the x-height. But it is also important to give due emphasis to all the parts of the letter and not just the top third.

A thorough understanding of the letter shapes and their relationships, and of how the pen makes the forms, is necessary for writing Foundational successfully. Once

Skeleton forms

The relationship between Foundational letters and the skeletons on page 23 is similar to the relationship between written Roman capitals and their skeletons. Notice the similar proportions, especially the width of the n which has a skeleton 3/4 the width of the skeleton o.

you have done the practice on page 31 it is worthwhile going back to the Harley Ms 2904 on page 29. If you look at the word 'multitudinem' you will realize that it shows elements of the script that you should, by now, begin to see in your writing. The eye is carried along the tops of m, the two t's and d, the n and m; there is a strong rhythmic feel to the bottom of u, l, t, u, d and e. The white spaces inside the letters are evenly balanced. The final serif of one letter leads into the next letter. Letterstrokes overlap without hairlines.

Warning

Be very careful to keep the pen angle consistent. For example, a tendency to steepen the pen angle for the crossbars of t and f reduces the contrast of their thinness with the thickness of the verticals.

Pen angles

The o is a circle but there isn't a circle round the outside of the letter. Rather, the square-edged pen, held at angle of 30 degrees (2 o'clock), makes two circles which overlap each other.

The crossbars are a 1/2 nib width thick and the verticals are about a 7/8 nib width thick.
 This gives a good contrast between thick uprights and reasonably thin crossbars, but it is important not to let the pen angle creep any steeper.

A pen angle of 45 degrees (half-past one) would mean that the verticals would have the same thickness as the horizontals.

Serifs and arches

The ink arrives at the writing edge of a pen nib by flowing along the slit, so until the ink is rubbed all the way along the writing edge it lies only at the middle of the nib.

The first movement of the pen on the page is a quick up-and-down sliding movement along the 'skating' thin edge (1). This gives us the lead-in serif. The eye reads the top third of the x-height in a letter and the top serifs are therefore more emphasized than the bottom ones (2) which mostly serve only to terminate the letterstroke. If the bottom serif is too big it intrudes into the white space of the letter. The last serif is a bit bigger and points the eye up to the top third of the next letter (3).

The curve of the arch in n (4) gives a strong stroke at the top of the letter. If the pen makes a hairline the vital top third is weakened (5).

Related forms and areas

If a square is drawn around one of the double circles of o (below far left) it shows that the cross-over points of the two circles occur about 1/8 of the square in from the sides. This shows

where the legs of n go (below centre left).
 Both o and n contain equal areas of white space (below centre right) and the curved part of n echoes the curve of o (below right).

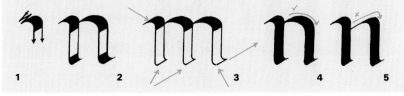

1 2 3 4 5

Avoiding common faults

• If the bottom of the bowl of p is too heavy, it draws the eye away from the reading line. After the first stroke the bowl can be made by two strokes, the lower curving out and up, or by making the whole curved stroke in one go.

• The tops of the bowls of d and q are flattened to keep the eye at the reading line. The right-hand point on the vertical of q is a focus for the eye.

• The t is made with only two strokes. The crossbar of t anchors the eye at the reading line so it is not a tall letter. The top of f curves out not down.

The crossbar of f may be slightly lower than that of t, to balance the white spaces above and below the crossbar. Take care not to steepen the pen angle for the crossbars or they will become too heavy. The crossbar (half a nib width thick) must contrast with the vertical (over 7/8 of a nib width thick).

• The dots on i and j should echo the vertical, not fight it. The large descender on j makes the letter bottom-heavy.

• The back of e is straighter than the circular o. The bowls of e and a are similar in space; an upside-down shows this clearly.

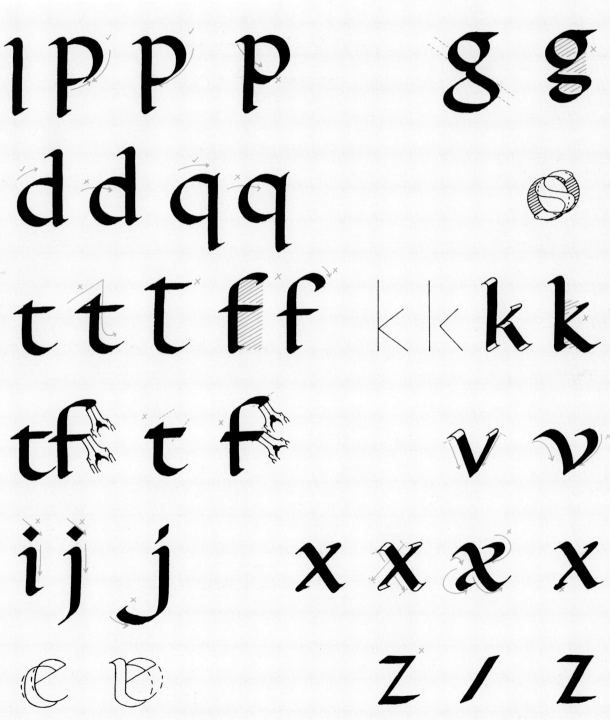

• If the connecting stroke between the top and bottom bowls of g is offset a long diagonal is avoided. A perfectly formed top of g can be ruined by making the bottom cramped. Too little white space can lead the eye down, away from the reading line.

• The s is notoriously difficult to define or analyse. Pay attention to making smooth inside curves and balance the white areas in the letter.

• Following the skeleton too closely gives a clumsy k with a thick junction and an ugly lower white space. The space can be balanced by slightly kicking out the lower stroke before becoming diagonal. The only curves are the serifs — the essential strokes are all straight.

• When the serifs on diagonal strokes are exaggerated the result is no distinction between the serif and the stroke it leads into and the writing becomes ill-defined. Here the k, v and x have been given white serifs to show how small and controlled they should be. Watch also the pen angle. To avoid the very thin stroke of the x on the right, steepen the pen angle for thick strokes and flatten it for thin strokes as on the left.

• The z needs a very flat pen angle for the middle stroke or the stroke will become insignificantly thin.

ITALIC

During the fifteenth and sixteenth centuries Renaissance scribes looked back to early manuscripts for patterns of writing on which to base their own scripts. Over the years this led to a new style of lettering that could be written more speedily to meet the demand for documents and books.

This Italic script was written by hand and was also reproduced by wood engraving.

The beautiful manuscript shown on the far right, Bembo's Sonnets in Italian, was written in Italy in the middle of the sixteenth century. The writing is well controlled and even, given that the actual size of the letters is very small. It is a formal Italic hand and unlike later cursive Italic ones which are much more like hand-writing. The letters are not joined but are evenly constructed and spaced and are made by the rhythmical movement of the pen on the page. The pen lifts off as little as possible, but even where it does lift off the end of a letter there is a fluent continuation of the eye on to the next letter as if the black stroke continued on.

Italic capitals are versatile and useful letters that can be adapted in many ways — the illustration on this page is just one example. The minuscules can be successfully combined with Roman capitals but when the Roman letters are used their forms are usually narrowed and slightly sloped to give capitals that link visually with the minuscules.

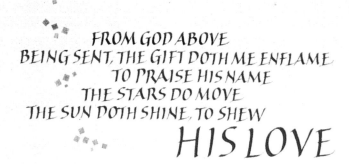

FROM GOD ABOVE
BEING SENT, THE GIFT DOTH ME ENFLAME
TO PRAISE HIS NAME
THE STARS DO MOVE
THE SUN DOTH SHINE, TO SHEW
HIS LOVE

Dies Natalis.
Thomas Traherne as set by Gerald Finzi in his cantata; written by Gillian Hazeldine. Steel nib, gouache, watercolor and sheet gold on hot-pressed paper.
 15 x 25 cm (5 7/8 x 9 7/8 inches).

A questa fredda tema, a questo ardente

Sperar, che da te nasce ; a questo gioco,

A questa pena Amor, perche dai loco

Nel mio cor ad un tempo, et si souente ?

Ond'e, ch'un'alma fai lieta et dolente

Inseme spesso, et tutta gelo et foco?

Stati contrari et tempre era a te poco

Se separatamente huom proua et sente?

Risponde, uoi non durareste in uita,

Tanto e il mio amaro e'l mio dolce mortale ;

Se n'haueste sol questa o quella parte .

Congiunti, mentre l'un ne l'altro male

S'auenta, et scemal di sua forza in parte ;

Quel, che u'ancideria per se, u'aita .

ITALIC MINUSCULES

Italic developed after printing had replaced the scribe as the maker of books and there are many variations of the hand. Because they were used for papal documents all the hands were written quickly which gives them certain characteristics in common.

It is easier to make rapid up-and-down movements than rapid wide-and-round ones so the letters are narrow. Because narrow letters contain less white space than wide ones, they are taller to compensate. Italic letters tend to have a forward slope.

The key concepts in Italic are:
• The letterstrokes appear to be parallel even when one is curved and another is straight.
• They appear to be evenly spaced, with the same distance — not area — between them.
• The eye still reads the top third of the x-height so this part of the letter is emphasized.

The key letter in Italic is a and not o as it is in Foundational. In informal Italic the a can be written without taking the pen off the page. But for formal writing several pen lifts may be necessary. The straight pen stroke that creates the left-hand stroke of the a (see below) should almost 'bounce' off the bottom line into a diagonal which takes it straight to the top right-hand corner of the letter. The pen is taken off the page and back to the top left-hand corner and replaced on the already black ink which gives a good, strong junction. The top stroke goes forward which holds the eye at the reading line and a quick pen lift results in a small 'point' at the top right-hand corner. This is a focus for the eye to be led on to the next letter. The right-hand stroke of a is made in a swift movement which again bounces off the bottom line. The bottom of o, c, e, t and l (below) is curved, not pointed, because there is no need for a diagonal connecting stroke. The curved backs of these letters are so close to straight that they seem parallel to straight strokes.

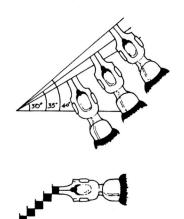

Pen angle and weight
An angle of between 30 and 40 degrees keeps the contrast between thick uprights and thin cross-strokes. The angle is often flatter at the letter's top. 5 nib widths set the weight.

Family groups

Pointed base:
a, d, g, q, u, y
Although it is difficult to push the pen, the writing should look as if it is done without lifting the pen off the page.
The curve at the bottom of the first upright of a, d, g and q is sharp so that most of this first upright looks straight enough to appear parallel to the second one. The sharp point at the bottom of u and y is retained to give a good family likeness. The serifs of descenders go forward and up to carry the eye back to the reading line.

Rounded base:
o, c, e, t, l, s, f
The bottom curve is rounded and the letters look like narrowed Foundational.

Crossbars:
t, f
f can stop at the line or extend below it. The crossbar is at the same level as t.

adgquy

os ocetl tf f

nmhk bpr

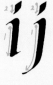
ij

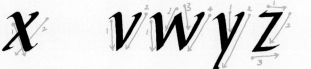
x vwyz v

Arched letters:
n, m, h, k, b, p, r
In concept the n is an upside-down u but as the eye reads the top third of the x-height the arch is curved, not pointed, to increase the weight at the top. The b and p must be the same width as n. The k looks like an h with a karate-chop in the belly and is a tiny bit wider than the h to keep the same white space.

Diagonal strokes:
i, j, x, v, w, y, z
All these letters as well as s in the rounded letters are the same as sloped, narrowed Foundational. The slope of awkward letters like v is given by an imaginary line which runs from the point at the bottom of the white space and bisects the width of the white space at the top of the letter. Narrow angled pen strokes need a flatter pen angle. Wide angled pen strokes are not noticeably different from other uprights.

SPACING

If the lines of writing are only a few words long they can be placed together and short ascenders and descenders will avoid clashes.

Spaces between letters depend on the size of the writing. Small letters like those shown in the illustration on page 35 need to have lots of space between them so that the eye is able to distinguish the tiny shapes.

Heavier, larger writing has less space inside the letters so the letters and words can lie closer together in order to make even black-and-white shapes.

Learning to write Italic minuscules

A good starting-point for writing Italic minuscules is to make the letters 5 nib widths high: use a large nib and black non-waterproof Indian ink to measure 5 nib widths and then rule pairs of lines that height apart with a sharp pencil.
• Study the points highlighted in 'Writing Italic letters' (below) then look at the family groups in the exemplar on the opposite page and Bembo's Sonnets in Italian on page 35 and use these as a guide for writing the letters of the alphabet between the lines you have ruled.
• Check that your letterstrokes look parallel and evenly spaced.

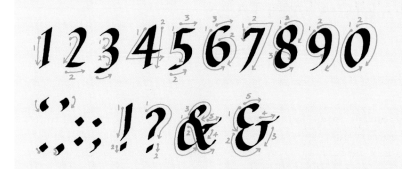

Numerals and punctuation
Italic is a tall letterform so it is less necessary to vary the height of numerals to ensure they contain enough white space. There is more variation than with capitals but less than with Foundational. Keep the curves in long curving verticals to the minimum so that the stress is in the uprights. The overall width of each number (except 1) is the same.
Punctuation marks carry the same forward slope as the letters, and the question mark is narrowed; otherwise they are the same as Foundational.

Writing Italic letters
The first (left-hand) stroke of a must be parallel to the second (1). The curve should be barely perceptible (2). Make sure there is a focus point at the top right-hand corner and that the bottom serif is sharp and not curvy (3).

Since the a is the key letter, the n has the same skating thin diagonal going into the arch (4). If the alphabet was based on an oval o the arch of n would be a narrowed Foundational without a thin diagonal (5).

The inside white shapes should be similar in a and u and very slightly rounder in n and b (6). The inside of the arch of n differs from the inside of the o; it is not as in the shaded diagrams (7). The curves of o only happen at the top and bottom of the letter so the uprights appear parallel to the uprights of the n (8).

The tail of y must go

forwards and up (9) rather than casting the eye downwards. Each part of m is the same width as n (10) to give a regular distance between upright letterstrokes. More control may be possible by lifting the pen off the page at the end of each stroke and replacing it at exactly the same place before the next stroke (11).

The bowl of p may be made in one movement (12) even though this involves a push stroke, as a broken line at the bottom is better than a black triangle.

abcdefghijklmnopqrstuvwxyz

ITALIC CAPITALS

Italic capitals are made in a similar way to Roman capitals except that the forms are based upon an O narrower than a circle. When the O is narrowed so is the H and the other letters correspondingly. The capitals in the family groups are based upon an O narrowed to two-thirds of its height. The same points about the making of Roman capitals (see page 26) apply to these letters. Care must be taken to think about the width of the letters in relation to each other so it is important to look at the internal shapes of the letters as well as the overall width of the finished letters. The diagrams on these two pages show how letters, numerals and punctuation are formed and how their weight can be varied. Spacing Italic capitals is similar to spacing Roman ones. But as the space inside the Italic O is narrower than that inside the Roman O the space between Italic capitals is narrower than between Roman capitals.

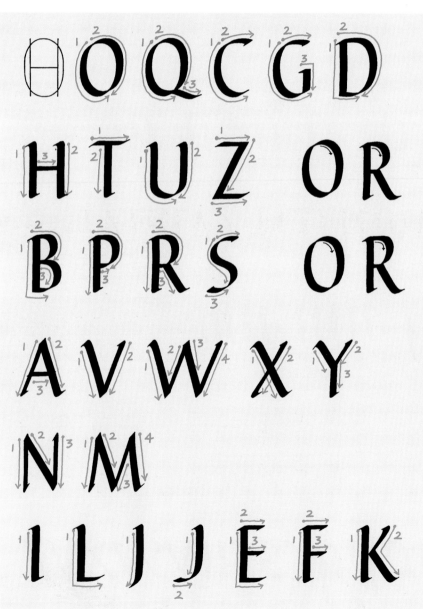

Family groups

Oval letters:
O, Q, C, G, D
The bowl of D echoes the right-hand curves of O and Q. The tops of C and G are flattened.

Rectangular letters:
H, T, U, Z
The crossbar of T is exactly the same width as the rectangle. Completely flatten the pen angle to make the centre stroke of Z. H and U should be 3/4 the width of O but as this can make them look too narrow, they may be made a fraction wider.

Small bowl letters:
B, P, R, S
The bowls of B, P and R must relate to the oval O but unlike the Roman letters need not be as narrow as half the O shape.
The bowls must relate to the O (top OR) not pull out (OR below).

Diagonal letters:
A, V, W, X, Y, N, M
These are narrowed Roman letters. Their widths relate to that of the Italic capital H.

Straight letters:
I, L, J, E, F, K
These are also narrowed Roman forms. The second stroke of K only just touches the first stroke of the letter.

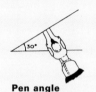

Pen angle
Use a 30 degree pen angle rising to 40-45 degrees for diagonal strokes.

Weight
Write capitals at 7 nib widths for minuscules written at 5 nib widths.

Slope of letters
Letters can sit upright or lean forwards from the vertical by approximately 5 degrees. If much more than a 5 degree slope is used the letters can appear to be falling over.

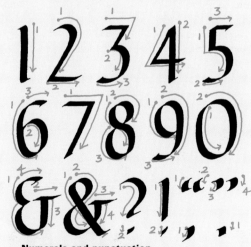

Numerals and punctuation
Italic numerals and punctuation are written at the same height as the capitals and are a narrowed version of those that go with Roman capitals. The inside shapes of bowls and of O are oval.

Weight and form

Choice of weight and form depends largely upon the content and size of a piece of work. The examples on the right show how varying weight and form creates differing impressions. A quotation in lightweight letters conveys a very different impression to the same quotation written in heavyweight letters. Always give careful thought to the meaning and mood of a quotation before choosing appropriate letters that best convey the message.

Learning to write Italic capitals

Use a wide nib for this exercise so that you can clearly see the shapes you are making.
• Start by copying the letters in their family groups to feel how their shapes relate to each other. Notice and correct any bad forms by looking again at the bad forms of Roman capitals (see page 59).
• Use the capitals to write single words or a quotation — this will help you to practise letter shapes and spacing at the same time.
• When you have gained confidence, write letters at different weights and sizes, as in the examples on the right, by altering the number of nib widths in the height of the letters or by changing the size of your nib.

DENSER, DARKER

TALL, NARROW

LIGHTWEIGHT LETTERS

NARROWED AND CLOSELY PACKED

HEAVYWEIGHT

FREELY WRITTEN CAPITALS

1 The letters are written at 7 nib widths, as in the family groups, but have been narrowed and therefore placed closer together.
2 The letters are written with the same nib but at 10 nib widths. More space has been let into them so that they appear lighter in weight than the letters above. Their serifs have been varied to give them a different appearance.
3 The letters are written with a narrow nib using the same proportions as in the family groups but at a very light weight.
4 The same narrow nib is used here but the O shape has been narrowed and the letters are therefore placed closer together to give a denser feel.
5 These heavyweight letters have been written at 5 nib widths.
6 These letters were written with a centre guideline and have been allowed to move up and down to create movement.
 Any of the other examples shown above could also be written on a centre guideline.

ABCDEFGHIJKLMN
OPQRSTUVWXYZ

FLOURISHED ITALIC

During thè Renaissance in Italy there was a growing interest in the written word. Classical Roman capitals and Carolingian minuscules formed a disciplined base from which new varieties of script grew naturally. Carolingian script is a minuscule script distinguished by its small rounded bodies. Ascenders are long in proportion to the bodies of the letters.

Some of the new scripts that grew from the Roman and Carolingian hands were flourished letters and by studying the masters of the period it is possible to see how ornamental and decorative effects can be achieved.

Ludovico degli Arrighi (Vicentino), Juan de Yciar, Giovanantonio Tagliente, Giovanbattista Palatino, Francisco Lucas and Vespasiano Amphiareo are master penmen whose work is well worth studying.

The diagrams on these two pages show, first, how to write simplified flourished Italic capitals and minuscules. The flourishes on these letters are basically simple extensions to their beginnings or endings. Then the advanced letterforms show more complex flourished strokes using twists and turns of the pen. It is important to start with the basic strokes of the simplified capitals and then move on to the minuscules. Do the advanced letters when you are confident of your ability to do the simplified ones.

There are no real rules for writing flourished Italic — you will have to rely on movement, rhythm and your eye. Shapes and spaces are equally important and learning to make flourishes is about learning to adjust these two elements.

Simplified flourished Italic capitals
These letters are written with the minimum of pen rotation and retouching, but with some variation of pressure within the strokes. The pen angle is 30 degrees, steepening to 40-45 degrees for the first stroke of N and diagonal strokes.

Simplified flourished Italic minuscules (left)
The stem of d is written in two strokes. When writing the tail of g you will have to choose whether to pull or push the pen.

The pen is pushed upwards on the crossbar of f. Flatten the pen angle slightly for the diagonals of x and z. See the illustration on the bottom right for alternative shapes for d and q.

Learning to write flourished Italic

Trial and error is the best way to learn to write flourished Italic.
• Extend parts of letters where extensions seem natural. When doing this, do not feel that you must make a flourish with a single stroke.
• Let your pen flow comfortably into and out of the flourish both as you hold it in the air before writing and as you write.

a a de e e

g g h r s v

x y z

Advanced flourished Italic minuscules
Complicated techniques of twisting and turning
the pen and retouching with it have been used
in the execution of these letters. This can be
clearly seen on rounded terminals of the letters.

'Pot-Pourri'; Lindsay Castell.
Quills, gouache and watercolor paint on Indian
handmade paper.
29 x 22 cm (11 3/8 x 8 6/8 inches).
Flourishes with large loops and long, flowing tails
give an airy, floating feel to the work. They were
executed with as much freedom as possible, helped
by the freely flowing paint and the quill pen.

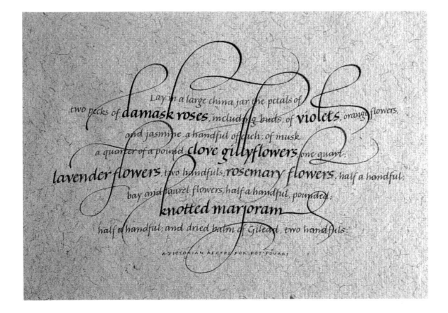

A A A A B B B C C C D D D E E E
E E F F F G G G H H H I I I J K K
K L L L M M M M N N N N O O O
P P P P Q Q Q Q R R R R S T T T U U
V V V W W W W X X Y Y Z Z Z Æ Œ & Å

Advanced flourished Italic capitals Some rounded terminals have been made by twisting the nib up on its corner then retouching with a pen, as in the second stroke of the first A.

UNCIALS

Uncial letters were developed in late antiquity as formal book scripts and were widely used from the fifth to the eighth centuries. Early examples from Greece and Rome are made simply with direct pen strokes. Later Uncials used a great deal of pen manipulation — twisting and turning the nib as it makes the stroke — and were much more complex in their structure and therefore much more difficult to write.

The Uncial alphabet is neither a minuscule nor capital script and has one letter height with few ascenders and descenders. Its rounded letter forms derive from Roman cursive hands and formal scripts in use in North Africa in the third century AD.

A true distinction between minuscule and capital letters developed after the eighth century and Uncials continued to be used well into the twelfth century as display letters, for headings and for important parts of the text.

The manuscript shown here is the Stonyhurst Gospel of St John. It was written in the late seventh century, probably at the twin monasteries of Wearmouth and Jarrow in the north-east of England. A papal emissary, John the Archcantor, came from Rome to teach the monks the Roman liturgy and brought with him books as well as knowledge and skills. The monks developed Uncial scripts for their own use from the Italian manuscripts and some of them may even have visited Rome themselves.

The Stonyhurst Gospel was written with a quill on vellum, probably for inclusion in St Cuthbert's coffin in AD 698. In the manuscript small, rhythmically written letters produce a clear script. It makes a good basis for a modern Uncial hand because of its clarity and fairly consistent pen angle with very little pen manipulation.

The Stonyhurst Gospel of St John. Folio 47R. On loan to the British Museum by the British Province of the Society of Jesus. Actual page size: 13.5 x 9 cm (5 1/4 x 3 1/2 inches). The illustration above is a detail taken from the sixth to twelfth lines of the page shown opposite.

ET NON PERTINET AD EUM DEOUIB;
EGO SUM PASTOR BONUS
ET COGNOSCO MEAS
ET COGNOSCUNT ME MEAE
Sicut nouit me pater
et ego agnosco patrem
Et animam meam pono
pro ouibus meis
Et alias oues habeo
quae non sunt ex hoc ouili
et illas oportet me adducere
et uocem meam audient
et fiet unum ouile
et unus pastor
PRopter ea me pater diligit
quia ego pono animam meam
et iterum sumam eam
nemo tollit eam ame
sed ego pono eam ame ipso
potestatem habeo ponendi eam

UNCIAL LETTERFORMS

A book hand needs to be clearly and formally written and as a result Uncials developed as letters that are rounded in character and rhythmical in movement — a rhythm that is also strongly emphasized along the line, helped by the concise nature of the letters in that there are few ascenders or descenders. They therefore produce strong bands of writing which help to make the book easy to read.

Uncials are best used for long lines of text; short lines do not read so well unless they are a quotation that consists of only a few lines.

Uncials must be well spaced along the line — not pushed together — with the spaces between the letters balancing the space inside them. In the original Stonyhurst Gospel of St John the space between the lines is 1 1/2 times the x-height of the letters which helps clarity of reading and give the lines strength. The strong forward movement of the letters along the line enables the eye to move quickly and smoothly over the text.

Family groups

Round letters:
o, c, g, e, q, p, d
An o is wider than a circle. This shape emphasizes the movement of the letters along the line. c and g relate to o. Their top strokes are slightly flattened to move the eye along the line. The tail of g has a kick-back movement. The second stroke of q and the lower part of the bowl of p are flattened to reduce weight at the top of q and bottom of p. Keep the hook of the ascender of d small; it must not hang over the left side of the bowl.

Straight letters:
I, J, L, T, k, F
The letters I and J are not dotted because they are not minuscule letters. The serifs are kept small. The letter L extends above the line. Keep a 15 degree pen angle for the crossbar of T so that it is not too heavy. Do not shorten or curve the crossbar. The second stroke of k just touches the upright stroke. The top of F relates to the curve of the arched letters where the stroke springs from the vertical stroke. The third stroke of F sits above the baseline and does not extend beyond the top.

Arched letters:
h, m, u
Arches spring from inside the upright strokes and relate to the shape of o. The internal spaces in the arches of the letter m

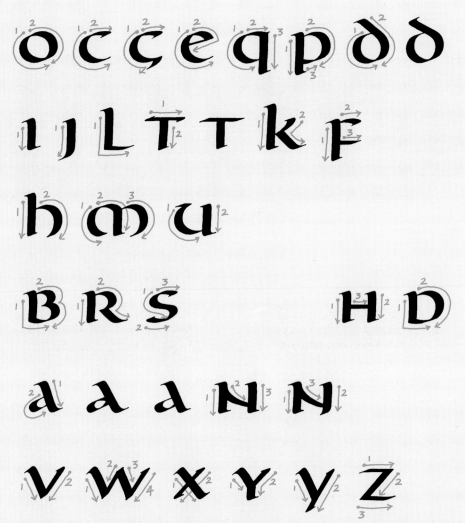

should balance in size and shape. The central upright stroke is straight and the third stroke springs back from it. The arches of h and m should cut just below the line to appear to sit on it. The emphasis of weight in the first stroke of the letter u should be towards the top of the letter, not sagging towards the bottom.

Small bowl letters:
B, R, s
The lower bowl of B is larger than the upper bowl. The second stroke can be taken across to touch the upright stroke or left open. The bowl of R relates to the oval shape of o. The tail pulls down diagonally. Flatten the pen angle to make the bottom and top strokes of s, to reduce weight and to keep the bowls open.

Diagonal letters:
a, N, v, w, x, y, z
Take care to keep the triangular feeling of a and do not pull the first stroke down too steeply. With N, keep a small serif on the bottom of the first stroke; the third must not be wavy or drop down to diminish the space below it. Steepen the pen angle to make v, w, x and y and keep the strokes straight. Make the horizontal strokes of z with a 15 degree pen angle. Flatten the angle as much as possible for the second stroke to add weight and balance the letter.

Alternative letterforms:
D, H
These Roman forms without ascenders can be used to help give solid bands of writing.

Weight and angle
The letters are written at a height of 3 1/2 nib widths. They can also be comfortably written at 3 nib widths.

The pen angle is approximately 15 degrees for all letters except diagonal letters where the pen angle is steepened or flattened as necessary.

Numerals and punctuation

1 2 3 4 5 6 7 8 9 0 ?!,'''

The numbers are all contained within the x-height of the letters. The bowls are oval in emphasis to relate to the o. The pen angle is kept to approximately 15 degrees.

çð h u m
n h k

Bad letter forms to avoid
- The tail of g kicks back too soon and too sharply.
- The ascender of d is not far enough to the left.
- The bowl of h stops short of the line.
- The bottom of u sags.
- The front arch of m drops so the second arch has to spring from a curve not a straight, giving awkward internal shapes.
- The crossbar of the first N is too low, the second too high.
- The second stroke of k cuts into the first stroke.

CENTURY
CENTURY
CENTURY

Spacing
Top: Spaces inside and between letters must balance visually.
Centre: Letters that are too widely spaced break down the rhythm of the letters within a word.
Above: Letters that are too closely spaced make the words look cramped which counteracts the pull along the line that is characteristic of Uncials.

Learning to write Uncial letters

• Begin by writing the Uncials in the family groups in the exemplar on the opposite page at a height of 3 1/2 nib widths of a large nib.

The wide nib will enable you to see the letter shapes you are making more clearly.

• Practise until you are satisfied with the shapes of the letters you are writing and then change to a medium-sized nib and reduce the height to 3 nib widths.

• Remember to keep your pen angle at approximately 15 degrees — considerably flatter·than the angles you have used previously — for all strokes except diagonals.

I saw, and behold
a tree in the midst
of the earth,
and the height
thereof was great

Using Uncials for quotations
Uncials have wide oval shapes so a quotation that consists of lots of short lines will have only a few words on each line. The sense of movement along the line breaks down and legibility is impaired.

I saw, and behold
a tree in the midst
of the earth,
and the height
thereof was great

Short lines of text need more space between them than longer ones to help separate the text into bands of writing which can be clearly read.

I saw, and behold a tree
in the midst of the earth,
& the height thereof was great...

Longer lines of text make the quotation more legible.

abcdefghijklmn
opqrstuvwxyz

VERSALS

As the use of minuscule letters for writing texts developed, capitals were used for headings and initials at beginnings of paragraphs. These letters were built up of several pen strokes, and were described as Versals by Edward Johnston, although he was not the first to call them this. He also referred to them as compound or built-up capitals, which describes the way they are made. Johnston considered Versals to be one of the roots of illumination, as they were later written in color and flourished and decorated.

The underlying form of early Versals is only loosely similar to Roman capitals, but, like them, the letters are greatly influenced by the movement of the pen. Later forms became exaggerated and less predictable and the best examples to study are therefore earlier Versals written at about the same time as the example shown here: the Benedictional of St Aethelwold, written in the late tenth century in Winchester, in southern England. The illustration shows a title page, but throughout the manuscript beautiful, large, single Versals are used as initial letters, and smaller built-up Uncial-shaped Versals are used as paragraph beginnings.

The thick strokes of the letters are gently 'waisted' or narrowed in the middle which gives a more graceful line than if they were made a constant width. The letters relate to each other in form, with a consistent roundness to O, C, D and G and the bowls of R, P and S.

The letters are packed together more tightly in some places than would be recommended today but even so they are fairly evenly spaced, the thin strokes help to lighten the line and the interlinear space helps to balance the lines as a whole. The S inside the D is a lovely use of space. The decorated arch is painted and the capitals are outlined and then gilded.

The Benedictional of St Aethelwold. Add. Ms 49598, folio 68R. British Library, London.
 Actual size: 30 x 21.7 cm (11 3/4 x 8 1/2 inches).
The illustration above is a detail from the page shown opposite.

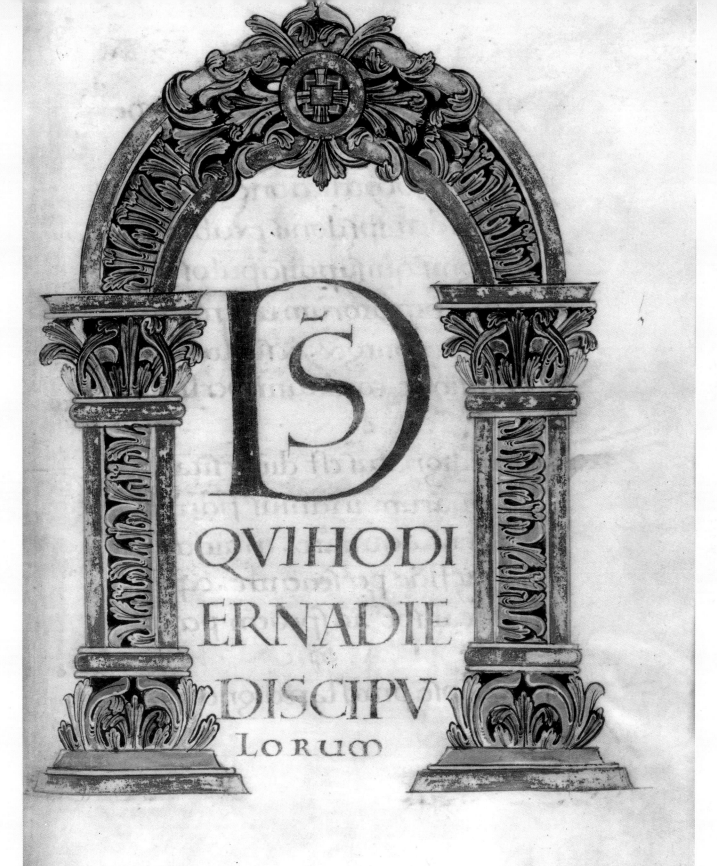

PS
QVIHODI
ERNADIE
DISCIPV
LORUM

VERSAL LETTERS

In both early and modern Versals the thick strokes of the letters are usually made up of three strokes of the pen and thin strokes are made with one full-width stroke.

The underlying form of the contemporary Versals written here closely follows Roman classical forms, so it is advisable to look again at skeleton capitals (page 20) before starting to write. It is essential to have a clear mental image of the skeleton forms as Versals must be made with an immediate, decisive line.

As with other capitals, Versals are placed so that the amount of space inside and between the letters balances to give an even pattern of stroke and space along the line. They are beautiful letters in themselves but are perhaps particularly useful for headings or prominent lines of text, and for initial letters in a manuscript book or panel.

Writing Versals can be a frustrating experience — their construction is complex and quite unlike other letterforms and the end result can be disappointing. One solution, once you have learnt what pen-made Versals should look like, is to draw the letters in pencil and then paint them with a fine brush.

Although the end result will look different from pen-made letters

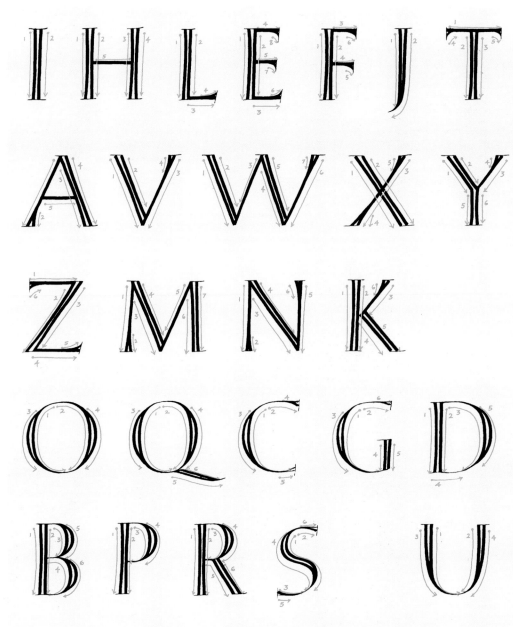

Family groups

The letters have no centre strokes so that their forms can be clearly seen. And there is no stroke number for thin serifs which are added to each completed letter.

Straight letters:
I, H, L, E, F, J, T
The built-up ends of the E, F, T and L crossbars are made by beginning the second stroke inside the first and curving gently out to thicken its end. This should be a continuous curve.

Diagonal letters:
A, V, W, X, Y, Z, M, N, K
The thickening of the ends of the thin strokes is usually on the inside.

Round letters:
O, Q, C, G, D
The pen angle can be slightly altered to build up the curved ends on the arms of C and G.

Small bowl letters:
B, P, R, S
The bowls of B, P and R relate to O. The inside shapes of S are rounded.

U is straight-sided.

Angle
Hold the pen so that it makes the widest possible line for all letterstrokes — vertical, horizontal and diagonal. Hold it to make the thinnest possible line for the fine serifs that finish the letterstrokes.
Hold the pen at a slight angle to make curves; this will avoid very thin strokes at the top and bottom of the bowls.

Basic form
O is circular with an inside oval shape. Make the oval first and add the weight on the outside to build the circular shape.

Weight
Each stem is made of three pen strokes and a stem width is therefore three times the nib width. The height of the letter is eight times the stem width (24 nib widths). Because it is difficult to measure 24 nib widths accurately in step form it is best to measure three nib widths and multiply the measurement by eight.

II EE NN CC

Constructing Versals

Straights, diagonals and curves are all made up of three strokes: two outer ones and a third stroke to fill in the centre.

The outer strokes of stems and diagonal strokes should be curved slightly inwards towards the centre so that the centre point of the stem is a little less than 3 nib widths wide.

This is known as 'waisting' and, although barely perceptible, gives a graceful line to the stems and horizontals of the letters.

The outer strokes of wide letters are made first and the insides of the letters are then flooded in: move the nib from top to bottom of the stroke.

The nib must be well loaded with ink, but keep the pressure light so that strokes are sharp and serifs fine. Try to make the letters with sure, direct strokes. They can, if necessary, be slightly retouched with the nib.

this method can be useful in a piece of work where the control and spacing of the letters in the heading are crucial to the overall design and space.

In addition, the action of painting Versals can bring a control and understanding that will actually improve your pen-made letters.

The diagrams on these two pages show how Versals are constructed, their related forms and how to write them. Bad forms are high-lighted to help you to avoid them and drawn and painted Versals are shown.

When you start Until you become more familiar with Versal letterforms you may find it helpful to start by drawing skeleton shapes in pencil. This will provide a rough guide on your paper to the basic shapes of the letters and will help you to visualize the Versals as you write. Use these skeletons as a guide only — it is easy to become so bound to them that you lose the flow of writing and the rhythm of evenly spaced letters.

OO DD EE AA MM

Bad letter forms to avoid

• A pointed O (left) is pear-shaped instead of an oval inside the letter.
• Straight and curved strokes must be of equal optical weight (right).
• Avoid triangular flags (left) on the ends of thin strokes.
• The thin and thick diagonals should overlap at the top of A (right).
• The legs of M must not be too splayed and the top inside joins must be at the same level (right).

DRAWN PAINTED

Learning to paint Versals

First draw the outlines of the Versals using a very sharp pencil. Trace and retrace over them to ensure the forms are as good as possible.

Mark the correct width of the thick strokes on a small piece of paper and use this to check that the stem widths of all the letters are the same.

This also provides a useful check for pen-made Versals.

Now trace the drawn letters accurately on to a sheet of paper.

Paint over the letters using ink or gouache and a fine-pointed 0 or 00 sable brush (or its synthetic equivalent). Hold the brush firmly but lightly and keep the brush strokes small and fine as you grow accustomed to the feel of the brush. Do not overload it or you will lose fine, detailed serifs.

ABCDE
FGHIJ
KLMNO
PQRS
TUVW
XYZ

BUILT-UP LETTERS

Although Versals are formal letters originally designed for use with formal scripts they can be developed to make letters of great variety — built-up letters — that can be adapted for many uses: to give a contemporary feel to a quotation, for example, or to accompany less formal variations on a script like Italic. They can also be used by themselves in a piece of work.

There are a number of ways in which they can be adapted to design built-up letters. They may be written so that they slope forwards; the serifs can be omitted; and the letters can be positioned on a centre guideline rather than being written between two lines.

Simply changing the weight, either of entire letters or within the strokes that make up a letter, will change their appearance.

The diagrams on these two pages show how these adaptations of Versal letters can be made and combined.

A thorough knowledge of making built-up letters is essential for painting letters with a pointed brush. These painted letters can be applied to fine cloths like silk or to papers that are too delicate to be written on with a pen. They can be drawn first and then filled in with a brush (see *A Painted Banner*, page 120) or they can be painted directly on to the cloth or paper with no pre-drawing — a technique that takes a certain amount of courage and a very clear image of the letters you wish to paint.

HEAVY

Heavier weight Versals
These have impact in headings to text written in hands like Uncial, Foundational or formal Italic. They are made by reducing the number of stem widths in relation to the height of the letters so that the inside spaces are also reduced.

LIGHT

Lighter weight Versals
These elegant letters create their own impact, especially when they are used in several lines of writing. They are made by increasing the number of stem widths in the height of the letter, which gives more white space inside the letters.

DIRECT PAINTING
To paint letters with no pre-drawing use a fine 0 or 00 sable brush or its synthetic equivalent and build them up slowly and carefully with small brush strokes. You may use ink, gouache or watercolor depending on which writing fluid best suits the fabric or paper.

FORWARD SLOPE

Adapting the letters

Forward sloping letters
Letters may slope foward naturally as the speed of your writing increases and you become more confident. Slope the vertical stems and strokes about 5 degrees forward. At first horizontal strokes should remain horizontal but you will see that they no longer meet the upright strokes at 90 degrees. As you gain in confidence and the speed of your writing increases the cross-strokes may slope slightly above horizontal so that the angle between the uprights and the cross-strokes changes even more. This adds vitality to the lettering but always be careful that you do not over-emphasize this effect. If you do the letters will look uncontrolled and exaggerated; it is better just to let it happen naturally.

SERIFS OMITTED

Omitting serifs
Finish the strokes and stems with a line that does not extend beyond their width.

LIFE AND GROWTH

Varying weights
Slightly decreasing the weight at the bottom of built-up strokes emphasizes the weight at the top of the letters adding a feeling of life and movement. The variation in weight should be very slight with the two outer strokes of a built-up stem only just moving towards each other as they reach the base — which should remain marginally wider than the centre waist of the stem. Alternatively, the tops of built-up strokes can be widened, but in this case more than one stroke of the pen may be necessary in order to fill in the centre of the stroke.

INFORMALITY

Centring
The letters can be written with a centre guideline instead of between two horizontal lines. The height of the letters will vary slightly but this is natural and adds to the informality of letters written freely. Do not consciously make them jump up and down; this will make them look contrived and there will be a sense of disturbance in the work rather than a feeling of vitality.

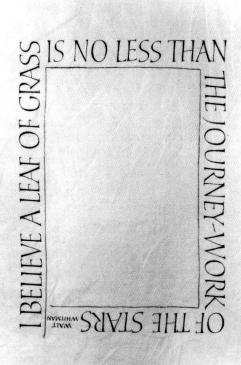

IS NO LESS THAN
I BELIEVE A LEAF OF GRASS
THE JOURNEY-WORK
OF THE STARS
WALT WHITMAN

Narrowed capital letters painted on silk with a 00 sable brush and liquid acrylic; Susan Hufton.

Numerals and punctuation
The forms of punctuation marks and numerals are similar to those that go with Roman capitals (see page 27). The thick parts are made up of three strokes of the pen. They can slope forward and be made with or without serifs.

Learning to write built-up letters

Rule lines 8 or 10 stem widths apart (see page 48 and page 27). Start by adapting your Versal letters in one way then work two adaptations together as in the first two examples below. Next combine three adaptations, then four as in the third example. This will prepare your hand and eye for painting letters with a pointed brush.

Letters are forward sloping and the fine line serifs have been omitted.

KNOWLEDGE

The weight at the bottom of the built-up strokes has been decreased and the letters have been written with a centre guideline.

WISDOM

UNDERSTANDING

This combines all four adaptations: the letters are forward sloping, serifs have been omitted, the weight at the bottom of the built-up strokes has been decreased and the letters have been written with a centre guideline.

PAINTED LETTERS

The various ways of adapting pen-made built-up letters can be applied to letters painted with a fine pointed brush. In this example forward sloping letters have been painted without serifs.

1 2 3 4 5 6 7 8 9 0 ;!? ""

MAKING A LAYOUT

Although it is essential to practise writing letters, the best way to make progress in calligraphic skills is to use them in the writing of finished pieces of work. This will give a purpose to your practice and encourage you to push your calligraphic skills to their furthest point.

The simplest way to start is to choose a poem or quotation and write it out on lines two x-heights apart so that there is plenty of interlinear space. The choice of writing style, letter size and weight will depend on the text. For example, if you select a poem about tall grasses it may be more suitable to write it in large, lightweight Italic than in small, heavyweight Uncials.

The next step is to decide on the layout. The positioning of words and lines on paper is all-important in calligraphic work and the diagrams on these two pages illustrate the standard layouts as well as some more unusual ones — and several that are best avoided unless they are intentionally required, when they must only be used with the greatest of care. They also show how margins help to frame the words and how the space they create around the text influences the feel of a piece and how readers respond to it. Margins can be as close or far away from the writing as the size, scale and content of the piece requires.

Before deciding on a layout it is useful to do a paste-up and begin to decide on the margins for the piece.

Standard layouts

Aligned left (above)
The beginning of each line starts on a vertical line drawn on the left of the paper. This is a standard layout but the very definite hard edge the alignment creates can be severe and static, especially if the line lengths vary a great deal giving a very broken right-hand edge with space from the margin entering the text block.

Aligned left (above centre)
Two vertical lines for alternate lines of text give an even but less hard left-hand edge and allow white space from the margin to break into the text.

Initial emphasis (above right)
An initial in the left margin achieves the same purpose as aligning text as above.

Aligned right (far left)
Each line must be carefully measured and then written to exactly the same length as the layout. This is difficult to do but can be necessary if a specific effect is required.

Centre space (left)
A layout can consist of two sections, one aligned right and one aligned left, with a central column of space.

Aligned centrally (far left)
Each line of a layout is measured, their central points are marked and the lines are placed equally on either side of a centre line. This gives a formal balanced layout.

Visually centred (left)
The lines are visually balanced around a centre line but placed asymmetrically. The overall appearance is balanced yet informal.

1. Write the text out on layout paper. The lettering must be as good as you can make it so that you have an accurate guide from which to take measurements for the final piece.
2. Separate the text into strips by cutting between the writing lines with scissors or a knife.
3. Lay the strips on another sheet of layout paper and move them around to get an idea of the various design possibilities. Cut between the words if necessary to experiment with different shaped layouts, but always remember that the text must make sense to the reader. Try not to split a line in the middle of a word.
4. When you have selected a layout, paste the strips down using a repositionable glue or a glue stick.
5. Take careful measurements from the pasted down strips with a ruler. Alternatively, make marks on a strip of paper and mark them on the paper you will be using for your finished piece.

For greater accuracy you may want to make a final rough: rule up (see page 60) from the paste-up and write out the whole piece.

It is a good idea to make several photocopies of your written text as this will enable you to make a number of paste-ups from which you can select the one that is most suitable. However, it is important to paste the photocopied strips down on paper of the same whiteness as the photocopy paper or the image of the design will be disturbed.

Aligned vertically

The straight letters are placed against the vertical line or centred about the line. Letters are then placed visually below each other.

Considering margins

Standard spacing

As a general rule allowing the same amount of space at the sides and top of the text, with more space at the bottom, sets the work in a good position.

Equal spacing

If the amount of space at the bottom of the text is the same as at the top and sides the work will appear to drop downwards.

Long vertical layout

The margins at the side can be narrower than those at the top and bottom (above left).

Long horizontal layout

More margin can be left at the sides than at the top and bottom.

Asymmetric spacing

Text may be placed asymmetrically (left) or towards the bottom (above) or top of the page. The overall shape of the finished piece should reflect the shape of the text area.

Creating a whole

Margins may need to be bigger than other spaces — for example, those between title and text, verses in a poem or text and credit — so that the different elements rest together.

Spacing to avoid

If the top and bottom margins are smaller than the other spaces the text will pull outwards. If the space between text and title or text and credit is bigger than that between the verses of a poem the verses will seem to pull apart..

DECIDING ON THE MARGINS

1. Cut four strips of colored paper or use four long strips of colored card to make two right-angled corners.

2. Move the colored strips or corners in and out around the text until the space that surrounds it looks comfortable with the words. If you pin the piece on the wall and look at it from a distance you will be able to have an accurate overall view of the work.

3. Mark the insides of the corners or strips and, using these marks as a guide, draw pencil lines that meet at right angles in the corners. Use a long ruler and the 90 degree corner of a set square to make sure that the angles are accurate.

4. Trim these lines with a knife and straight-edged ruler. If the work is to be framed allow an extra 6 mm (1/4 inch) around the marked margin line for the rebate of the frame.

Margin size

Narrow margins

When you are working on an all-over textured piece of writing margins can be kept narrow to emphasize the pattern of the writing (left). Beware though: they can make spaces within a piece of work more noticeable (right).

Wide margins

Wide margins emphasize the shape of a block of text (left). When wide instead of narrow margins are used for the piece illustrated above right, space within the text flows into and becomes one with the margins (right).

Layouts to treat with caution

Bottom heavy text

This gives a feeling of heaviness and solidity. Heavier text at the top suggests light and growth.

Diagonals

Strong diagonals where lines align diagonally underneath each other pull the eye uncomfortably.

Weak centre

The space cuts in from the sides to narrow lines in the centre creating a weakness in this part of the text.

Lack of centre core

Text wanders from side to side which creates weakness and a lack of direction.

The starting-points

There are two main ways to set about making a finished piece of calligraphy.

Some calligraphers start with the words they wish to use and develop their ideas from there. The words suggest the script and the size of the letters, the color they should be written in and their shape and position on paper.

All these different elements are used to interpret the text.

Other calligraphers start by visualizing a piece of work and find the words that best express this image.

Both ways of working are valid. They are different approaches to the same end: a finished piece of work.

BOOK MARGINS

The considerations to bear in mind when setting the margins for a manuscript book are different to those that are involved when a piece of calligraphy is written on a single sheet of paper.

There are various kinds of manuscript book:
• A single pair of pages, or spread, possibly with a title.
• A single section booklet consisting of two or more folds of paper giving four or more pages of writing and illustrations, plus a title page. (See *A Garden Journal,* page 86.)
• A multi-section book with many pages of writing and illustrations, plus a title page. (See *Manuscript Book,* page 106.)

In some books all the pages are very similar with the writing on each page occupying the same amount of space. The margins and text area are the same for most of the pages. The only exceptions would be the title page, if there is

The starting-points
(above)
The corners of the spread are marked ABCD and the centre-fold line is marked EF. Diagonals AC BD ED and EC are drawn and the intersections of these diagonals are marked G and H. Vertical lines are drawn from G and H to the line AB to make points J and K. The diagonal lines JH and KG are drawn. The starting-points for making the margins are where these diagonals cross ED and EC (circled).

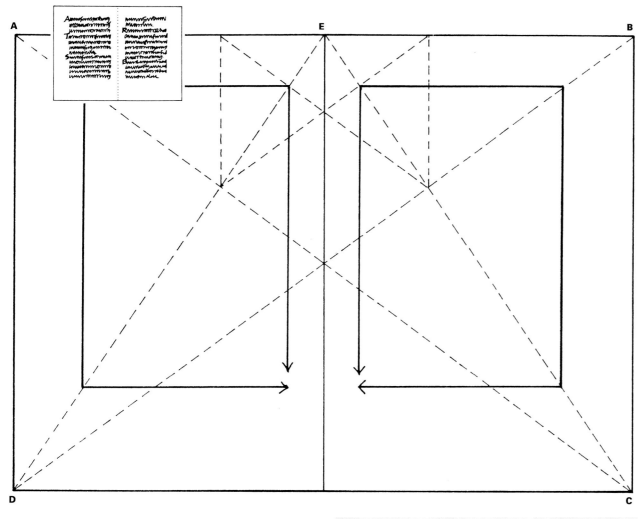

A E B

D C

one, and text involving headings or credits. In this case margins can be set first when the approximate page size is decided and the text then written within the lines that indicate the text area.

Others have different amounts of text on each page. In this case each pair of pages, or spread, must be considered individually as well as with the other spreads to make the book work as a whole; and the margins must be checked visually (see page 53).

As a general rule, the text that occupies the greatest space sets the margins for the whole book. However, there may have to be an element of compromise.

Traditional book margins are a useful guide. The diagrams on the left are based on the method devised by Jan Tschichold, a Swiss type designer, to provide a starting-point that gives margins that are similar in proportion to traditional book margins.

Setting the margins
(above)
Horizontal lines are drawn left and right from the circles to meet the diagonals AC and BD, then drop down vertically until they meet diagonals ED and EC. From there they are taken horizontally across to meet vertical lines drawn down from the starting-points.

The text area can be reduced or increased by choosing any starting-point on EG or EH. Using this method, the top margin is roughly half the bottom margin and the centre margins of both pages combined are equal to each side margin. This applies to both horizontal and vertical pages. However, never be afraid to break away from the starting-point — the deciding factor is always what the pages look like.

Horizontal pages
(opposite page, below)
The largest margins are at the sides. The top margins look small and may need to be readjusted.

This opening from 'St Cuthbert and the Stonyhurst Gospel', a manuscript book written and bound by Susan Hufton, shows how the position of titles, credits and illustrations must be considered in relation to the text areas so that there is visual continuity throughout the book. The size of the opened book is 42 x 28 cm (16 x 11 inches).

WEIGHT

The weight of a piece of writing is largely determined by the amount of white space within the letters, which is decided by the width of the nib and its relationship to the height of the letters. The more white space the letters contain, the lighter their weight. This can reduce the overall impact of a piece. Decreasing the white space gives heavier weight letters which usually have a greater visual impact on the page. See also Italic Capitals (page 38).

Using different weights can be important in visually interpreting quotations. Although these can be the most straightforward of calligraphic works even the simplest piece can have three elements:
• Title
• Main text
• Credit

If all three are written with the same nib at the same height and size they all contain similar amounts of white space and all assume the same importance. The choice of weights and their relationship is, therefore, as important as positioning the elements of the design on paper. Generally, as in the examples on the right, the credit is smaller and lighter in weight than the other elements in the piece.

Decide on the relative weights within a work at the layout stage; this will give you the opportunity to increase or decrease them in particular parts of the design — and so change their impact on the page — before you start writing the finished piece.

Using different weights

It is better to be faithful than famous.

1 THEODORE ROOSEVELT · 1859–1919

SONG ON A MAY MORNING
HOW THE BRIGHT MORNING STAR, DAY'S HARBINGER
COMES DANCING FROM THE EAST, AND LEADS WITH HER
THE FLOW'RY MAY. JOHN MILTON

2

Forward, forward let us range,
Let the great world spin for ever down
3 the ringing grooves of change. TENNYSON

AIRE AND ANGELS
Twice or thrice had I loved thee,
Before I knew thy face or name;
So in a voice, so in a shapelesse flame,
Angells affect us oft, and worship'd bee.

4 JOHN DONNE C. 1571–1631

SONNET
IF THOU MUST LOVE ME,
LET IT BE FOR NOUGHT
EXCEPT FOR LOVE'S SAKE ONLY

ELIZABETH
5 BARRETT BROWNING

1. Pencil credit
Tiny skeleton capitals written in pencil below a quotation work well.

2. Standard contrasts
The title is normally bolder and heavier in weight than the text, and the credits smaller and lighter in weight. This helps the eye to follow the order of reading, flowing from title to text to credit wherever these may appear on the page. It is important that the weights are balanced (see 5).

3. Emphasis
An initial or a few key words of text can be written in heavier letters to give emphasis and contrast.

4. Creating contrast
A lightweight title combined with a text written in heavyweight letters will provide a noticeable contrast. Part of the text written in large lightweight letters can also act as emphasis.

5. Balancing weights
Areas of writing should balance in weight. Two weights need to be noticeably different and three weights must be evenly balanced in steps: heavy weight to medium weight to light weight (see 2). In this example ('Sonnet') the balance of weight is uneven. The title and text are nearer in weight than the text and the credit.

Assessing weight
When working on a layout you can more easily assess how the relative weights of the different text areas of writing are working together by looking at the work through half-closed eyes. This allows you to see the piece as a whole. It also helps to fix the layout to the wall, step back and look straight at the piece instead of down on to it.

Changing weights

THINNER

Nib sizes
These two examples are written at the same height, but with a narrow and a wide nib.

THICKER

Letter heights
(below)
Increasing and decreasing the heights of the letters changes their weights. The smaller the number of nib widths the heavier the letters. These two examples are written with the same nib.

ABC
ABC
ABC
ABC

Two important factors
As letters change in weight they also change in character and in the amount of space they take up along the line. Both factors have to be borne in mind when considering any change in the weight of the writing.

/LIGHT

/HEAVYWEIGHT

Checklist

Using this checklist will help you to decide how to use contrasting weights in a calligraphic work.
• Size: do the words suggest a large, bold piece, or a small, quiet piece?
• Purpose: what is the piece for? Will it be handled or viewed from a distance? The impact of the words may be crucial.
• Shape: do the words suggest the shape of the piece or is it to be hung in a specific place? Both factors influence the choice of weight.
• Scale: will the size or weight of the writing work with the intended size of the piece, its purpose and shape?
• Focal points: what will be the focal point of the piece? Which part or parts are to be most prominent, and where will they be positioned?

Using contrasting weights

Sketches help you to visualize your work and how different weights can be combined.

1. A larger, heavier heading or text is used above a lighter weight text.

2. Heavier text — or the title — is placed in centre of the piece. Ideally there should be more text below it, as here, or it will appear to drop below the centre of the page.

3. This has a column of heavier text between two lighter weight columns. The bands of writing above and below the columns help to hold them together.

4. This more complex layout has a centre block of text surrounded by lighter weight text, all held together by the title and a line of small writing. When combining different weights of letters in this way in a piece of work it is important to decide whether the title or the centre text should be be the heaviest part of the piece, or whether they work at the same weight.

5. A block of heavier writing works well placed to one side of a block of lighter weight text.

6. Blocks of writing in different weights are here arranged asymmetrically.

INTERLINEAR SPACING

Interlinear spacing — the amount of space between the lines — is influenced by the weight and style of the writing. Together with these elements it plays a part in determining the overall appearance of a piece of work.

There are three general rules to bear in mind when deciding how much space to leave:

• Interlinear spacing may need to be visually more than the space between the words. This will ensure that the words appear as continuous lines of writing rather than a series of individual words dotted within an area.

• To be easily read, long lines tend to need more interlinear spacing than short lines.

• The amount of interlinear spacing depends on the weight of the writing as well as the length of the lines.

The examples on these two pages use capitals which have no ascenders and descenders to cut into the interlinear spacing. They show how the number of words in a line and therefore the length of the line also help to determine the amount of interlinear space.

The capitals illustrate the basic principles. However, the ascenders and descenders in minuscules mean that it is more difficult to push lines of these letters very close together: the ascenders and descenders can become tangled and the lines are harder to read because the overlapping strokes create dark patches in the writing. Lines of minuscule letters therefore tend to need more space between them than do capitals.

Using interlinear spacing

NOW THE BRIGHT MORNING STAR,
DAY'S HARBINGER,
COMES DANCING FROM THE EAST...

NOW THE BRIGHT MORNING STAR

DAY'S HARBINGER,

COMES DANCING FROM THE EAST...

NOW THE BRIGHT

MORNING STAR,

DAY'S HARBINGER,

COMES DANCING

FROM THE EAST...

NOW THE BRIGHT
MORNING STAR,
DAY'S HARBINGER,
COMES DANCING
FROM THE EAST...

Long lines
Long lines placed close together in the weight of writing used in the illustration above are not as easy to read as the same lines with more space between them.
Top: The text becomes a block shape, which can be useful, but the space between the words is more than the interlinear space; this impairs legibility especially as the eye has to travel along the line in order to take in the whole piece.
Above: Adding to the interlinear space strengthens the lines and the words read easily along them. This is because the space between the words is less than the interlinear space.

Short lines
Left: The interlinear spacing is the same as in the example immediately above but the widely spaced short lines are not as easy to read as the long lines. The eye has to travel further down to the next line relative to the length of the line.
Below left: These lines are closely packed, as in the example at the top of the page, but because there are fewer spaces between the words the eye is able to hold the piece together as a whole.

Rules as reference points

As always, the visual result is all-important in a calligraphic work and there are exceptions to the three rules given in the text on the far left. Indeed, decisions can be taken to break them in order to achieve a particular feel that is appropriate to the text, depending on the size, weight and style of the writing.

Nevertheless, the rules provide useful reference points when a piece of calligraphy needs revising or reworking. They can also be used as a check to highlight mistakes in a work.

NOW THE BRIGHT MORNING STAR, DAY'S HARBINGER,
COMES DANCING FROM THE EAST,
AND LEADS WITH HER, THE FLOW'RY MAY.

NOW THE BRIGHT
MORNING STAR,
DAY'S HARBINGER,
COMES DANCING
FROM THE EAST
AND LEADS WITH HER
THE FLOW'RY MAY

Heavyweight writing and interlinear spacing
Long lines in heavyweight writing need more interlinear space than do short lines. Reducing the internal space within the letters affects the amount of space that is needed.
Above: The interlinear space is a little more than one x-height, as in the widely spaced examples opposite.
Left: The interlinear spacing is the same as in the closely spaced examples opposite.
In both heavyweight examples the interlinear spacing seems to be wider than in the other examples because it is in contrast to heavier writing.

Lightweight writing
Because of the amount of space within the letters themselves, lines of lightweight letters can be placed very close together (right) or further apart (below) depending on the desired result. The example below gives definite lines of letters.

NOW THE BRIGHT
MORNING STAR,
DAY'S HARBINGER,
COMES DANCING
FROM THE EAST...

NOW THE BRIGHT MORNING STAR
DAY'S HARBINGER
COMES DANCING FROM THE EAST...

Left: Detail from 'Burning'; Christopher Haanes. Brause nibs and square-edged brush, gouache and ink on Rives BFK paper. Approximately 80 x 120 cm (31 x 47 inches). Lightweight capitals placed very closely together create an overall texture over which the word 'burning' is written.

Above: Detail from a broadsheet; Gillian Hazeldine. Gouache and steel nibs on hot-pressed paper. Texts from Vita Sackville-West, Flora Thompson, A.E. Housman. 40 x 56 cm (15 1/2 x 22 inches) The complex use of interlinear spacing in this calligraphic work is seen particularly clearly if you look at a part of the panel at a time rather than the whole piece. Varying interlinear spacing is used to separate lines for reading or to create blocks of text. The short diagonal lines are well spaced to give a clearly defined pattern. The centre four lines are packed closely to give a block of writing. The top three long lines are placed widely apart to aid reading and to give definite bands of writing to the layout.

MAKING A FINISHED PIECE

When you have finalized the design of your work and have a paste-up or a final rough from which to work the next step is to prepare your paper. This preparation is integral to the finished work so it is important to spend time on this stage.

DETERMINING THE GRAIN OF THE PAPER

During the manufacture of machine-made and mould-made papers the fibres align themselves in one direction giving a grain to the paper. The fibres in handmade paper tend to move in all directions and there is generally no distinct grain. It is important to determine which way the grain is running through the sheets you using — rolling, folding and tearing paper in the direction of the grain is much easier than working against it.

The grain in machine-made paper is usually easily found, in mould-made paper it is a little more difficult to find and in handmade paper it is very difficult to detect or simply non-existent. There are three ways of testing for the grain (see below).

FOLDING PAPER

When thin and medium-weight papers are folded with the grain they usually fold sharply and easily. When they are folded against the grain the result is rough and imprecise.

To obtain a consistent sharp fold in the exact place you wish, a line must be scored first. A bone folder is the best tool for this, but you can also use a small, blunt instrument which will flatten and weaken the fibres allowing them to fold more easily. The back of a knife is not ideal as it can be sharp enough to cut the fibres and weaken the fold.

A new bone folder is sometimes too thick and will score too wide a line. If this happens, sand down both the pointed and square ends until they are smooth and fine. Use a coarse sandpaper and then progressively finer sandpapers.

Fold the paper along the scored line and then run the folder along the folded edge to give a good, sharp crease. The folder can leave a shiny line on some papers. To avoid this, put a piece of layout paper between the bone folder and the paper.

Storing and carrying paper
Store paper flat and protect it from dust. To transport sheets of paper roll them with the grain to avoid creasing and slip the roll into a cardboard tube. Alternatively, wrap the sheets around a cardboard tube. Always lay the paper flat as soon as possible.

CUTTING PAPER

Always use a very sharp knife to cut paper — a blunt knife will tear the paper instead of cutting cleanly. Use a metal straight-edge ruler. The best ones have a non-slip base and are made of metal over 5 mm (1/4 inch) thick with a bevelled edge which protects the fingers if the knife slips. Put more pressure on the straight edge than on the knife when you cut to avoid both edge and knife slipping.

If your knife is sharp only a little pressure will be needed — nothing more than a stroking action which can be repeated several times if necessary depending on the thickness of the paper.

Always be aware of the angle of the blade as you hold the knife. Try to keep the blade vertical unless you actually want a bevelled edge to your cut.

PREPARING THE PAPER SURFACE

Some paper surfaces can be difficult to write on.

If the the paper you are using is too 'slippery' or does not take the ink easily, rub the surface gently with a soft pencil eraser before you start to write.

If the ink or paint bleeds slightly into the paper, sandarac dusted on to the surface sometimes helps to prevent this.

Sandarac is a resin that can be bought either ground or unground. If you buy the unground version you will have to grind it very finely until it is an off-white dust before applying it to your paper.

Where possible, however, if you are having difficulty writing on the paper you have chosen it is best to change it for one that has a more easily workable surface.

Applying sandarac
Put a little ground sandarac into a finely woven cloth pouch or small tissue and stroke the paper lightly with the pouch or bunched-up tissue. Be sparing with the powder — too much will make writing difficult and clog the nib.

RULING UP

When a piece of calligraphy has been developed to a paste-up or final rough the next stage is to rule up your paper before starting to write the finished piece.

There are three different ways of ruling up, all of which require a sharp HB, H or B pencil. The

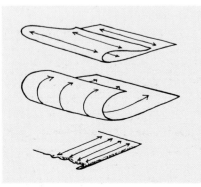

Testing the grain in paper
Bend the sheet of paper over without creasing it. If it lies down comfortably it is bending with the grain. If it is springy and bouncy it is bending against the grain.

Fold the paper. Against the grain it will not give a clean, accurate fold. Folded with the grain it gives a sharp, clean line.

Wet one edge of the paper. If it cockles it has been wetted against the grain. If it curves over and waves it is moving with the grain.

measurements are marked on both the left and right margins.

The three methods are:

1. Use a ruler with clear markings to measure the height of the letters and interlinear spacing and transfer the marks to the paper.

2. Mark the letter heights and interlinear spacing on a separate sheet of paper and use these measurements as a guide to marking the paper for the finished piece.

3. Set a pair of springbow dividers to the distance between one top line of writing and the top line below it and 'walk' the dividers down the sides of the page. The points of the dividers will mark the paper. Then repeat the process for the base lines.

For all three methods, use a pencil and ruler to join the marks accurately to make parallel lines.

BEFORE YOU START TO WRITE

• Always double check measurements after ruling up. Some calligraphers rule up two or three sheets in case they make mistakes or so that they can work on two or three finished pieces and choose the best one.

• Ensure that all materials are to hand. Begin by writing on a spare sheet of your paper before starting

Manuscript books

When preparing a manuscript book you should ensure that the grain of all the paper used is lying vertically from head to tail. This helps the book to lie flat and stable, and is vitally important if glue is to be used in the making of the cover. Paper that has the grain line lying horizontally from spine to foredge can cause the covers of the book to bow up and out away from the text pages.

Deckled edges

Sheets of machine-made paper generally have cut edges on four sides and handmade and mould-made papers usually have deckled edges on four or two sides of the sheet. Deckled edges are formed by the pulp in the deckle, or frame, of the mould that is used during the manufacturing process.

In the past manuscript books written on paper traditionally kept the deckled edge on the tail (lower) edge and foredges with a cut edge at the head (top) edge to avoid trapping dust.

A piece of calligraphy can be mounted or it can be left with the deckled edges showing, giving a simple decorative element to the presentation of the piece.

If only one or two deckled edges on a sheet of paper can be used because of the size of a piece of work it is possible to make a mock deckled edge.

Score a line where the edge of the piece is to be. Using a clean paint brush, brush water on to and slightly beyond either side of the score line. You may need to do this more than once in order to ensure that the fibres around the score line have been softened.

Pull the paper apart along the wet score line. Pull the sides directly away from each other using the same amount of force for both sides. The edge of the paper will dry slightly cockled and rough, almost like a true deckled edge.

Do not hold one side and pull the other up at an angle — the usual way of tearing paper. The fibres should pull out at right angles to the edge when the paper has been torn apart.

on the finished piece. This will relax your hand and accustom you to writing.

• Make sure you have enough time to write the whole piece — or a particular part of a piece — in one sitting. If you interrupt your work your writing will very probably be inconsistent.

Although a large panel of work may take far too long to do in one sitting, different parts can be done at different times. If you are working on a manuscript book with a lot of text pages, write each pair of pages in one sitting, so that the writing remains consistent on each spread.

ERASING MISTAKES

The despair that comes from making a mistake when writing a finished piece is known to every calligrapher. However, it is not always necessary to write the whole piece again; mistakes can often be erased with time and care.

• It is always best to practise first, using a piece of the same paper. This will show how the paper behaves, whether it discolors and

if the erased surface can be written on again.

Using a scalpel Scrape the ink, very gently, off the surface of the mistake with a sharp scalpel. Do not dig into the paper. Remove the fine dust of ink that will result, using a tissue or by gently rubbing with a soft pencil eraser. When you are unable to scrape off any more ink without cutting into the paper, continue rubbing gently. Disturb the fibres of the paper as little as possible.

When all the ink is removed, flatten the fibres by rubbing the area with the flat edge of a bone folder or the flat of a fingernail. If you are doing a trial erasure this is the stage to find out whether the paper you are using can be written on again.

Use as little ink on the nib as possible when re-writing, to avoid bleeding. If bleeding does occur try dusting the surface with a little finely ground sandarac before writing again.

Using an eraser Some soft papers cannot be easily scraped with a scalpel and it is best to use an eraser. A small piece of ink eraser

Easing the tension

Most calligraphers find making a finished piece a nerve-racking experience. The final rough may have gone well with fluent writing, but tension somehow mounts with the prospect of having to do the finished piece successfully. This tension tends to show in the lettering — resulting in frustration which further impedes the fluency and freedom of the writing.

Every calligrapher finds their own way of dealing with this problem. Some find that background music takes away the intensity of the silence needed for concentration, others find that working on more than one finished piece helps.

held between tweezers or the prongs of a ruling pen can be used to rub small, specific areas. A 'pencil' typewriter eraser can be good for this purpose. Be sure to rub slowly and carefully.

With time and practice you will eventually find the best way of erasing mistakes depending on your touch and the paper surface.

THE WIND HAS STOPPED
THE·CURRENT OF THE MOUNTAIN STREAM
WITH ONLY A WINDROW
OF RED MAPLE LEAVES.

ARUMICHI NO TSURAKI

Garden Journal

I had
NOTHIN
BUT AS
AND A
ING OF S
CAU
ALL
F MY LIT

Heil
b. 1805

Barthol
James

George
Lydiard Agr
b. 1832 b.

b. 1824 James
 b. 1826

Nora

The fifteen projects that follow start with simple pieces of calligraphy and build up to more complex works, allowing you to develop your calligraphic skills.

• Individual calligraphers explain the rationale behind their projects and describe the techniques they used to create them.

• Captioned illustrations take you step-by-step through each project.

• Tools and materials that will be needed in addition to items from the basic equipment on page 11 are listed at the start of each project.

ORANGE & CINNAMON CONSERVE

Apple WINE

1995

haricot BEANS

Juniper Berries

Fruit Compote

WITH BRANDY

Bro Sa

Blackber

WINE LABEL: LETTERING AND A DECORATIVE BORDER

Selection of labels;
Anna Ravenscroft
The wine label is ink
and gouache on
Ingres paper

Although a label is one of the simplest of calligraphy pieces, it is also one of the most satisfying to do — possibly because it combines creating a sense of order with a definite visual appeal. The materials required are relatively inexpensive in themselves and many printers are happy to give away offcuts of paper in a variety of surfaces and colors, which could be added to your own collection.

The essential element in a label is that it is laid out with a sense of clarity and design, and to achieve this a number of decisions must be made before you start work:
• The size and shape that will best suit the object for which the label is intended.
• Whether the label is part of a series.
• And, if it is, whether it will relate sympathetically to other labels in the series.
• Whether the approach should be formal or informal, bright and cheerful or restrained.

The wine label in this project was designed with a farmhouse kitchen in mind and is intended to be seen with labels on jars of food. In other words, it is part of a series that has an overall sense of identity.

There are, of course, other approaches for other purposes. Labels for presents would demand a sense of fun or informality; place names for a dinner or wedding party would be more formal; even a filing cabinet label can reflect its user's individuality. But whatever the purpose, the method of working described on the following pages is a basic guide.

Equipment

• Papers: Ingres paper; layout paper; tracing paper.
• For writing and illustrations: Square-edged nibs; black, non-waterproof Indian ink; green and yellow gouache paints; apple.
• Basic equipment plus: Glass slab or flat ceramic tile.

Wine bottle labels come in a variety of shapes but I decided to use an oval which echoes the overall curves of the bottle itself. As the wine is made from apples an apple print was the obvious main decoration. The border evolved as the project developed — I tried a variety of designs before making a final decision. I used an Ingres paper and wrote the words in Roman capitals and Foundational miniscules using black, non-waterproof Indian ink for the words and shades of green gouache for the apple, date and border.

The other labels in the illustration on the previous page are different shapes and sizes but their overall effect is the same as that of the wine label.

2 Thumbnail sketches
Do rough sketches to help you to decide where to put the writing, and what size and shape the words should be in relation to the bottle. They will also help you to consider decoration and color.

▼

3 Making the apple shape
Trace oval shapes from your 'guide' label on to the final paper. Then mix green gouache pigments on a glass slab. Cut the apple in half and press it into the paint. Then press the apple on the paper inside one of the traced oval shapes. Its juice will release the paint. Make as many prints as there will be labels, plus two or three extra for designing the label.

◀ **4 The border**
Experiment with nib sizes and designs. When you have one you like, draw it on a spare label to check for adjustments. The one I chose (see Step 6) was drawn with a No. 3 nib and a green mixed from green and yellow gouache.

1 Making an oval-shaped guide
Draw a quarter of an oval on tracing paper. Fold the paper from top to bottom and left to right and trace the rest of the shape.

5 Writing the words ▶
The next step is to write out the words in different sizes and weights (see page 56) using a variety of nib sizes. I decided to use a No. 3 nib for 'apple' and the date and a No. 1 1/2 for 'wine'. I used black, non-waterproof Indian ink for all the lettering except the date, which is in green gouache.

6 Using an overlay

Write the words on tracing paper, then pencil in the border. Place the tracing paper over the apple. This will enable you to judge the weight and suitability of the nib sizes that you have used.

7 The paste-up ▶

The paste-up (see page 52) allows you to check the design, line spacing and nib sizes. Cut out the words and place them over one of your extra apple prints. Avoid too little or too much space around the writing and make sure all the words can be seen on the bottle. I used a centred layout (see page 52) here.

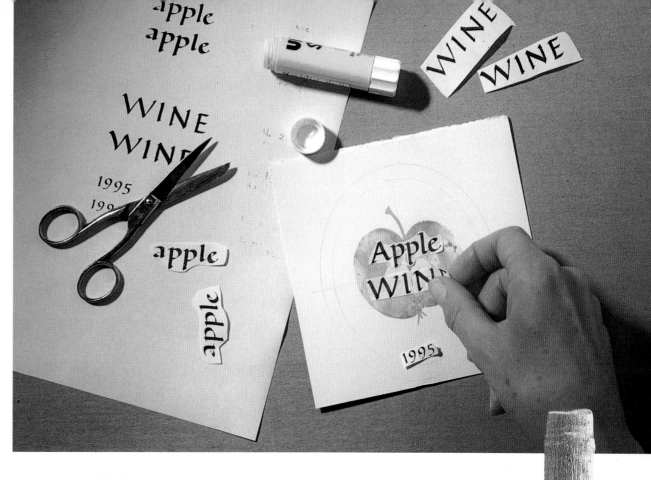

◀ 8 Ruling up

The next step is ruling up (see page 60). I used a strip of paper for this and transferred the measurements from the paste-up to the finished label with a moderately soft (HB or B) pencil.

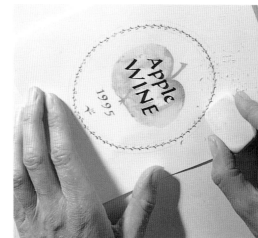

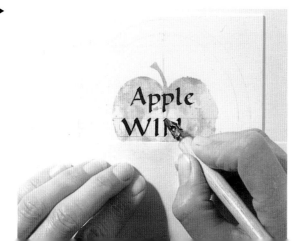

9 Centring the writing ▶

Lightly draw a vertical line at the centre of the label. Then measure each line of writing on the paste-up, find the centre and align this to the label's centre. Mark the beginning of each line from the centre of the label and write the words. Practise first on layout paper.

10 The final touches

When the writing on the label is dry, trace the border on to the label and draw it in. Allow it to dry then gently erase the pencil lines. Use scissors to cut the label out around the outer edge of the pencil line and stick it on the bottle. Make sure no glue gets on to the label.

This project has shown:

- How to design a centred layout within an oval.
- Draw a pen-made border.
- Create a printed background for lettering.
- Work with word and line spacing and margins.
- Use different-sized nibs for one piece.

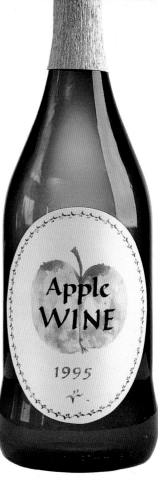

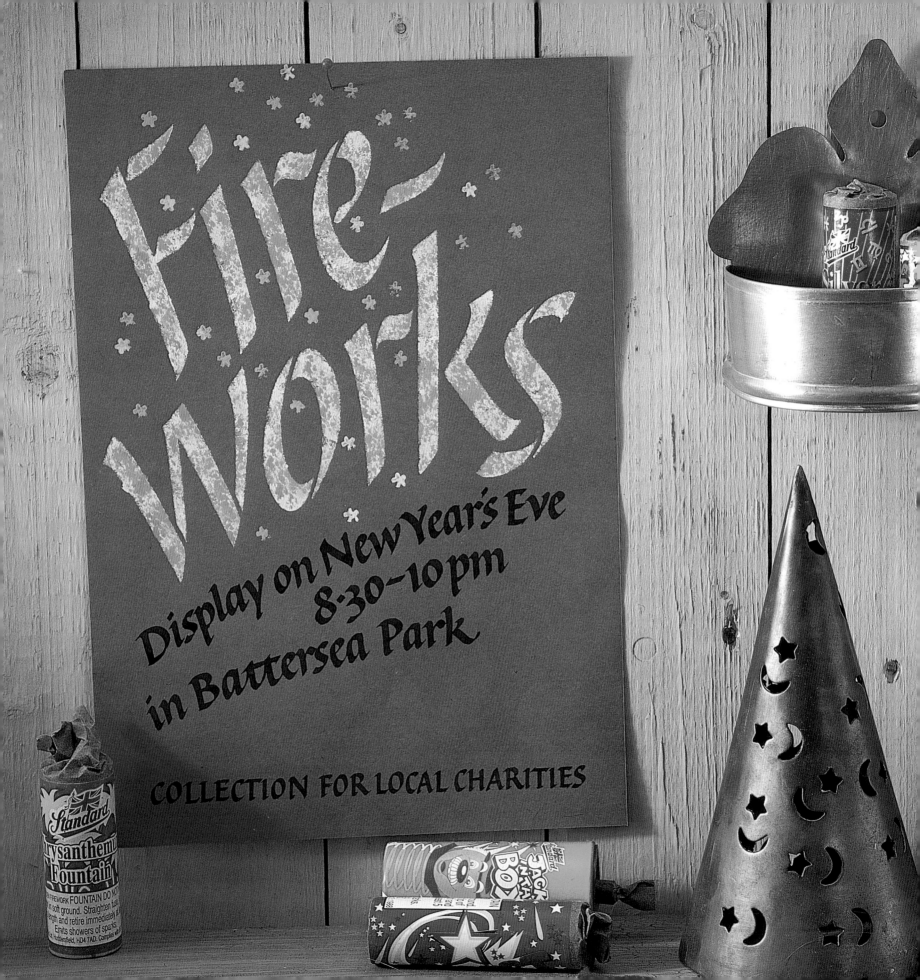

A FIREWORKS POSTER: WEIGHTS AND SIZES OF LETTERS

A Fireworks Poster;
John Woodcock
Gouache on cartridge
paper
A4 (29.4 x 21 cm/
11 5/8 x 8 1/4 inches)

Posters can be highly illustrated or, as in this project, they can depend for their impact on color and a balance between the various sizes and weights of lettering. Certainly, calligraphic versions come into their own when neighbourhood activities are being advertised as local groups seldom have the funds needed for more sophisticated productions.

Before starting work there are a number of facts to be taken into consideration:

- The kind of event it is advertising.
- The size of the finished poster.
- Whether it will be displayed inside or outside.
- The number of copies that are required.

By their very nature posters tend to be works that are commissioned — either formally or informally — and it is always worthwhile establishing that you have a free hand to create the best design for the circumstances. Ask for the text to be typed not handwritten so that correct spellings are confirmed at the outset and, if necessary, suggest alterations that may put its message over more clearly.

The poster in this project is a comparatively simple design but the basic method of working can be adapted for more complicated versions that may include additional information such as a celebrity connected with the event. Always work out the hierarchy of this information before starting work — this will affect your choice of sizes, weights and the emphasis given to the letters with color. If a company is sponsoring an exhibition, for example, it may be necessary to display its name prominently on the poster.

Equipment

- Papers: Blue cartridge paper; oiled manila; tracing paper; layout paper.
- For writing and illustrations: Square-edged nibs; double pencils; stencil brush; white, pink and yellow gouache paints.
- Basic equipment plus: Balsa wood.

The poster is intended to be displayed indoors, on shop windows and notice boards, so A4 (11 5/8 x 8 1/4 inches) is the most suitable size. It is also convenient for photocopying. As the project developed I decided to stencil the word 'fireworks' partly for the textural interest of the stencilling and partly as an economic means of printing a number of copies in several colors (a simply written version is shown in Step 4). I used blue cartridge paper to suggest the night sky and provide a good contrast to the other colors and white, pink and yellow gouache paints, evocative of fireworks, for the lettering and decoration.

2 Thumbnail sketches
Do thumbnail sketches inside the scaled-down outlines. These will quickly help you to establish the best design, size and script for the poster. I decided at this stage that 'fireworks' should be the largest word, written in either Roman capitals or Italic.
 Select the best of your thumbnail sketches and draw it to a larger, or even to actual, size on a sheet of layout paper.

▲

3 Trying out nib sizes
Try out different nib sizes on your enlarged sketch using the thumbnails for reference. Think ahead to the type of pen and nib size you will need for the largest sizes of the final writing. 'Staggered' letters, a hyphenated word and letters written on a diagonal are ways to keep the title as large as possible and closely spaced in a narrow width.

4 Positioning text
Write out the words following the positioning in your selected sketch and photocopy them on to different colored papers. Cut the papers to size with a sharp knife and steel rule on a cutting mat or sheet of thick card. The examples in this illustration (not used here) show how the size of the margins affects the overall design of the poster.

▼

▲

5 Stencilling and paste-up
Make a half-size stencil of 'fireworks'. The 'ties' that prevent the centres of e or o dropping out are placed in the other letters where the pen lifts to give continuity of design. Put the stencil over colored paper and apply dryish gouache with a stencil brush. Do a paste-up (see page 52) using words from the same color paper.

1 Outlines
Fold an A4 (11 5/8 x 8 1/4 inch) sheet in half and half again, then draw a number of these shapes on layout paper.

6 The full-size stencil ▶
Rework the stencil at twice the size for the finished letters that will go on the full-sized poster. Use double pencils that are of a suitable width for the now larger letters.

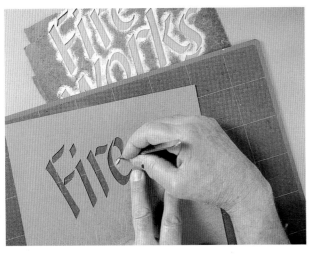

◀ **7 Cutting the stencil**
Trace the stencil lettering on to oiled manila paper and cut it out as before. The spacing in my first stencil (above in the illustration) was too wide and the letters were not dynamic enough so I adjusted the letters and spacing to increase the vigour of the title. A tie was mistakenly cut through. It has been repaired with brown paper and is shown being re-cut.

8 The final stencil ▶
Position the stencil on the final colored cartridge paper and stencil in the letters using white and pink gouache paints — the mix must be fairly dry to give a rough texture that will reinforce the vigour of the letters. Cut away the corners of the oiled manila so that you can position the stencil accurately on the blue paper.

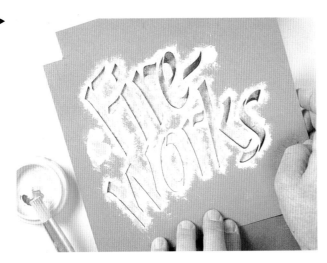

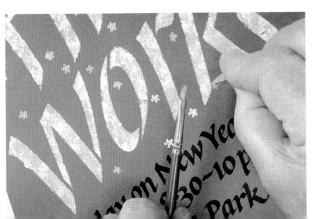

◀ **9 Additional color**
Cut a small star in a piece of balsa wood for the decorative motifs. Brush on some yellow gouache — the paint should be fairly thick — and press the stars on to the poster. Repeat the process with the white paint.

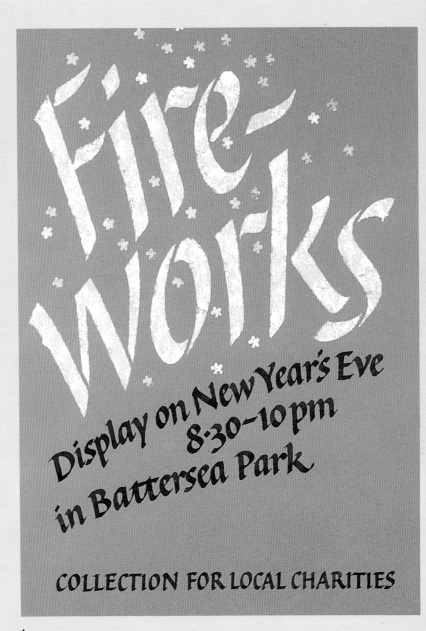

▲
The final piece
The black writing has been photocopied on to the blue cartridge paper. The title has been stencilled in gouache colors and stars have been cut from balsa wood and printed in gouache.

This project has shown:
• How to create an eye-catching layout.
• Combine different sizes, weights, forms and colors of letters.
• Use space for emphasis and effect.
• Use color for emphasis and visual interest.
• Adapt pen forms to another medium (stencilling).

SUN'S ◆ BRIGHT ◆ LIGHT

Bathes
He
The Li

GREETINGS CARD: PRINTING AND GILDING

Greetings card;
Kathryn Deville
Gouache and gold on
black and terracotta
paper
11 x 18 cm (4 5/16 x
7 1/8 inches)

The ephemeral nature of a greetings card means that it is an ideal medium for experimentation. You can have fun trying out ideas and create a card that is totally individual.

There are a number of decisions to be made before starting work on a card. They are:

• The occasion for which the card will be sent.

• The size and format of the card.

• The type and size of the envelope and whether it will be made by hand or bought.

• The type of fold for the card — and for the envelope if it is to be made.

• How many cards are to be made and whether they will be handmade, printed or photocopied and finished by hand.

• The words and how they will be arranged.

• The style of lettering that is appropriate for the occasion and the card itself.

• Decorative elements and how these should be applied.

• Special features such as interesting closing devices, inserts, unusual methods of assembly.

• The type of paper and its color or colors.

In this project the card is not linked to any particular occasion such as Christmas, which has its own traditional decorative motifs, so it is possible to produce something that is unusual and imaginative. I wanted a striking, bold design and decided on one that conveys a vaguely tribal feeling. The method of working could be adapted to make cards and envelopes for a variety of occasions like birthdays, Christmas and anniversaries.

Equipment

• Papers: 160 gsm (75 lb) textured drawing paper (terracotta and black); layout paper; carbon paper; tracing paper (optional).

• For writing and illustrations: Square-edged nibs; No. 2 brush, soft brush; sheet of transfer gold; black, white and red earth gouache; black non-waterproof ink; plastic erasers; scalpel; burnisher; PVA glue.

• Basic equipment.

I decided on the size of the card and that it should be folded with a gatefold. The envelope is designed to echo the semi-circular shapes used in the card. The handmade envelope enhances the 'specialness' of the card. I chose the words and decided to use a rubber stamp to apply the decoration. Both the card and envelope are closed with semi-circular tabs. After experimenting with the lettering I decided to use terracotta and black medium-weight 160 gsm (75 lb) textured drawing papers that are heavy enough to stand straight without curling but not so heavy that it is difficult to fold them.

◄ 2 Making a stamp
Transfer each of your decorative motifs on to a plastic eraser — one for each motif — either by drawing directly on to the eraser or by tracing it on using tracing paper over carbon paper. The stamp will print the reverse of the image cut into it, so trace the design on to the eraser in reverse. I decided on three motifs: a lizard, diamond shapes and sun ray shapes.

3 Cutting out the stamp
Use a scalpel to cut around each shape to a depth of not more than 2mm (1/8 inch). Take care not to undercut it: the edges of the shape should be straight or cut at a slight angle away from the image. This ensures a firm, definite print.
Cut away the unwanted parts of the eraser leaving the image raised.

Test the print ▶ quality regularly on a sheet of layout paper with the gouache paint that you will be using for the motif and correct any faults by re-trimming the shape.

4 Applying the color
Now apply color to the face of the image. I used red earth gouache for the ▼ lizard and gold for the other shapes and applied them with a No. 2 brush. Make sure the paint covers the shape evenly and is not too thick. Use a spare piece of paper to find the right pressure and correct covering of gouache.

1 Thumbnail sketches
Do rough pencil sketches on layout paper to get ideas for the shape of the card and envelope and the decorative motifs.

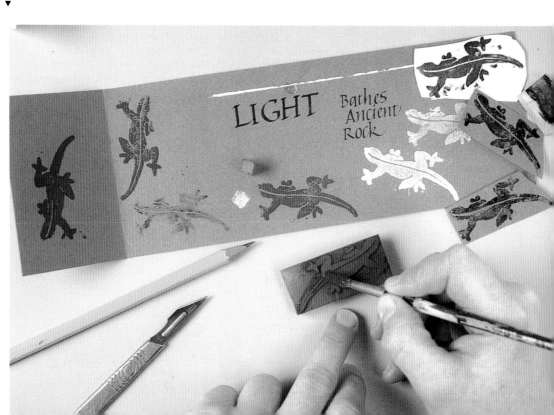

5 The lettering

Try out different styles and weights of lettering to fit in with the idea and feel of the design (see Weight, page 56 and Interlinear Spacing, page 58). I decided on Roman capitals with slab serifs, which I applied with a No. 2 1/2 nib, for the front of the card and Italic with slab serifs, applied with a No. 4 nib, for the inside. I used black non-waterproof ink. At this stage I made my final decision about the paper I would use.

6 Making up dummies

Use the template on page 141 to make a complete black-and-white dummy of the card. Do a paste-up (see page 52) then make a color dummy with the final paper. Determine the grain of the paper (see page 60) then draw the card on the paper with a pencil, ruler, set square and compass. Cut out the card (see page 60) and score and fold it (see page 60).

This illustration shows the gold decoration (see Step 11) but because gold is expensive it is best only to apply it to the finished piece.

7 Checking the design

Check your color dummy carefully to make sure that all the colors work together as planned and that the rubber stamps are effective against the colored paper. The dummy will also allow you to ensure that the 'mechanics' of the card work with your chosen paper.

Use the template on page 140 to make a plain white dummy of the envelope. Check that the card and envelope fit together and then score the card for the envelope.

8 The final lettering ▶

Use a pencil and ruler to rule up the lines for the lettering (see page 60) and write the lettering on to the outside and inside of the card. When the ink is totally dry, rub out the lines with a soft eraser.

◀ 9 Applying the black strip

Cut out a strip of black paper (see template for exact measurements) and glue it to the outside of the card. Rub the strip through a piece of layout paper to make sure it is stuck down.

▲

11 Gilding the sun ray shapes

Use a pencil to indicate the positions of the lizard and diamond shapes inside the card and the sun ray shapes on the outside. Then apply an even layer of PVA glue to the face of the sun ray stamp and print it on to the sun ray positions on the card. Allow the glue to dry thoroughly then breathe on it so that it is reactivated.

Place a transfer sheet of gold face down on the glue and rub it gently with your finger so that the gold adheres to it. Lift off the sheet of gold.

Repeat the process if the results are patchy at first.

Use a dry, soft brush to brush away any excess gold around the shapes. Burnish them lightly with a burnisher to bring a shine to the gold.

10 Applying the white lines ▶

Rule light pencil marks on the card following the measurements on the template. Then apply white gouache to the edge of a ruler with a brush. Press the edge carefully on to the card using the pencil marks as a guide. This should give a broken, irregular line.

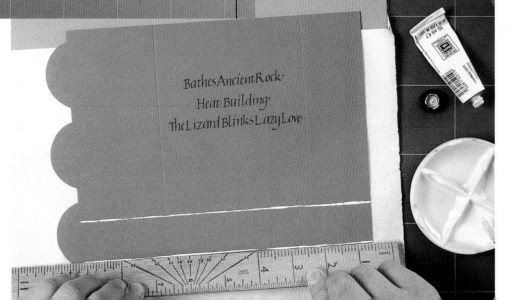

13 Making the envelope ▶
Draw the outline of the envelope on to black paper using a ruler, set square and compass. Black paper is easily marked so handle it carefully and use a guard sheet between the bone folder and paper when folding along scored lines.

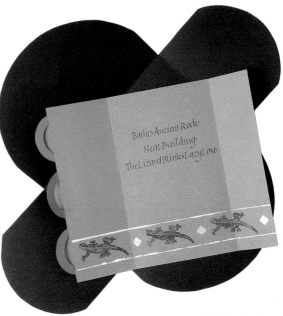

14 The finished card
This illustration shows the opened-out card. It will be held closed by the three tabs on the left.

▶

▲

12 Gilding the diamond shapes
Repeat the process in Step 11 to gild the diamond shapes. Print the lizard between the diamonds. When

paint and glue are used in close proximity, gilding should be done first as breathing on to the glue could reactivate the gum-arabic binding

medium in gouache and the gold might stick to the painted areas.
Fold and crease (but not too sharply) the card along the score lines made in Step 6.

◀ **15 The finished envelope**
Use a sharp knife to cut the slits shown on the template. The card can be closed with one semi-circle showing but is best with three, as in the illustration on page 72. The card lies in the envelope's centre. The flaps are folded in — left, right, top, bottom. The semi-circles hold it closed.

This project has shown:
• How to create a design with a rubber stamp.
• Gild curved and diamond shapes.
• Make an envelope.

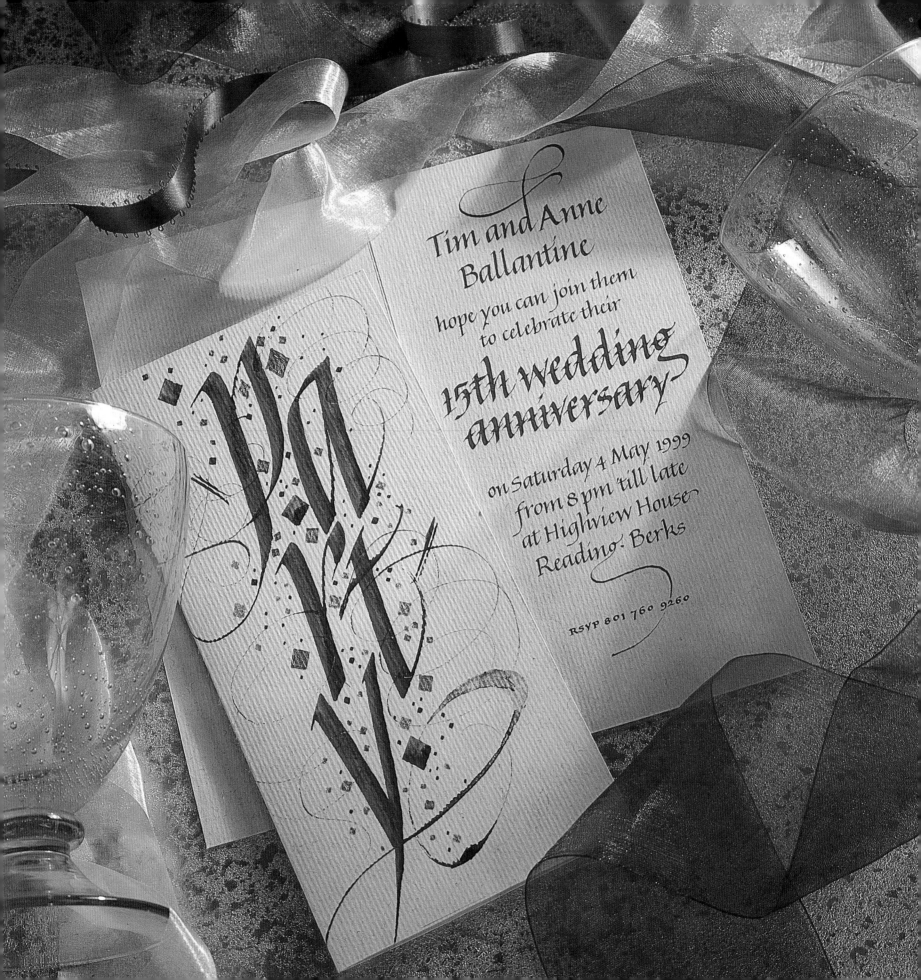

Tim and Anne
Ballantine
hope you can join them
to celebrate their
15th wedding
anniversary

on Saturday 4 May 1999
from 8 pm 'till late
at Highview House
Reading. Berks

RSVP 801 760 9260

Invitation;
Jane Addison
Gouache and gold on
textured paper
21 x 9.8 cm (8 1/4 x
3 7/8 inches)

AN INVITATION: COLOR AND FLOURISHES

Invitations can be conventional or they can allow the calligrapher to let his or her imagination run riot. One to a traditional wedding calls for a formal design, usually a centred format with an appropriate script. Less conventional invitations may combine decorative motifs with the lettering. Others may lack decoration but create a sense of celebration by the imaginative use of letterforms. In the case of a children's party an invitation can be highly colorful to attract a child's eye; one to an adult party is probably more subdued but can still be attractive and unusual. The first step is to make the following decisions:

• The kind of envelope that will be needed.
• How the words will be arranged.
• Whether the invitation will be a single card or have one or more folds so that it is freestanding.
• The shape of the invitation: vertical or horizontal.
• Whether it will be reproduced in quantity or handmade.
• Whether it will include decoration.

Once these decisions have been made it is possible to decide on the script, colors and paper.

If the invitation is to be reproduced do the artwork in black and white and prepare it for the printer (page 85). It can be printed in one color or in two (which is more expensive and may involve doing separate artworks for each color). Or it can be printed in one color and another can be added by hand.

This project is an invitation to a wedding anniversary party, but its basic components — words and decorative motifs — can also be applied to greeting and Christmas and New Year cards.

Equipment

• Papers: Textured paper (blue); layout paper.
• For writing and illustrations: Square-edged nibs; automatic 3A pen; blue and red gouache paints; gold and silver felt-tipped pens or inks or gouache.
• Basic equipment.

A t the time I was asked to design this invitation I was working on one to a children's party — and adapted elements in my thumbnail sketches for use in the wedding invitation.

I used an A4 (11 5/8 x 8 1/4 inch) sheet of blue, textured paper. It can be folded into quarters or one-thirds, both of which will fit into standard envelopes. The word 'party' does not fit comfortably into the quarter shape so I used the one-third one. As the invitation was to be handmade I was able to use blue and red gouache paints for the lettering. I added gold and silver dots on the outside and linked the inside to the outside by dotting the words 'wedding anniversary'.

2 The inside ▶

Experiment with weights, sizes and scripts for the inside of the invitation. Work on layout paper and use different-sized nibs. I decided to write the words in Italic script using small and medium square-edged nibs.

Now do a rough paste-up (see page 52 and Interlinear Spacing, page 58). The spacing will need adjusting and refining but you will have something visual to work from.

▲

3 The cover

The size of the lettering for the cover is important as it has to fit into a predetermined format and it is worthwhile taking time to experiment on layout paper until you achieve the desired effect.

In this illustration I am using an automatic 3A pen and trying out scripts and combinations of colors.

◀ **4 The lettering**

I decided to do the lettering for the cover in Italic, emphasizing the p and y with flourishes, and added diamond-shaped motifs.

This is the time to decide on the paper to be used as this will determine the color of the lettering. I chose a textured blue paper and wrote with the automatic pen filled first with indigo blue and then red gouache paints. Combining colors will not give you total control — but it will create interesting patterns.

1 Thumbnail sketches

Make thumbnail sketches of the inside and outside of the invitation. I used the cover of one of the children's invitations and the inside of another.

5 Refining the lettering ▶

The color of the lettering in Step 4 seemed rather sombre so I decided to use a mixture of pure ultramarine blue and primary red gouache paints, and worked on creating a design with the letters and flourishes.

Watch points
When working freely like this always take care that the letters are not placed too close together, as they are in this illustration. And remember to determine the grain of the paper (see page 60). It must run from head to tail. I did not do this and had to make a few more attempts at writing with the grain in the right direction.

6 The final paste-ups ▶
Do final paste-ups of the inside and the cover. After completing the one for the inside I wrote on the textured paper. I decided to reduce the space between 'anniversary' and the date and between 'to celebrate' and '15th wedding' and to move the RSVP upwards. I then added the dots above and below the main lettering. At this stage it is important to check that all the elements on the cover and inside of the invitation work as a whole.

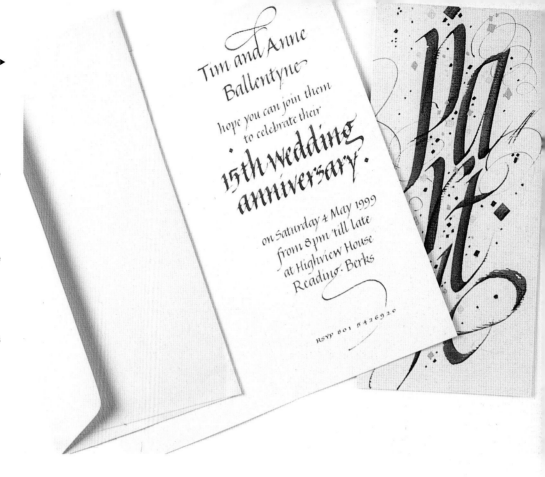

◀ **7 Finishing the cover**
Carefully copy the lettering from your final paste-up. In this illustration I am putting on the gold and silver dots. Use felt-tipped pens or gold and silver inks or gouache for this.

The finished piece ▶
This shows how the various elements on the inside and outside of the invitation complement and balance each other.

▼

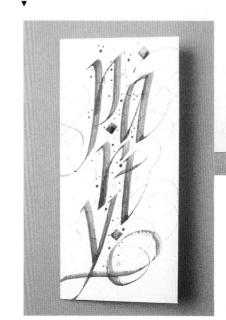

8 Finishing the inside ▶
Rule up (see page 60) the inside of the invitation and copy the lettering from the final paste-up.

This project has shown:
• How to begin using flourishes.
• Add pen decoration.
• Combine cover and inside words.
• Combine colors within a pen.

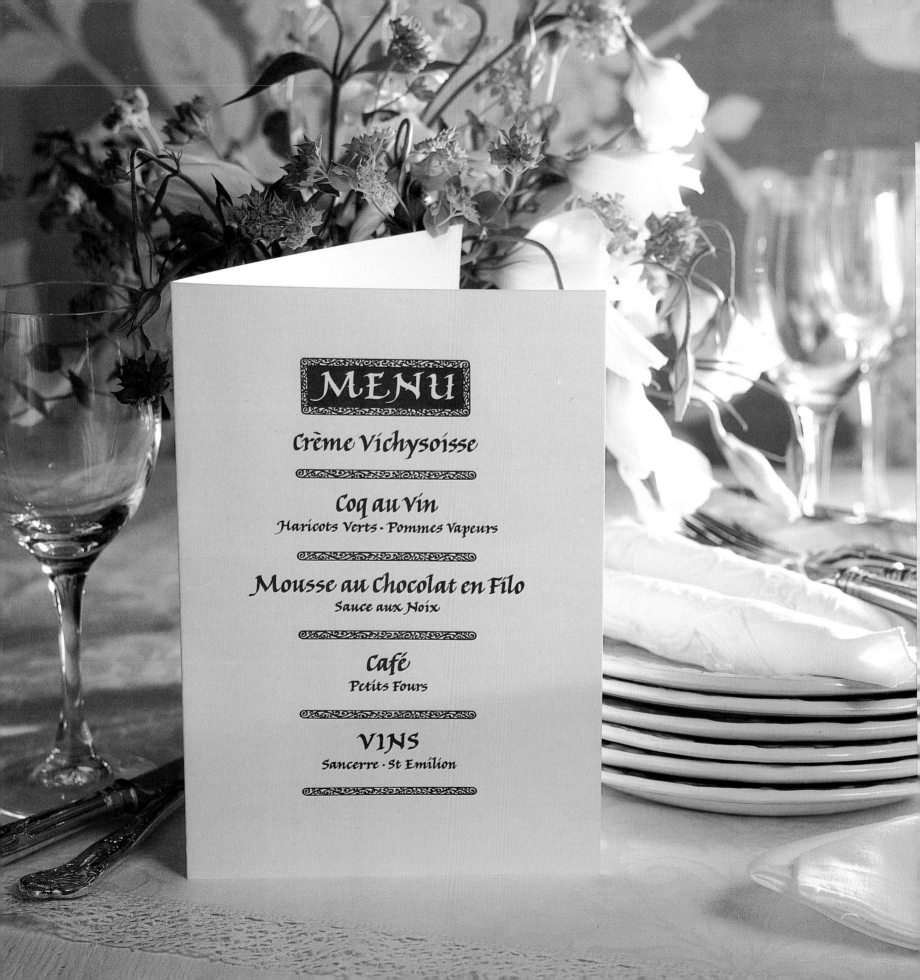

A DINNER MENU: SPACING AND DECORATIVE MOTIFS

A menu card;
Rod Edwards
Pen lettering printed
on cream card
A5 (2l x 14.7 cm/5 7/8
x 8 1/4 inches)

A menu card can be formal and written in a formal script or it can
be relatively informal. Whatever the design the menu must be
clearly laid out and easy to read and, although it is essentially a
listing of names, this legibility requires careful analysis of the
groups of items. The way in which space is used is important, as
are the sizes or weights of letters and their color. Decorative
motifs may or may not be included and are another design
element that must be carefully considered. They can vary from
lifelike drawings to geometric motifs or the decorative bars used
in this project.

Whether a menu card is to be formal or informal
a number of facts must be taken into
consideration before starting work.
- The occasion when the menu will be used.
- The number of courses in the meal — and often
the dishes within each course.
- The size and shape of the menu card.
- Whether it will be reproduced in quantity or
made by hand.

The menu in this project was designed for a
small party of a dozen people celebrating a
birthday in a restaurant. I decided to reverse out
the 'menu' title — a process that requires access to a photocopier
with a reverse function —in order to attract the eye immediately
to the heading. Because each guest was to have his or her own
menu card I produced artwork which I sent to a commercial
printer. The menu lettering is in black but the colors in which a
card is to be printed can be specified.

Equipment
- Papers: 250 gsm (125 lb) cream card; A4 (11 5/8 x 8 1/4 inch) layout paper; 250 gsm (125 lb) white board.
- For writing and illustrations: Pre-mixed Chinese stick ink; black and white gouache; square-edged nibs; fine brush; ruling pen; technical pen.
- Basic equipment.

Fvrom the beginning the format I considered for the menu card was a centred one. I do not like the overall look of complete decorative borders nor do I like realistic illustrations such as flowers, a table with wine glasses, etc. combined with calligraphy. I therefore decided to separate the courses on the menu by using fairly abstract decorative bars. Interlinear spacing and the relative weights of the lettering and bars were all-important in being able to create the right overall effect.

The finished card is A5 (8 1/4 x 5 7/8 inch) size but I worked on A4 (11 5/8 x 8 1/4 inch) paper which has the same proportions until the project's final stages.

The menu is on 250 gsm (125 lb) cream card with Italic lettering.

◄ 3 The paste-up
Photocopy the decorative bar several times. Write 'menu' with a No. 1 nib and put it into a doodled decorative box. Decide on the reductions for the different elements. I reduced 'menu' to 58 % of its original size and the text and decorative bars to 65%. Cut out the different elements and do a paste-up (see page 52) on an A4 (11 5/8 x 8 1/4 inch) sheet of layout paper. The line spacing has so far been done by eye so it is necessary to measure the space between lines and take an average in order to measure and rule the exact spacing.

▲
4 Checking the design
Do reductions of the paste-up to check the effect of the design when on A5 (8 1/4 x 5 7/8 inch) paper.

5 Adding emphasis
Inking out the background to the box shows how reversing out 'menu' will attract the eye to the word.

▲
2 The main elements
Write out the main and secondary elements of each course in pre-mixed Chinese stick ink. I used a No. 2 nib for the main ones and a No. 3 for the others. This gives the right contrast of lettering. Then doodle the decorative bars between them with a ruling pen. They should be roughly the same height as the No. 3 nib writing. Finally, sketch in the menu box.

Try the rough at several different reductions as shown here.

1 Preparing a rough
Do a rough on A4 (11 5/8 x 8 1/4 inch) paper and select a script — I used Italic. This shows my final rough..

7 The menu box
Reverse out 'menu' on a photocopier, then cut photocopies of the decorative bars and use them to make a frame for the box. Cut out the reversed word 'menu' and paste it into the frame. Black out any white that may show around the cut-out with a fine brush and black gouache

8 The lettering
Rule up (see page 60) and then write the lettering on layout paper. Keep as close as possible to the writing on the paste-up (Step 3). Measure the height of the rough lettering and keep an eye on the length of line, height of ascenders, etc when you are doing this so that nothing differs too much. As this will be photocopied and reduced you can write out the words several times and cut and paste the best ones for the final artwork.

6 The decorative bars ▶
Do the decorative bars on layout paper with a technical pen, trying to keep as closely as possible to the rough. You may have to touch it up several times before you are satisfied with it. Use black and white gouache and a very fine brush. Make five photocopies.

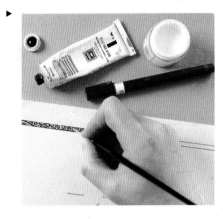

9 The finished artwork
Start by checking the measurements of the spacing on the rough paste-up again. Indicate these and a centre line on the layout sheet. Then paste up the lettering and decorative bars on an A4 (11 5/8 x 8 1/4 inch) sheet of layout paper. Paste up the menu box on a separate sheet.

Reduce this artwork by the amounts decided on in Step 3.

For the outside of the menu place two of the decorative bars at the same distance from the top and bottom of the card as the top and bottom bars on its inside. Use layout paper and centre the bars horizontally within the area of the menu card.

10 Preparing artwork for printing
Paste up the artwork in position on 250 gsm (125 lb) white board within actual-size margins. Do two separate sets of paste-ups, one for the inside and one for the cover. Add trim marks and a score mark (which the printer will score along to make folding the cards easier). White out all marks, pencil lines, etc.

Specify a color if you wish and decide on a paper — I chose a 250 gsm (125 lb) cream card.

▼

This project has shown:
• How to group lettering and decorative elements.
• Use a photocopier as a tool.
• Prepare artwork for printing by a commercial printer.

Garden Journal

EX·LIBRIS EX·LIBRIS EX·LIBRIS EX·LIBRIS

Herb Garden

Thyme

Thymus vulgaris

Rosemary

Rosmarinus officinalis

A Garden Journal: Combining Lettering and Illustrations

A Garden Journal;
Anne Cox
Gouache on mould-made paper; cover in handmade paper
Page size 25 x 17.5 cm (9 3/4 x 7 1/4 inches)

A handmade book is a pleasure to make, to handle and to receive and the idea of a garden book, in particular, is very appealing. It may contain general gardening information, garden plans, poetry or lists of plants and can be a small single-section (eight-page) book or a larger multi-section one. It may be illustrated with drawings, paintings, rubber stamps or patterns. Whatever its size and contents it is always important to ensure that the cover and inside pages form a harmonious visual whole with the balance of text, illustrations and space remaining consistent throughout the book. Before starting work it is important to decide on:

- Its extent — the number of pages it will contain.
- Whether the format will be horizontal or vertical.
- The proportion of illustrations to text.
- Whether a bookplate will be included.

For this project I decided to make a simple single-section book for listing plant details in a garden and to personalize it by including a bookplate. The same basic method of working could be used to make a book for listing personal details, an album or even an illustrated address book or a simple diary.

You will need a fairly lightweight paper for the text pages. Test its suitability by folding a piece in half and holding it along the fold. It should bend over gently and be neither too limp nor too rigid. If both sides of the paper are to be written on test both sides to see if the text shows through. The cover is generally made of a heavier weight paper.

Equipment

- Papers: 90 gsm (45 lb) mould-made papers; handmade paper; layout paper; card.
- For writing and illustrations: Gouache paints; square-edged nibs; pointed nib.
- Basic equipment plus: Bulldog clips; needle; linen or embroidery thread.

I decided that the journal should be in a vertical format and used a creamy 90 gsm (45 lb) mould-made paper for the inside of the book and a heavier handmade paper containing plant material — which seems appropriate for a garden journal — for the cover. Its greeny-brown hue blends well with the text paper. I used a complementary shade of the text paper for the endpapers.

The illustrations and writing are in gouache paints. The journal is sewn as a single-section book.

I was careful to make sure that all the aspects of the book — text, illustrations, text and cover paper and the shape of the book itself — related to each other.

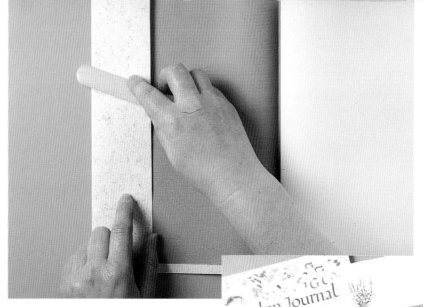

◀ 2 Folding and creasing
Cut and fold the pages using the final papers for the inside and cover. Determine the grain of the paper (see page 60) and make sure it is running from head to tail of the page. Make the cover slightly deeper than the text pages at top and bottom and about one-third wider than the text pages at the sides to allow for a flap to be folded in and creased. Use a sharp knife and metal ruler to cut the paper on a cutting mat.

Fold each sheet in half (see page 60) and slip the sheets into each other.

Use a bone folder in order to crease the paper.

3 Deciding on the script and illustrations
Try out different scripts on layout paper until you find one that you feel is suitable for the journal — I decided on Foundational for the cover and Italic and Foundational for the text pages. And experiment with the illustrations. Make sure that the writing and illustrations are in proportion and look balanced on the page. Try out a variety of different colors for the script on spare pieces of your final paper.

The writing throughout the book is created by color changes in the pen.

1 Deciding on a format
Sketch pages on layout paper, decide on their size and number them. Make a mock-up with your final paper.

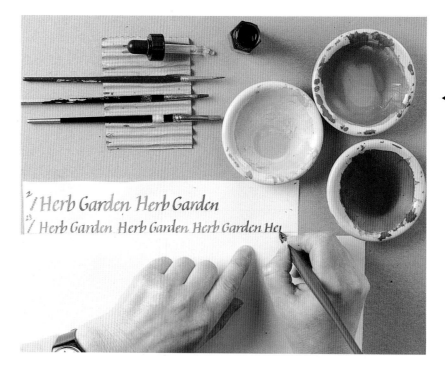

◀ 4 Creating color changes
Load your chosen colors randomly into the nib and reservoir using a different brush for each color. This allows the colors to mix together within the reservoir. I used three colors — green, yellow and dull red gouache mixed with water — in three separate containers. Experiment by writing on pieces of the final paper. Try not to start a new word with a newly loaded color.

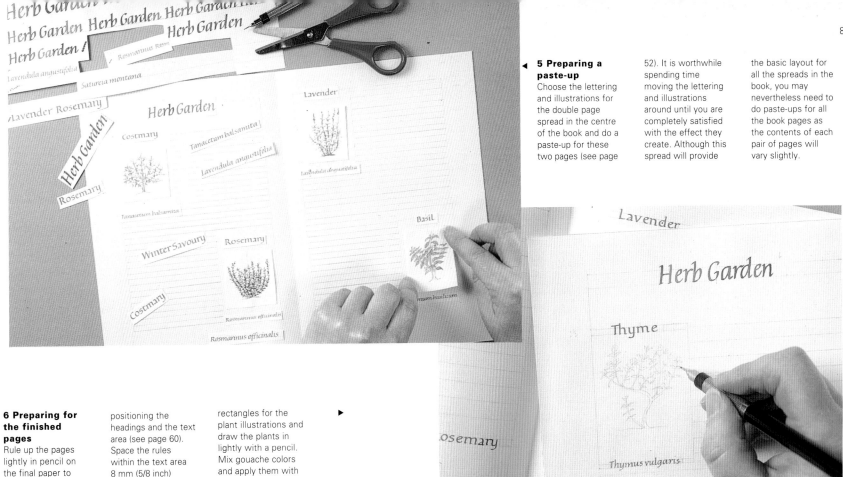

◀ 5 Preparing a paste-up
Choose the lettering and illustrations for the double page spread in the centre of the book and do a paste-up for these two pages (see page 52). It is worthwhile spending time moving the lettering and illustrations around until you are completely satisfied with the effect they create. Although this spread will provide the basic layout for all the spreads in the book, you may nevertheless need to do paste-ups for all the book pages as the contents of each pair of pages will vary slightly.

6 Preparing for the finished pages
Rule up the pages lightly in pencil on the final paper to provide guidelines for positioning the headings and the text area (see page 60). Space the rules within the text area 8 mm (5/8 inch) apart. Draw pencil rectangles for the plant illustrations and draw the plants in lightly with a pencil. Mix gouache colors and apply them with a pointed nib. ▶

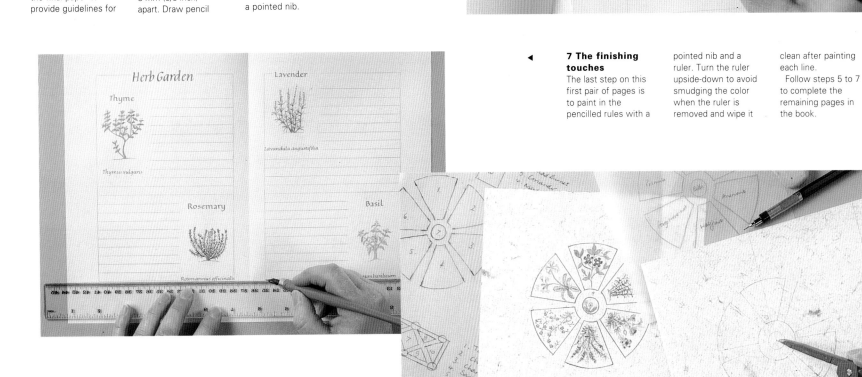

◀ 7 The finishing touches
The last step on this first pair of pages is to paint in the pencilled rules with a pointed nib and a ruler. Turn the ruler upside-down to avoid smudging the color when the ruler is removed and wipe it clean after painting each line.
 Follow steps 5 to 7 to complete the remaining pages in the book.

8 Designing the cover
Prepare a rough for the cover following the guidelines for the text pages paste-up. In this case the lettering and the illustrations are vertically centred (see page 52). Use a compass and a pencil and tracing paper to trace the design until it is right. Go over the pencil with green gouache and a pointed nib. ▶

9 Finishing the cover ►
Draw the main characteristics of each plant in light pencil; then paint them in with the gouache colors that are suitable for the plants you are illustrating. Use a pointed nib.

◄ **10 Preparing the bookplate**
Start by doing thumbnail sketches for the bookplate. I decided to create a square with the words, creating a space within which to place a plant. Follow the previous guidelines for preparing a paste-up. Remember that the lettering and illustrations should relate to the script and illustrations within the garden journal.

11 The finished bookplate
Use the gouache colors mixed with water that you used in Step 4 for the words and suitable gouache colors for the plant illustration. Use a pointed nib for the illustration and a square-edged one of a suitable size for the text. Add a line of watery green gouache for the owner's name. Paint the border in the same green using a square-edged nib against an upturned ruler.

Make sure all the writing and illustrations are throroughly dry and then rub out the guidelines.

12 Preparing for sewing the book
Now prepare the endpapers — which should be a complementary shade to the text paper. Fold all the pages and arrange them in order inside the cover with the endpapers.

Open them up to the centre pages and hold them steady with bulldog clips.

▼

▲

13 Marking the sewing stations
Take a piece of paper or card the same height as the book page, lay it along the centre fold and mark its centre point. Mark four other points, two on either side of the central mark, so that they are evenly spaced and within the text area. Using these as a guide prick these five sewing stations along the centre fold with a needle.

Make sure the needle goes through the centre fold to the spine of the cover when you do this.

◄ **14 Sewing the book**

Thread the needle with linen thread or embroidery thread and, leaving a 10 cm (4 inch) thread inside the book, take the needle through the central hole. Bring it back in at the first hole below it and out at the bottom hole. Bring the needle in at the hole above the bottom hole again, and out at the hole above the central hole. Bring it in at the top hole, out at the hole below and finally in at the central hole.

15 Tying the knot

Tie the ends of the thread together in a knot. Trim the ends so that they are about 1 cm (3/4 inch) in length and, using the point of the needle, fray the ends of the thread.

▼

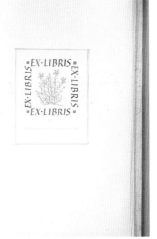

▲

The finished bookplate

The book opens to the endpapers with the bookplate on the first page providing a visual introduction to the text.

The finished book inside ►

The text pages are designed to look pleasing from the start — both before and after they have been filled in with the gardener's notes.

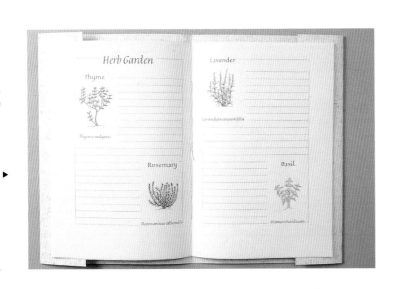

◄ **The finished cover**

The edges of the cover have been folded in over the endpapers. This gives the cover a more substantial and softer foredge than it would have if the cover paper was simply trimmed to size.

This project has shown:

• How to combine drawings, text and space.
• Make a bookplate.
• Sew a single-section book.
• Make a simple, folded paper cover.

A golf certificate;
Richard Middleton
Indian ink and
gouache on
watercolor paper
37.5 x 21 cm (14 5/8
x 8 1/4 inches)

A GOLF CERTIFICATE: CENTRING LETTERING AND USING COLORS

Calligraphers are often asked to produce certificates and commemorative presentations. The work involved can vary from simply writing names on pre-printed blanks to designing an entirely original calligraphic piece, one that reflects a sense of occasion. There are, inevitably, constraints in creating a formal work like a certificate: its function and the words to be used are already pre-determined. Nevertheless, most calligraphers enjoy doing a plain, straightforward layout and inevitably bring a sparkle of originality to the piece.

Before starting work on a certificate — which is generally a commissioned piece of work — it is essential to discuss it with the client; and although the details of method and design tend to develop during the working process it is sensible to agree on:

• The shape and size of the certificate.
• Whether it will be illustrated.

The certificate in this project was for a golf club and it was important to balance the title with other elements in the design such as the heraldic motifs and border. When working on a commissioned piece it is also essential to work with the client keeping him or her informed of any changes you may wish to make.

Although this finished piece has been framed and mounted the basic method of working can be used for a formal scroll — for the presentation of an academic award, for example — or even for the prize card at a local agricultural show.

Equipment

• Papers: Cream 220 gsm (90 lb) hot-pressed watercolor paper; layout paper.
• For writing and illustrations: Non-waterproof Indian inks; gouache; steel nibs.
• Basic equipment.

There are obvious constraints on shape and size in a project like this, but these apart it is almost impossible to prescribe what will work. Although I decided on the script — Foundational — at the start, other elements changed as the certificate developed. I decided, quite early on in the project, that my initial choice of greens and grey for the text would not work on the brown of the paper so changed to a creamy white 220 gsm (90 lb) hot-pressed watercolor paper. I later changed to red and black inks for the text and added a border for increased formality — which in turn resulted in using golf flags instead of green elm trees as decorative motifs.

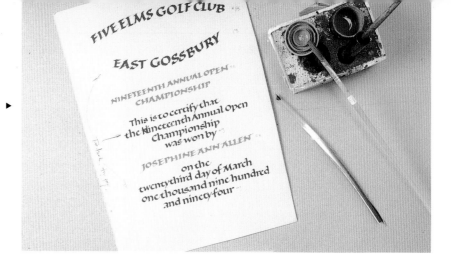

2 The first draft
Experiment: pick up any size pen, any color ink and any paper and, without ruling lines, write the words out positioning them as best you can. I used black ink because it was to hand and green because it seemed a natural color for a golf certicate.

I used a tan print-making paper at this stage. However, black is very dominant and, as the illustration shows, it was immediately obvious that it would have to be lightened. I therefore decided to use grey ink instead of black.

1 Thumbnail sketches
Make pencil sketches of how you imagine the final piece may look.

3 Color trials
Continue experimenting with colors. I tried various grey and green gouache paints and different sizes of nib. Putting down more or less of the color affects how much the white space inside the letters dilutes the impact of the color. Because the white space has this effect you can never make final judgements without doing some actual writing although initial trials can be made by comparing different mixtures of gouache by painting them in blocks on the paper. I eventually found a nice tonal balance of green and grey.

Colors change as they dry so wait for about 30 minutes before making an assessment. Keep a record of how much of each color is in each of the mixtures

4 Starting to write
Rule up carefully (see page 60) on a sheet of your final paper placing the lines equally about a centre vertical line and start to write out the words in the colors you have chosen. I used quills cut to the equivalents of 2 mm, 1.25 mm and 0.5 mm steel nibs. At this stage I changed the brown paper, which did not work with the greys and greens I had selected, for a creamy white 220 gsm (90 lb) hot-pressed watercolor paper.

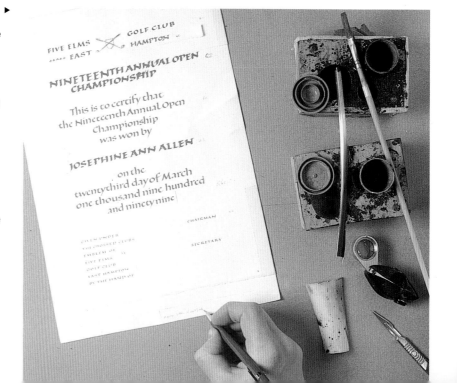

5 The border and heraldry ▶

At this stage I realized that the green lettering did not have enough impact so I decided to replace it with red and wrote the rest of the lettering in black. The trees at the top (see Step 4) now looked out of place so I used golf flags — in a different position — instead.

I also repositioned the name of the golf club. It had read as one line when it was in green and grey but black writing means that the elements on either side of the crossed club device are read separately.

To add the border, use the nib you used for the main writing and make it slightly wider than the bulk of the text but shorter than the longest line so that it 'frames' the writing. The small heraldic motif is drawn simply with a small nib.

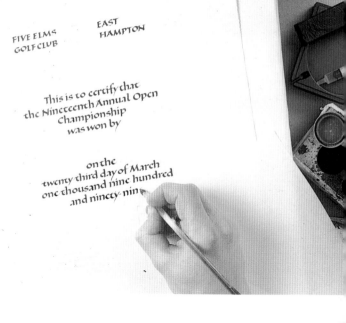

▲

6 Writing the piece

Rule up (see page 60) on your final paper and write the finished piece. Do all the lettering of the same size at once rather than changing pens every few lines. This keeps the flow going. A guard sheet protects the surface of the paper from the natural grease of your skin.

◀ 7 Choosing a mount and frame

If you are having your work framed and mounted remember that this can either make or ruin a piece of work. I put the finished certificate against an already framed piece of work to see how the colors would respond. I decided to use the same framing material with a darker mount.

◀ 8 Setting the margins

Set the margins (see page 53). In this project the centre line has become displaced a fraction to the left as the final writing varied from the rough slightly. Let your eye be the final judge of the margin positions. And it is always safest to err on the side of wider, rather than narrower, margins.

This project has shown:

• How to use a title as part of a design.
• The use of decorative motifs with a title.
• How to frame text with a border.
• The importance of margins when framing and mounting a piece of work.

STATIONERY: COMBINING A MONOGRAM AND LETTERING

Stationery;
Rod Edwards
Pen lettering printed
on white laid paper
Letterhead paper: A4
(29.5 x 21 cm/11 5/8
x 8 1/4 inches)

Whether stationery is commercial or personal it needs to have an 'atmosphere' that conveys a clear image of the business or person concerned. For this reason designing a letterhead and its matching envelope and business card can be an intriguing challenge for a calligrapher. An old-established firm of lawyers could call for the use of conventional and formal letterforms; Italic script would suit an antique dealer; an advertising agency might demand something relatively unconventional. Personal stationery, like the letterhead, envelope and business card in this project, can be even more informal.

Whatever the ultimate 'character' of the stationery, a number of facts must be considered before starting work on its design.
• The position of the words (and logo or monogram) on a sheet of paper must allow enough space for correspondence.
• The size of the paper and position of the design must look comfortable when folded into an envelope.
• Whether correspondence will be handwritten, typewritten or printed out from a computer.

The stationery in this project has a monogram of the client's initials as a logo and this is repeated on the business card and the envelope. Both the letterhead paper and the envelope are standard sizes and the card is the size of a credit card. I produced artwork for a commercial printer; if you wish, a color in which the stationery is to be printed can be specified.

Equipment
• Papers: 100 gsm (50 lb) white laid paper; 250 gsm (100 lb) paper; layout paper; A4 (11 5/8 x 8 1/4 inch) paper; tracing paper (optional).
• For writing and illustrations: Pre-mixed Chinese stick ink; white and black gouache paints; square-edged nibs; fine brush.
• Basic equipment.

I wanted the design to feature the initials in the form of a monogram and also to incorporate the full name and address on all three elements of the stationery: the letter-head, envelope and business card. I also wanted the overall effect to be fairly bold.

The monogram presented a challenge as I wanted to create a design that is fairly busy, dynamic and full of movement, but did not want something with standard calligraphic flourishes.

The paper for the letterhead is A4 size (11 5/8 x 8 1/4 inches) and the envelope is 110 x 220 mm (4 3/8 x 8 6/8 inches). I made the shape for the business card by drawing around a credit card.

2 Deciding on the script

Now decide on the script for the name and address.

I used a solid Italic with no flourishes etc. that will contrast with the movement in the monogram.

▼

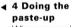

▲

3 Judging the balance

Do some doodles for the monogram (see the background of the illustration), cut them out and put them against the name to judge the textual relationship. I used pre-mixed Chinese stick ink throughout and wrote the monogram and name with a No. 2 nib and the address with a No. 3. I work at a comfortable size and reduce or enlarge to fit the required space.

◀ 4 Doing the paste-up

When you are happy with the balance between monogram and text, cut out the different elements and roughly paste them down (see page 52) at what seems to be the correct spacing.

Reduce the paste-up on a photocopier and try a variety of reductions until you find ones that suit the letterhead, envelope and card. I found that a 50 % reduction fitted well into the space for the card, so all I had to do was stick the paste-up at its original size into a box double the size of the credit card. I reduced the letterhead by 75% and the envelope by 62.5%. Whatever the reductions, the boxes must be sizes that will reduce down the same amount as the artwork to give the required sizes.

1 Thumbnail sketches

Do thumbnail sketches for the name, address and monogram. Make sure all three elements are balanced and in proportion.

5 Finalizing the lettering ▶

Practise writing the name, using a top and bottom writing line that gives you the same height letters as on the paste-up, until you have a version you are happy with. I used a No. 2 nib. Rule up (see page 60) and write your chosen lettering on layout paper. Do the same with the address.

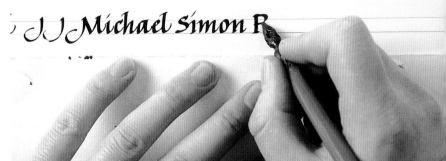

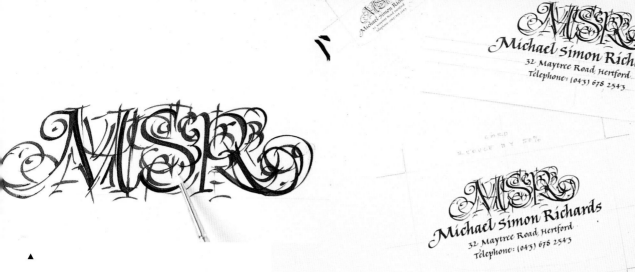

▲

6 Finalizing the monogram
Draw the monogram on layout paper — I used the No. 2 nib —

then touch it and the lettering up with white and black paints and a fine brush.

◄ 7 Finalizing the artwork
Paste up the finished monogram and lettering on layout paper. Take measurements from the paste-up (see Step 4) and follow these as closely as possible.

▲

8 The letterhead and envelope
Resize the artwork for the envelope and letterhead on a photocopier using photocopier paper. Make the reductions decided on in Step 4. Paste these on to white 250 gsm (125 lb) board, following the positions on the paste-ups.

9 The business card ►
Take the original artwork and photocopy it on to photocopier paper. Draw a box of the required size on the white board and paste the photocopy into the box.

▲

10 Preparing artwork for the printer
Add trim marks to all three items and white out the pencil lines with white paint and a fine brush. Give the printer instructions on the amount by which each item must be reduced and specifiy color or colors if needed.

If you want to print in more than one colour, put a tracing paper overlay on to the artwork to show the colors of the different parts of the

piece. The letterhead is on white laid 100 gsm (50 lb) paper and the envelope is on matching paper. The card is printed on 250 gsm (125 lb) weight of the paper.

This project has shown:
• How to design a monogram.
• Make a harmonious whole of three different elements.
• Visually adjust the scale and position the artwork for each of the elements.

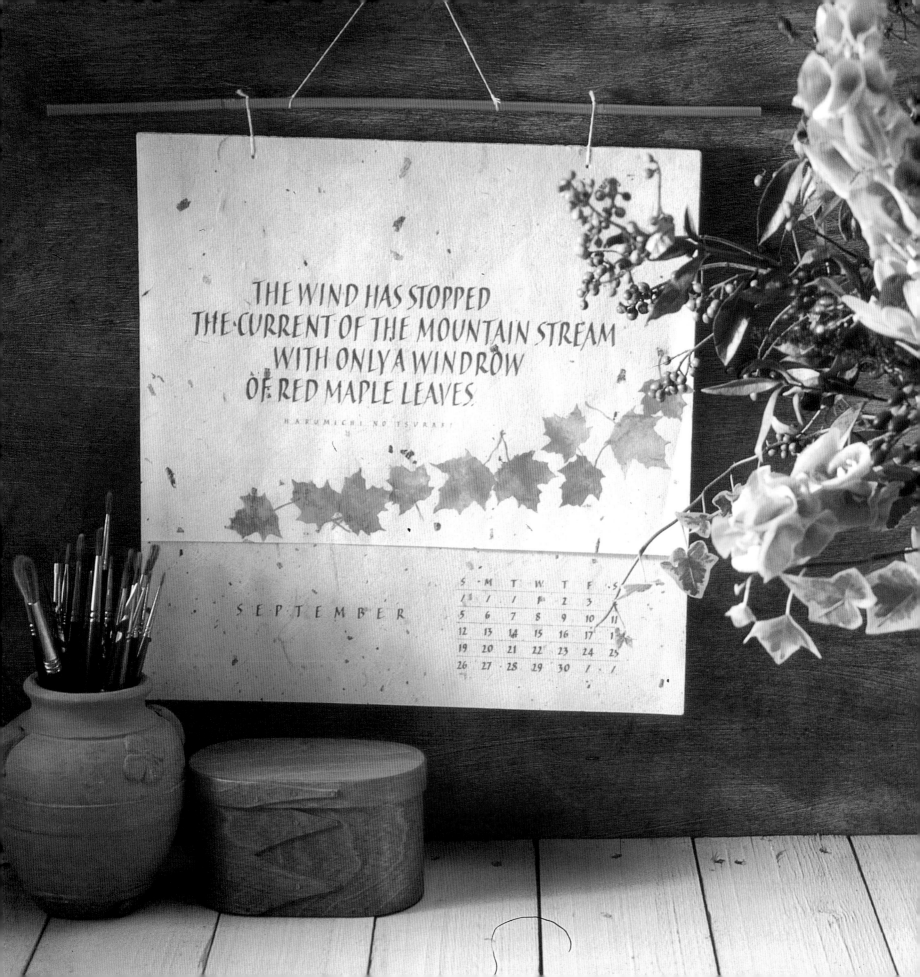

A Seasonal Calendar;
Lindsay Castell
Gouache and collage
on handmade papers
30 x 30 cm (11 5/8 x
11 5/8 inches)

A Seasonal Calendar: Numbers and Quotations

A calendar can be very simple or it can be a complex example of calligraphic skills. At its most basic it could be largely numerical with the names of the months emphasized in color or with decorative motifs, or with just one piece of calligraphy for the entire year. At the other end of the scale there could be a different piece for each month. And, of course, the complexity of the illustrations or decorations is up to the calligrapher.

There are, nevertheless, some fundamental decisions to be made in order to achieve a balance between its functional and decorative aspects.

• Where the calendar will be used.
• Who will use it.
• Whether it will be viewed from a distance — or from close by.

Once these decisions have been made the theme of the calendar can be decided. It could be based on the months or seasons of the year; it could be a collection of quotations from a favourite author. If you decide to use quotations they will need to be treated appropriately in terms of calligraphic style; and if you combine them with illustrations or decorative motifs these — and the materials you use for them — must blend with the calligraphy.

For this project I decided on a calendar of medium complexity, with one piece of calligraphy for each of the four seasons. I decided to use Japanese poems for the quotations; you could use verses from a long poem or quotations on a theme like the natural world. The basic method of working is the same.

Equipment

• Papers: Japanese handmade papers; Indian handmade repair tissue; layout, cartridge and tracing paper; thin card; kitchen paper.
• For writing and illustrations: Square-edged nibs; No. 5 soft brush; gouache paints; scalpel.
• Basic equipment plus: Embroidery silk; bamboo rod; leatherworker's punch; tweezers.

My first decision was to divide the calendar into four seasons of three months each and to divide each month of the calendar into two elements: a decorative overlay with a quotation and decoration that reflected its season, and, below, the numerical part of the calendar. I decided to make a cover and, because the quotations are Japanese poems, I designed the whole calendar — format, construction, layout, materials and decorative motifs — to give an oriental feel. The decorative overlays are separate from the numerical parts so they can be re-used — only the dates and month names will need to be re-written.

2 Thumbnail sketches
Make sketches of design ideas for your calendar. Decide on the treatment of the quotations, the balance between function and decoration, and construction, shape and size. The short poems seemed suited to a horizontal layout and I decided to keep the calligraphic treatment simple. The decorative elements carry through the oriental feel. I wanted the calendar to look attractive from a distance so the overlay finally occupied most of the space. The numerical part is in a pleasing proportion to this and allows easy reading from nearby.

3 Binding trials
Experiment with different types of thread and ways of sewing or threading. Do this on a small scale using inexpensive layout or cartridge paper to start off with, then, when you have come to a decision make a large-scale model with the same paper to make sure that the ▶ calendar works and hangs well. At this stage I decided to use a double thread of embroidery silk for binding and hanging the calendar pages from a bamboo rod. The thread can be easily undone allowing the numerical pages to be removed.

1 Small-scale trials
Trials with small-scale models made from layout paper help to decide the format.

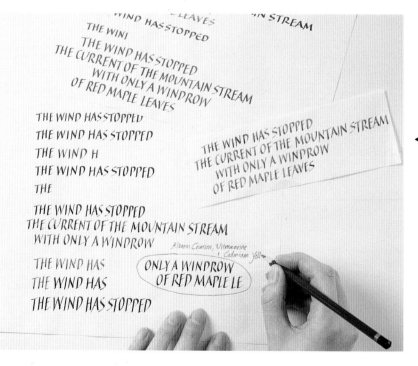

4 Writing style and color
Experiment with different scripts to find which is the most appropriate for the quotations. Use square-edged nibs and various colors of gouache paint until you find the right style and color. I chose narrow, serif-less capitals and plum-colored paint — its tonal strength and color will work well with the maple leaves.

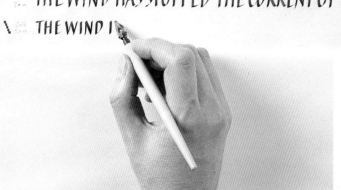

5 Weights and sizes

Now experiment with different weights and sizes of writing (see Weight, page 56 and Interlinear Spacing, page 58). I used No. 2 and 2 1/2 square-edged nibs for the text and No. 6 for the credit. I tried 5-7 nib widths weights of writing, bearing in mind that the text has to work well with the leaves and numerals.

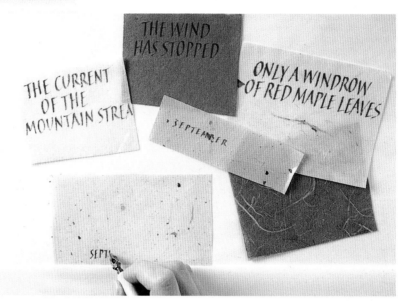

6 Paper trials

When you are using fibrous or textured papers it is important to see how the paint reacts on them as some writing surfaces can be unsuitable for calligraphy. It is therefore worthwhile getting samples of the kind of paper you want to use and testing them before making your final decision. These quotations are written on a Japanese handmade paper.

The one I am writing on in the illustration has an appropriately autumnal feel.

7 Painting paper for collage

Add lots of water to your paints — I was using yellow, orange, red and purple — and use a large, No. 5 soft brush to apply them to some Indian handmade repair tissue. Work carefully — the paper is very thin. I blended the patches of color together but made sure they were not of an even depth — the leaves should look natural.

Put kitchen paper under the tissue to absorb excess moisture. Allow the tissue to dry.

8 Making the leaves

Trace the outlines of your motifs on to tracing paper and then on to the painted, dried tissue paper. I used reduced photocopies of pressed leaves. Put a sheet of white paper under the tissue so that you can see the traced outlines clearly and put a cutting mat underneath the white paper. Use the tip of a scalpel to cut out the motifs with great care. It is useful to make them in a variety of sizes and colors.

9 Writing numbers

The style and size of the numbers must relate to the writing in Step 5. I kept mine narrow and did trials with No. 3 1/2 and No. 4 nibs on layout paper. The numbers can be arranged vertically or horizontally — the space to be occupied and the balance with the calligraphy will help to determine the design. I decided to place them to read horizontally but, either way, white space can be an additional decorative element that helps the eye to travel along a row or down a column. ▶

Emphasize the days of the week by using color, a heavier weight of writing or underlining the row. Paste the numbers down in position on layout paper, along with the month name.

12 Making and using a template

Use thin card to provide a backing for the calendar and use it as a template for the calendar pages. Determine the grains of the card and the calendar papers (see page 60) and make sure they run vertically then cut the card to size. Use the backing card as a template, drawing around it and marking the hole positions with a sharp, soft pencil. Cut the pages out using a metal ruler and a scalpel or craft knife. Use a leather-worker's hole punch to make the holes. Cut the decorative overlay to size.

▼

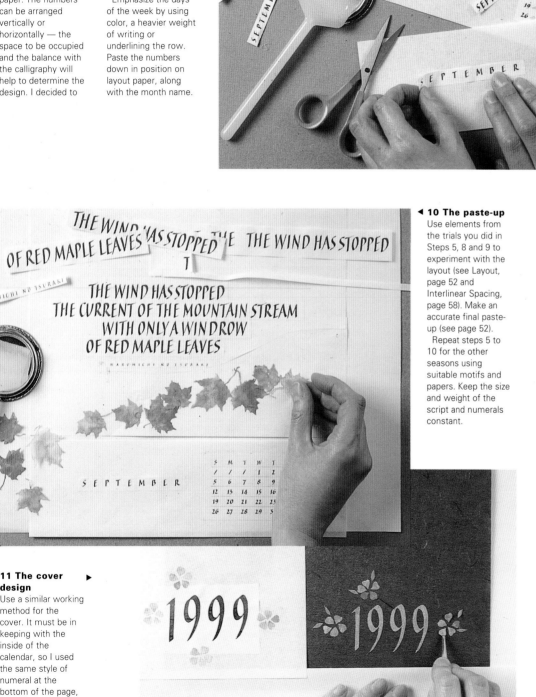

◀ 10 The paste-up

Use elements from the trials you did in Steps 5, 8 and 9 to experiment with the layout (see Layout, page 52 and Interlinear Spacing, page 58). Make an accurate final paste-up (see page 52).

Repeat steps 5 to 10 for the other seasons using suitable motifs and papers. Keep the size and weight of the script and numerals constant.

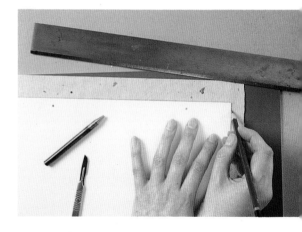

◀ 13 Ruling up

Start by ruling up on the decorative overlay paper (see page 60): cut a piece of cartridge paper to size using the template and, working from the paste-up, mark the line positions for the numerical part along one vertical and one horizontal edge. Place on top of a calendar page, mark off the line positions and rule lines for the numerals. Repeat for each calendar page.

11 The cover design ▶

Use a similar working method for the cover. It must be in keeping with the inside of the calendar, so I used the same style of numeral at the bottom of the page, and used the paper and colors of the spring overlay.

Make a final paste-up for the cover.

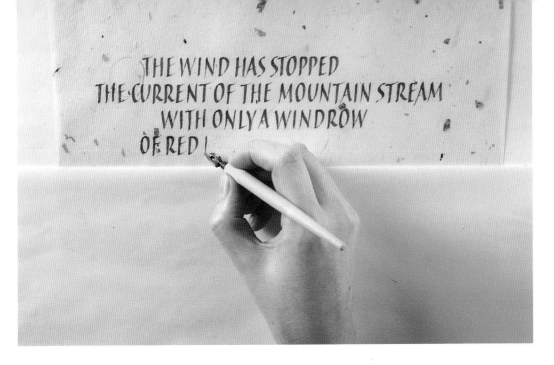

14 The final writing out

Start by doing some warm-up writing using spare pieces of the paper for the decorative overlay and the paint for the finished work and then do the final writing.

The quotation is in the largest writing, so complete this before doing the smallest lettering — the credit. Warm up for the numbers as you did for the quotation.

Complete all the remaining pages.

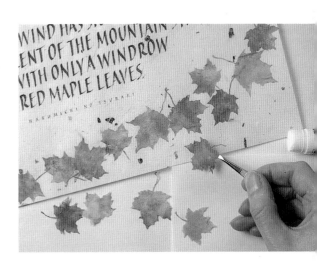

15 Attaching the leaves

Carefully apply stick glue — not liquid glue which might cause cockling — to the back of a leaf. Then, using tweezers, apply the leaf to the paper using your final layout as a guide to its positioning. With your fingers, gently press the leaf on to the background paper. Do this for all the leaves

16 Assembling the calendar

Align the backing card, calendar pages and calendar cover. Bind them together using the doubled thread decided on in Step 3. I used a looped method here because it allows the calendar to be easily undone to remove a page and then done up again. This means that the decorative pages can be kept intact.

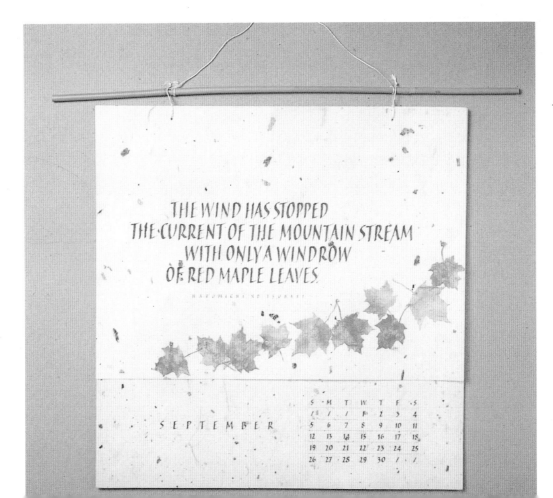

17 The final touch

Push a thin piece of bamboo through the binding loops. Tie each end of a single piece of thread to the bamboo rod so that the calendar can be hung up.

This project has shown:
• How to use numerals.
• Work on textured paper.
• Combine script, illustrations and numerals in one design.
• Make a simple loose-leaf binding.

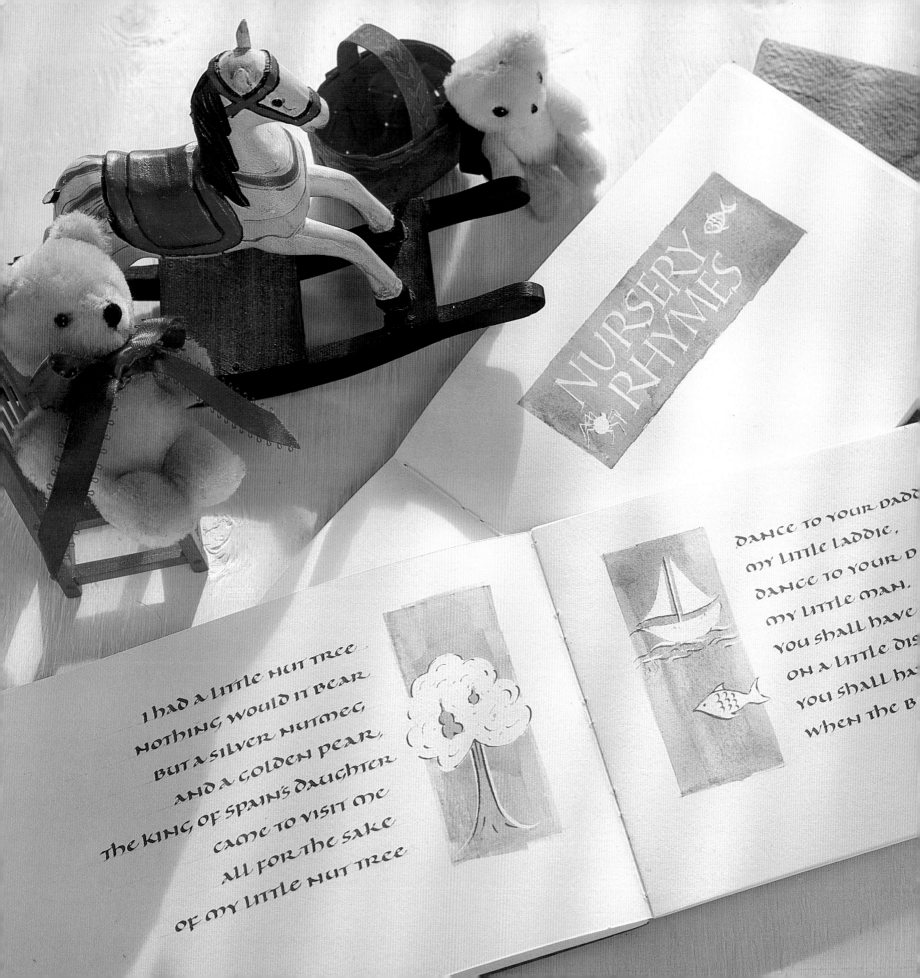

NURSERY RHYMES

I HAD A LITTLE NUT TREE
NOTHING WOULD IT BEAR
BUT A SILVER NUTMEG
AND A GOLDEN PEAR,
THE KING OF SPAIN'S DAUGHTER
CAME TO VISIT ME
ALL FOR THE SAKE
OF MY LITTLE NUT TREE

DANCE TO YOUR DADD
MY LITTLE LADDIE,
DANCE TO YOUR D
MY LITTLE MAN.
YOU SHALL HAVE
ON A LITTLE DIS
YOU SHALL HA
WHEN THE B

MANUSCRIPT BOOK: ILLUSTRATIONS AND BINDING

Manuscript book;
Susan Hufton
Gouache on print-making paper; cover in handmade Indian paper
14 x 21 cm (5 1/2 x 8 1/4 inches)

Pen-written letters evolved as people began to communicate in book form and it is therefore particularly appropriate to use calligraphy to make a manuscript book. In addition, a project like this involves creating a whole object from start to finish — from idea to presentation — and there is something very pleasing about reading and handling a handmade book.

The first step is always to make the following decisions:
• The purpose of the book and who it is for.
• Its form and structure and the type of binding that will be appropriate.
• How it will be read and handled.
• The characteristics of the book.

Once you have determined the purpose, function and nature of the book you can start to consider specific elements: content, order, scale of text and illustrations, space, color and materials. More often than not you will find that decisions about these are made as the work progresses, shaping the book's feel, look and character.

The project on the following pages is a book of nursery rhymes, but the basic method of working can be adapted for a variety of subjects: a long poem, limericks, proverbs, quotations or continuouse prose.

As a starting-point in making this book of nursery rhymes I thought of my own children. The illustrations should keep the attention of my two-year-old, who would have the book read to him, be interesting to my six-year-old, who could begin to read the rhymes himself — and would have to be governed by my limited illustrative skills. The lettering must be clear but not static and color would add interest.

Equipment

• Papers: 270 gsm (125 lb) print-making paper; green machine-made paper; terracotta handmade Indian paper; layout paper.
• For writing and illustrations: Square-edged nibs; gouache paints; masking fluid; balsa wood; soft eraser.
• Basic equipment plus: Ice-cube tray; cotton or linen tapes; smooth plastic-covered board; wrapping tape; weight; thread; beeswax; needle.

I considered making a small, single-section book (see *A Garden Journal*, page 86), but finally decided to make one that consists of four sections each with two folds of paper, which gives enough room for 12-14 nursery rhymes plus the title page and dedication. Blank pages at the beginning and end provide leads into and out of the book. The endpapers are green machine-made paper and the cover is folded from a piece of heavy, textured terracotta handmade Indian paper. The text paper is a soft print-making paper used because it does not cockle when the washes are applied. Each page has a nursery rhyme of six to eight lines of text written in gouache and an illustration drawn in resist with a colored wash over the drawings.

2 Thumbnail sketches

Now make rough sketches of the pages to see how the text and thumbnail sketches fit together. These will give the first indication of what will be the most suitable size and shape for the book and whether it should be single-section or multi-section. The best way to do this is to make a model with layout paper, showing the position of the title, dedication and rhymes. This will show how the contents might work out into sections.

◄ 3 Experimenting with color

Write out some of the rhymes in colors made from gouache paints. I used a No. 3 nib. Two scripts can be clearly read by a child and are therefore suitable for this project: Foundational, a natural choice for a children's book, and Uncials, traditionally a book script. I used both at this stage. Combine them with the illustrations (see Step 4) to make sure that text and pictures balance and that one does not overwhelm the other.

◄ 4 Making the illustrations

Use a No. 4 nib and masking fluid (see page 12) for the outlines and solid white parts of the illustrations. When the fluid is dry, dip a piece of balsa wood 3 mm (1/8 inch) thick and 2.5 cm (1 inch) wide into very watery paint and drag it gently over the illustrations. Make several strokes from top to bottom and side to side. The color must look watery but have contrast with the paper. When the wash is dry, rub off the masking fluid with your finger or a soft eraser.

5 Color trials ►

Do trials with all the colors you will be using to be sure the washes in the illustrations will have the desired depth of color. In this illustration I am doing trials of the washes and adding details to the illustrations with a No. 6 nib and a slightly darker green when the washes are dry. I mix my paints in an ice-cube tray so that the paints for the washes and the text are adjacent to each other.

Use a heavyweight print-making paper.

1 Initial ideas and roughs

Write out nursery rhymes in pencil and make thumbnail sketches of illustrations. Check the relative lengths of the rhymes.

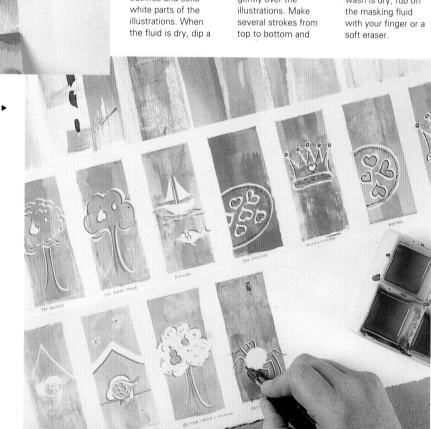

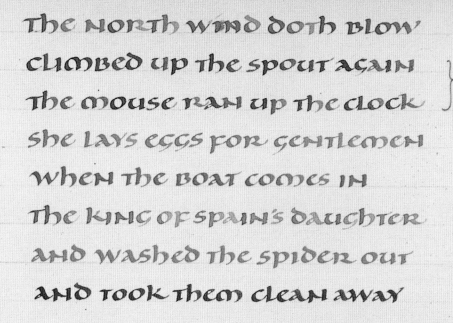

The NORTH wind doth blow — W B S C

Climbed up the spout again
The mouse ran up the clock } A C B W

She lays eggs for gentlemen — W C B A

When the boat comes in — S W B C

The king of spain's daughter — C S W

And washed the spider out — W B A

And took them clean away — A C W

A — ALIZARIN CRIMSON
C — CADMIUM YELLOW PALE
S — SKY BLUE
W — PERMANENT WHITE
B — IVORY BLACK

Blue and green lines need deepening

6 Pasting up illustrations and text
Paste up the text and illustrations together (see page 52). This will give you a clearer idea of the page design. Align the text to the right or left as necessary (see page 52). At this stage the details of the illustrations are still evolving — and I am still using both Foundational and Uncial scripts.

7 Setting the margins
The margins must work well for pages with eight-line rhymes as well as for those with six, and at this stage the final decision as to script must be made. I decided to use Uncials (above in the illustration). In a book like this it is perfectly in order to set the margins visually with strips of colored paper (see page 53) but you could use traditional book margins as a starting-point (see page 54). Mark the edges with pencil lines and cut two of the page roughs to size to see how they look with six and eight lines of text.

8 Checking line lengths and colors
Using the print-making paper, write out the longest line in each rhyme to see if the pages will need to take account of varying widths of text. Use the colors you are thinking of using for the different rhymes when you do this to make sure their tonal values harmonize.

9 Ruling plan
Making a ruling plan of an opened page on layout paper will provide a guide when you are preparing to rule up the final pages (see page 60). I used this one for the final roughs and adjusted it where necessary for the finished piece.

10 Pricking pages
To speed up the ruling up process, use a needle to prick through two folded sheets of paper. The ruling points of four pages will be marked and when the sheets are opened up you will be able to rule two pages at a time. You can do this for the final rough and final piece.

11 The final roughs
Now do your final roughs first making the illustrations and then going back and writing the words. Work on the pages in pairs, not in consecutive order. In other words, work on pages one and six together, then two and five and finally three and four — the centre of the section.

12 The title page
Use masking fluid and a No. 6 nib for the Versal letters of the title and give a sense of continuity by adding small motifs from the book for decoration.

Following the guidelines in Step 4, apply several different colors over the text area. I was unhappy with my first rough (above in the illustration) and so I put the title in a more central position and used more colors. The top edge of the title block aligns with the top of the eight-line rhymes to give visual continuity throughout the book.

13 Preparing the sections
Fold the paper for the final book to make four sets of folded pages (the sections). Trim the top edge only of each section at right angles to the fold, using a sharp knife to give a clean cut. Once the sections are prepared prick and rule up the pages, measuring from the top edge.

14 Writing the finished book
Complete the illustrations, following the guidelines in Step 11, then add the text using a No. 3 nib. Follow the measurements on your final rough very carefully.
Do a pair of pages at a time and finish with the title page.
Now trim the sections to their margin lines. Fold them before cutting, as in the previous step, and measure them very accurately before you cut — always double-check the measurements.

15 The dedication
This is the time to write the dedication page — the size of the dedication can be chosen more easily once the pages have been trimmed. Align it visually with the top of the title block and the top lines of the first pages of text inside the book.

Practise writing it on a spare piece of paper. Measure your writing and mark the page accurately before writing the dedication in place.

Binding the book

Four book-binding terms are used here. The *head* is the top of pages; the *tail* is the bottom of pages; the *spine* is the folded edges of pages; and the *foredge* is the open edges of pages.
 Start by making a mock-up book using the same paper or a similar weight of paper as the finished book. This will help you to bind the finished manuscript without mishap.

16 Preparing the tapes ▶

This method of binding a manuscript book ideally uses strips of vellum but cotton or linen tapes make a good substitute. They must be stiffened with PVA glue. Lay them on a smooth plastic-covered board then brush over them with the glue. Peel them off when they are almost dry. Then turn them over and apply the glue to the other side. The tapes will be stiff but flexible when dry. You will need three tapes for this project.

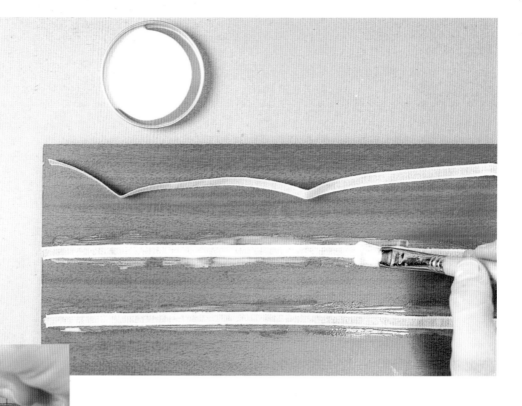

◀ 17 Marking up the spine

Mark the head and tail and number the inside of each section. Place the sections in order, on top of each other. 'Knock up' the sections by holding them loosely and tapping them on a table-top until their tops are level and the folds are aligned vertically. Place the sections between two boards and secure them firmly by sticking tape around the boards or putting a weight on them. Do not let the sections slip out of line. Use a pencil to mark the kettle or anchoring stitches at the head and tail. Mark three points in between the kettles to show the tape positions. right angles across the sections, 6 mm (1/4 inch) and 9 mm (3/8 inch) from the head and tail. Mark three points in between the kettles to show the tape positions.

18 Marking the sewing holes

Remove the sections from the boards. Then position the tapes on one of the boards so that they align with the sewing holes. Secure them with masking tape. Put the sections on top of the board and ▶ the tapes with the spine facing towards you, then lift each tape in turn and wrap it over the sections. Put a pencil mark on the spine on either side of each tape. These indicate the sewing holes.

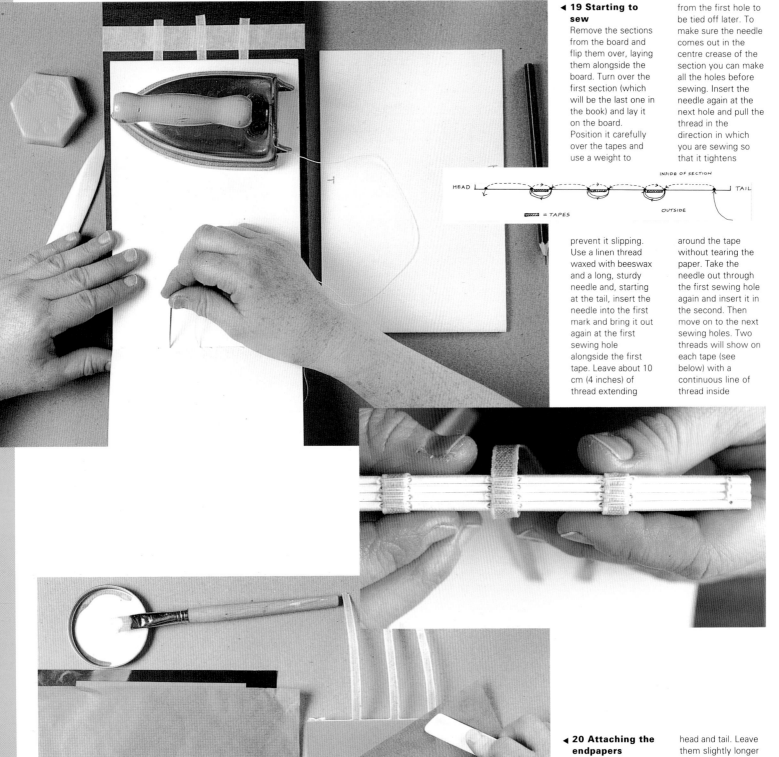

◀ 19 Starting to sew

Remove the sections from the board and flip them over, laying them alongside the board. Turn over the first section (which will be the last one in the book) and lay it on the board. Position it carefully over the tapes and use a weight to prevent it slipping. Use a linen thread waxed with beeswax and a long, sturdy needle and, starting at the tail, insert the needle into the first mark and bring it out again at the first sewing hole alongside the first tape. Leave about 10 cm (4 inches) of thread extending from the first hole to be tied off later. To make sure the needle comes out in the centre crease of the section you can make all the holes before sewing. Insert the needle again at the next hole and pull the thread in the direction in which you are sewing so that it tightens around the tape without tearing the paper. Take the needle out through the first sewing hole again and insert it in the second. Then move on to the next sewing holes. Two threads will show on each tape (see below) with a continuous line of thread inside each section.

When you come out of the head kettle hole, remove the weight and rub down the crease of the section with a bone folder.

Turn the next section over to join the one on the board, replace the weight and continue sewing, this time working from head to tail. When you come out of the tail kettle, tie the thread with the beginning thread of the first section . Remove the weight, rub down the crease again and flip the next section over to join the other two on the board. Replace the weight and stitch this third section like the first one. At the head kettle stitch, insert the needle behind the stitch that joins the two previous sections, take it through the new stitch and into the head kettle hole of the next section. This is called a kettle stitch. This fourth section is stitched like the second section. When you reach the tail kettle make another kettle stitch. Cut off the thread and fray the ends with the point of the needle. The finished sewing is shown on the left.

◀ 20 Attaching the endpapers

The paper for the endpapers can either blend or contrast with the text pages and cover. I decided to use a green machine-made paper. Cut two folded endpapers and trim them to size at their head and tail. Leave them slightly longer than the book. Mask off all but a small area down one side of the fold of one of the endpapers. Apply PVA glue then position the endpaper on the inside of the cover and rub it down with a bone folder. Place another piece of paper over it or the folder will rub the paper to a shine. Trim the ends of the endpaper to the same length as the text pages.

Now repeat the process with the other endpaper.

22 Finishing the cover inside
Make sure that the tabs at the spine head and tail of the cover are folded in, then fold the flaps of the cover around the outer sheet of the endpapers. Insert the tabs into their slots. Smooth the cover down carefully and close the book. Flatten the cover gently to expel air.

▼

21 Lacing the cover
The paper for the cover needs to be firm and able to hold its shape and stand up to handling. I used a stiff, handmade Indian paper. Cut out the cover according to the shape of the template on page 140, remembering to ▶ measure your own book carefully, and mark the tape positions carefully on the inside of the cover. Then cut the slots for the tapes. Trim the tapes so that they are pointed and of equal length and thread them through the slots.

◀ The final touch
Draw an illustration — in this case a small spider — to denote the front cover.

This shows one opened spread from the finished book. There will be a slight gap between some of the spreads because no glue is used on the spine. However, this means that the book always opens easily and lies flat.

▼

This project has shown:
• How to make a layout that uses book margins.
• Make text and illustrations work together visually.
• Combine color in text and illustrations.
• Bind a multi-sectioned book.

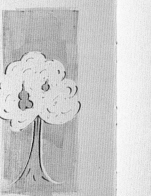

I HAD A LITTLE HUT TREE
NOTHING WOULD IT BEAR
BUT A SILVER NUTMEG
AND A GOLDEN PEAR,
THE KING OF SPAIN'S DAUGHTER
CAME TO VISIT ME
ALL FOR THE SAKE
OF MY LITTLE HUT TREE

DANCE TO YOUR DADDY
MY LITTLE LADDIE,
DANCE TO YOUR DADDY
MY LITTLE MAN.
YOU SHALL HAVE A FISHY
ON A LITTLE DISHY,
YOU SHALL HAVE A FISHY
WHEN THE BOAT COMES IN.

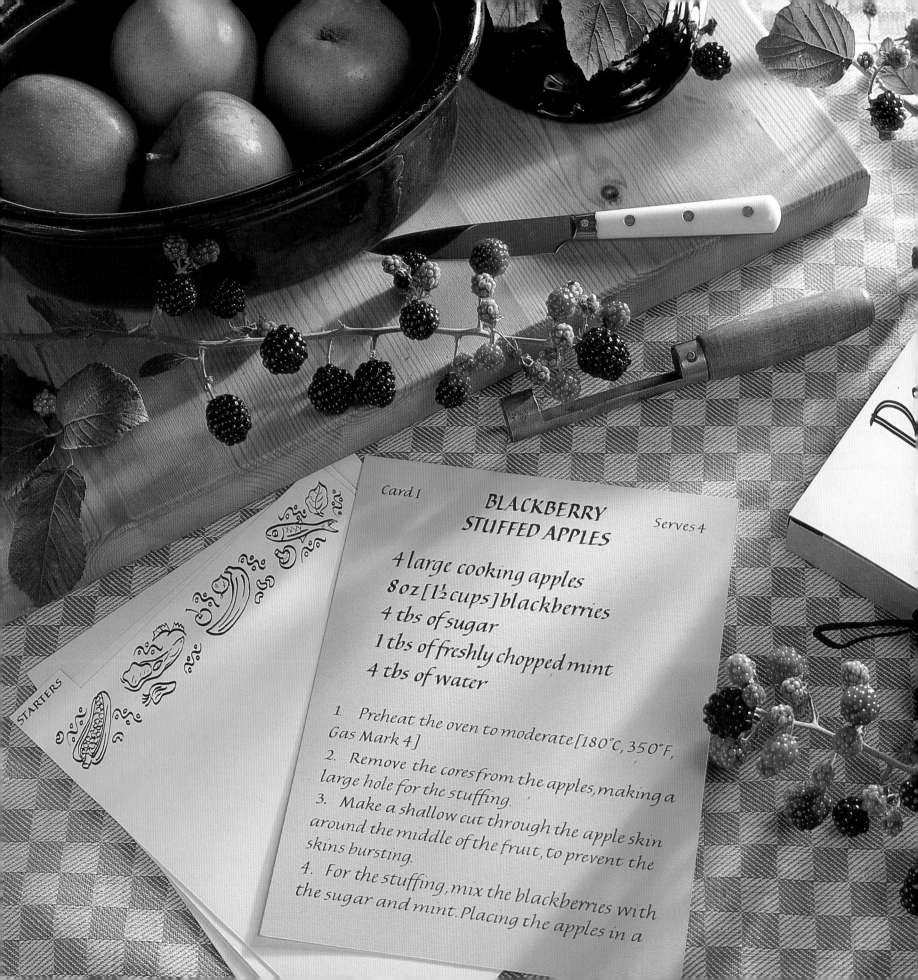

Card 1

BLACKBERRY STUFFED APPLES

Serves 4

4 large cooking apples
8 oz [1½ cups] blackberries
4 tbs of sugar
1 tbs of freshly chopped mint
4 tbs of water

1. Preheat the oven to moderate [180°C, 350°F, Gas Mark 4]

2. Remove the cores from the apples, making a large hole for the stuffing.

3. Make a shallow cut through the apple skin around the middle of the fruit, to prevent the skins bursting.

4. For the stuffing, mix the blackberries with the sugar and mint. Placing the apples in a

STARTERS

RECIPE CARDS: USING INDEX CARDS AND MAKING A BOX

Recipe cards
and box;
Anne Cox
Black Indian ink on
card
Box: 22 x 16.5 cm
(8 5/8 x 6 1/2 inches)

Recipe cards are a good way of keeping favourite and much-used recipes close at hand and although the individual cards are comparatively simple to make their calligraphic design is important to their success. The three elements on each card — recipe title, ingredients and method — must be easily distinguishable from each other but must nevertheless create a harmonious whole. And it is important that each element is immediately legible. The different categories of recipe should be separated with index cards. The cards obviously require a container of some kind — options include a folder, a wallet file, a concertina file and a box. The choice is up to the individual calligrapher.

Before starting work on the recipe cards and container a number of decisions must be made:

• The type of container — this will determine the shape of the recipe and index cards.

• The number of cards.

• The size of the container.

• Whether the recipe and index cards will be illustrated.

• How to indicate the different recipe categories.

In this project I wanted to keep the recipe cards as simple as possible and therefore limited illustrations to the front of the container — in this case a box — and the index cards. I kept the text on the recipe and index cards, and on the box, visually linked so that the overall design was all of a piece.

The basic method of making cards and a container for storing information can be used for a variety of purposes including filing household hints or names, addresses and telephone numbers.

Equipment

• Papers: 260 gsm (125 lb) card in a variety of colors; layout paper; card or rough paper.
• For writing and illustrations: Black Indian ink; automatic pen; scroll nib; square-edged nibs.
• Basic equipment plus: Wax varnish; cloth; double-sided tape.

I tried various alternatives like envelope folders or expanding and wallet files for the container for the recipe cards and finally decided on a box file with cords to tie it shut. The layout of the recipe cards is simple so that they can be written up speedily and easily read, and the box is varnished with wax to protect it from kitchen spills. The recipes are in six categories — starters, soups, main courses, puddings, cakes and 'others'. Each category of recipe is on different-colored cards and each has an index card in the same color with a list of recipes and a tab indicating the category. Food symbols on the front flap of the box are repeated on the relevant index cards.

2 Paste-up for the recipe cards

Cut the lettering trials into strips and move them round on rough paper or card the size of the recipe cards combining different sizes and weights, until you are happy with the balance between the heading, ingredients and method and the way they look on the card (see paste-up, page 52).

This will be your guide for ruling up all the recipe cards.

◀ 3 Preparing the recipe and index cards

Choose a different colored card for each category of recipe. The index cards must be taller than the recipe cards so that the category name can be written on the tabs. The tab width is the width of the card divided by six — the number of categories. I used a 260 gsm (125 lb) paper for the cards.

◀ 4 Ruling up

Cut out the number of recipe cards you need in each category, plus the index cards. Mark out the card shapes on a sheet of colored card and cut them out using a craft knife and metal ruler on a cutting mat.

Lightly rule up the recipe cards and the index cards tabs (see page 60), with a light pencil. Use the paste-up as a guide.

5 Completing the recipe cards ▶

Write the recipes on to the cards, following the measurements on the paste-up. I used waterproof Indian ink which is smudge-proof. It contains shellac, which is harmful to steel nibs, so it is very important to wash your nibs thoroughly after use.

1 Writing trials

Experiment on layout paper with different weights, sizes and scripts. I decided to use Italic.

6 Choosing a container for the recipes
This illustration shows various alternative designs

▼

for the container for the recipe cards. There are a number of possibilities but I decided that I would make a box.

7 Drawing up the box
The recipe and index cards are fairly small so the box can be made from one sheet of

260 gsm (125 lb) card. Following the template on page 140, draw the box on layout paper to the size of the finished box using a ruler.

8 Relating the index cards to the box
This illustration shows how the index card relates

▼

to the size of the back of the box. The space around the card ensures that the box will be large enough to take all

the recipe and index cards comfortably. If the fit is too tight it will be difficult to get the cards in and out of the box.

10 Waxing the box
Use a wax varnish to protect the box against kitchen spills, etc. Apply it like polish, with a cloth, and polish it when it is dry.
 Do not apply the wax to any parts of the box that will eventually be stuck to other areas.

12 Assembling the box
Insert the extra bottom piece and stick it down with double-sided tape. Then apply double-sided tape to the unwaxed side flaps and join the front of the box to the sides of the box

▼

▲

9 Cutting out the box
Mark the final plan on the green box card with a pencil. Take time to check your measurements and to make sure the lines meet each other at true right-angles. Use a knife, cutting mat and metal ruler to cut out the box.

11 Scoring the box
Score the fold lines of the box lightly with the edge of a pair of scissors held against a ruler on the outside of the box, so that the flaps can be crisply folded. Make holes in box's side with a compass

point and thread the side cords through, leaving about 1 cm (3/8 inch) of cord showing on the inside of the box. Use double-sided tape to stick down the separate tabs shown on the template and secure the cords in place.

13 Sample scripts and illustrations
Cut layout paper to the size of the 'Recipes' card on the front flap of the box

▼

and use an automatic pen with a scroll nib to try out capital Rs. Choose one and use a square-edged nib to finish off 'Recipes'. I tried Foundational.

Try out different square-edged nibs for the illustrations below 'Recipes' and on the index cards. Make a paste-up of the card. I centred 'Recipes'.

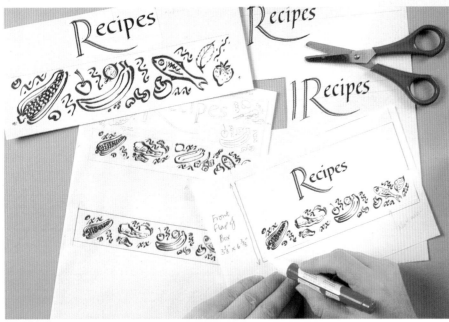

▲

14 Finalizing 'Recipes' and illustrations
Apply the final lettering and illustrations to the piece of card that will

go on the front flap. Rule up carefully, following the measurements and positioning you selected when you did your paste-up.

15 Sticking down
Wax the front of the 'Recipes' card (see Step 10). Make sure you know the exact position for the card

▼

on the box then stick it on to the outside of the front flap of the box. Use double-sided tape to do this.

17 Inserting the cords
Cut lengths of cord and insert them in the holes (see Step 16) leaving about 1

▼

cm (3/8 inch) on the inside. Apply double-sided tape to the inner box flap and stick the flap down to secure the cords.

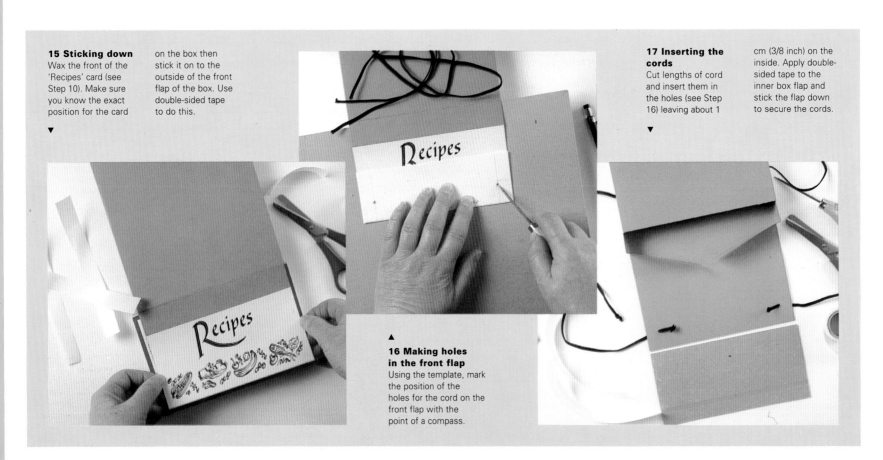

▲

16 Making holes in the front flap
Using the template, mark the position of the holes for the cord on the front flap with the point of a compass.

18 Finalizing the ▶ index cards
Trace the illustrations on to the index cards and go over them with your chosen square-edged nib and Indian ink. Rule up the index cards so that the recipes in their categories can be written on them.

◀ 19 The index cards
This illustration shows how the index cards are positioned within the box. The titles can be read as soon as the box flap is opened.

▲
The finished work
This shows the cards pulled out to reveal the illustrations on the index cards and three different, yet visually linked, recipe cards.

This project has shown:
• How to link different elements of text.
• Make a box file.
• Design a card index.

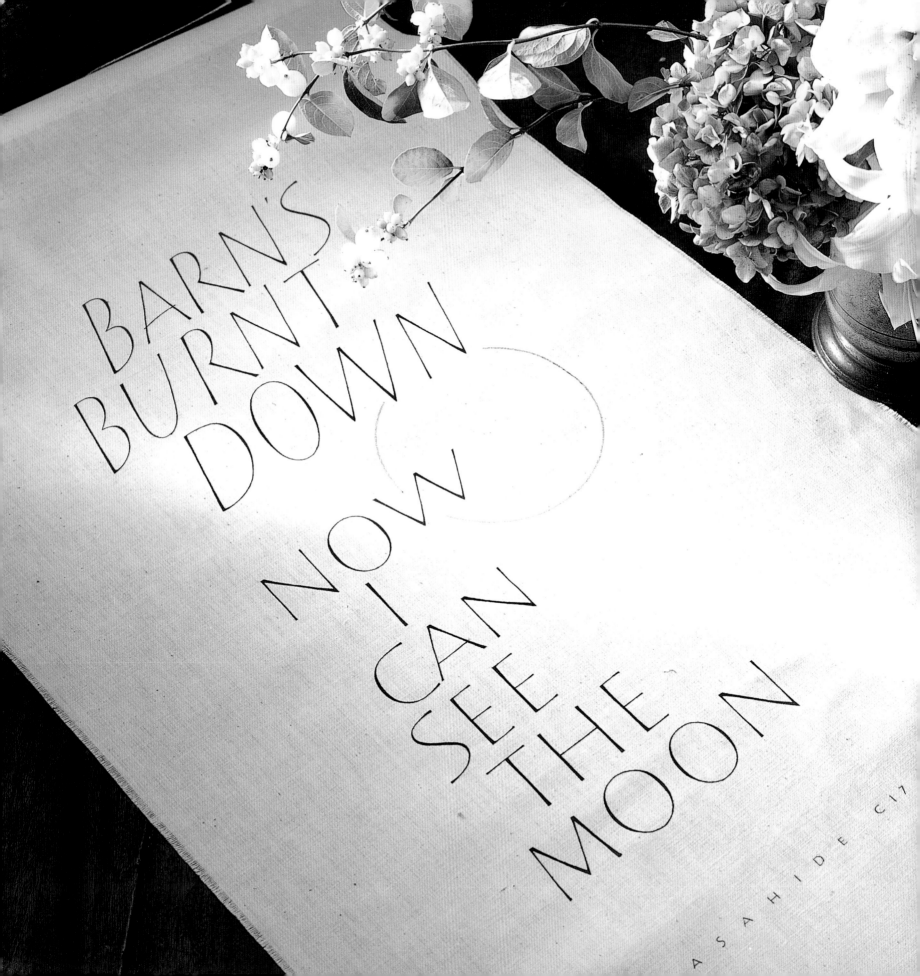

A Painted Banner: Working on Fabric and Using a Brush

A painted banner;
Anne Irwin
Gouache and gold on
unbleached calico
90 x 47.5 cm (34 7/8
x 18 1/2 inches)

Banners have a long history. Originally they were square flags charged with coats of arms that proclaimed identity or gave a simple message, and were often large and richly decorated. Made of flexible materials, they could be easily rolled and stored when not in use but were ready to be viewed when supported by two poles or hung from a cross-piece. Today banners are still used to make important statements but are generally more humble than their predecessors and are often intended for temporary use.

Whatever the purpose of a banner, the first step after selecting the text it will show is to decide how best to convey the imagery in that text. Other decisions, which will flow from that, are:

· The size of the banner and how to support it.
· The fabric that will be used.

The banner in this project is of domestic proportions, suitable for a modest building, and is not intended to be a long-term hanging. My aim was to reflect the spirit of the text: a *haiku* or short Japanese poem.

A work like this depends necessarily on the words that are chosen and, above all, on the inspiration of the individual calligrapher — no two people will interpret even the same text in the same way. The method described on the following pages is therefore a practical guide to working on fabric with paints and gold.

The way I have worked does require some specialist equipment and materials: a light box (a primitive one can be made by putting a short strip-lighting tube inside a drawer and covering it with opaque glass set in a picture frame); and graphite paper for tracing down the lettering.

Equipment

• Unbleached calico, silk, cotton or synthetic fabric.
• Writing and illustration: Pencils; black non-waterproof Indian ink; gouache paints; chisel-edged brush; fine pointed brush; graphite paper; compass; ruling pen; gum ammoniac; sheet of transfer gold.
• Basic equipment plus: Light box; thread; semi-circular dowelling.

I decided that the banner should be very simple — almost stark — to reflect the simplicity and directness of the *haiku*. I wanted a cloth with a natural-looking surface that accepted paint, giving the lettering a clean line. I eventually chose unbleached calico for its interesting texture. It is user-friendly — its small specks make wobbles and splashes almost invisible — and this compensates for the uneven loose weave of the cloth which makes hanging a slight problem.

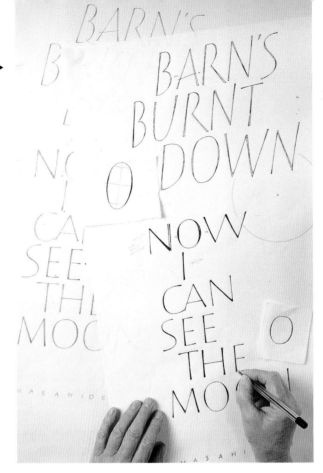

2 Improving letter forms and spacing ▶

Do as many drawings as you find necessary to achieve the effect you want. Consider each letter form and its position and relationship to the whole.

Here the two halves of the poem have letters of different size and style — the first three words are large, narrow and sloping and the last six words are smaller, wider and upright — and are separated by space. I linked them by color and the circle. I worked with pencil and black ink.

When working on a large piece keep stepping back to view it from at least 5 metres (15 feet) to see whether it is working as a whole.

▲ 3 Cloth trials

Silk, fine cotton, calico and various synthetic fabrics are all suitable for banners but before making a final choice buy samples and experiment with different paints. I bought various natural-looking fabrics and wrote on them with acrylic paints, fabric paints and gouache. I finally selected unbleached calico and decided to use gouache paints as they are easy to apply, give a solid color and come in a wide range of colors. Calico is heavily sized to give it body, greatly aiding the application of paint; without size the material would act like blotting paper.

Cut your banner so that its sides are parallel with the selvedges.

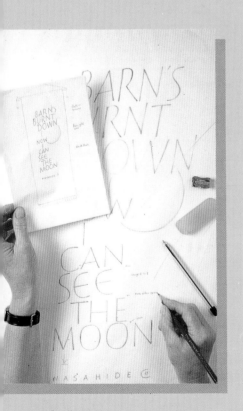

1 Scaling up

Do a number of rough thumbnail sketches then scale up the one you select to full size on layout paper in pencil.

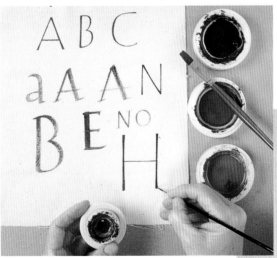

◀ 4 Selecting scripts

Experiment with weights and sizes of lettering on a spare piece of cloth. Use a chisel brush for one-stroke letters and a fine pointed brush for built-up ones. I used gouache paints. Write your final trial lettering in black ink on layout paper.

5 Color gradations

The next step is to choose the colors you will be using. I decided on the complementary colors cadmium red pale and ultramarine blue; I used these separately and also mixed them to make three hues. Use a separate palette for each color you select. ▶

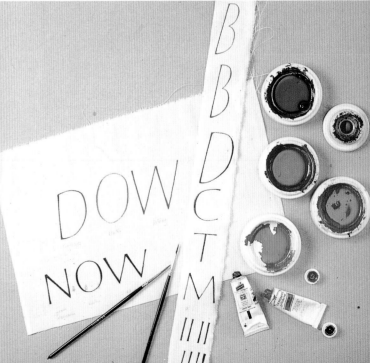

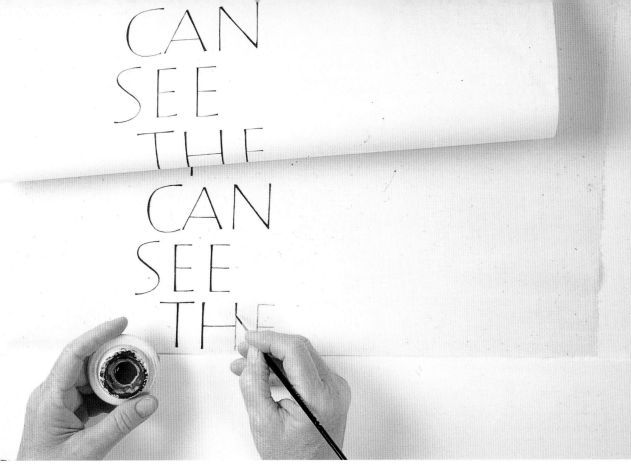

6 Tracing
Lay graphite paper face down on the cloth and overlay with the paper with your final lettering. Secure with masking tape and place on a light box. Using a sharp pencil trace a line for the centres of straight lines and indicate top and bottom widths of thick strokes. Trace the outside of curves and mark the thickest points. I also marked the circle's centre.

7 Painting the letters on to cloth ▶
Mix your colors to the consistency of single cream and apply them with a good quality pointed brush. Start by painting over the single pencil lines then fill them out with short, fine brush strokes. Refer constantly to the final drawing. Work slowly and carefully — this stage must not be rushed.

◀ 8 Drawing a circle
I extended a compass with a ruling pen, then dipped the point of the pen in gum ammoniac and drew a circle using the traced centre.

Other motifs of your choice can be used. Draw them with gum ammoniac or PVA glue using a brush, ruling pen or even a nib so that the gold can be applied (see Step 9).

9 Gilding ▶
When the gum is touch-dry breathe hard on it and place a transfer sheet of gold face down on the motif. Press firmly with your fingers and lift off the transfer paper. I started with a section of the diameter of the circle and continued until it was covered with gold. If the gold does not stick breathe on the gum and re-gild.

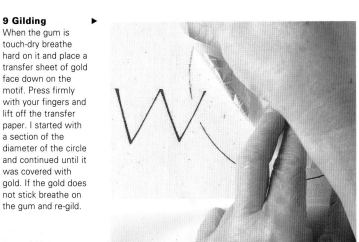

10 Sewing
Hem the top of the banner with a running stitch, then fringe the side seams and bottom and iron the banner on the reverse side. Thread a 15 mm (6/8 inch) semi-circular piece of dowelling through the hem with the flat side at the back and make a cord out of nine calico threads plaited together. Cut grooves into each side of the dowelling and tie the cord into them.

The finished hanging ▶
By its very nature a cloth hanging will move with any draught of air. This emphasizes its life and movement.

This project has shown:
- How to work in fabric.
- Create a large-scale calligraphic work.
- Use large letterforms.

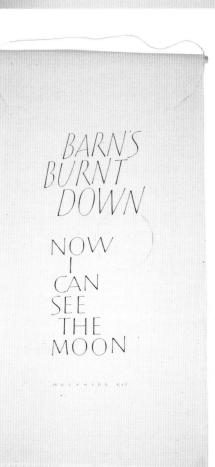

A Village Map: Combining Text and Title Lettering

A village map;
Teresa Dunstone
Gouache and pastels
on acid-free paper
46 x 74.5 cm (17 7/8
x 28 7/8 inches)

Calligraphers delight in making a map decorative as well as a source of information and it can include illustrations, symbols, heraldry, gilding and borders as well as small panels of descriptive text that add texture to the work. All these elements need to be in harmony with the geographic shape of the particular area chosen — without, of course, obscuring place names and other vital pieces of information. To be successful, the calligraphy and illustrations in a decorative map must blend with, and not overwhelm, each other.

The first step, before starting work on a project like this, is to make the following decisions:
• The purpose of the map — whether it will be informative or decorative.
• The general area it will cover.
• The amount of information to include.
• The proportion of text to illustrations and how to deal with the text.
• Whether background information as well as place names will be included.
• The style of the illustrations.
• The size of the finished piece.
I was born and still live in the village featured here and doing a map that showed aspects of its history and development appealed to me. The purpose of the map is to inform in an attractive way rather than to be purely decorative and I decided to have a higher proportion of text than illustrations — a decision that emphasizes the calligraphic nature of the project.

The method of working shown on the following pages can be adapted, with differing proportions of text to illustrations, to a variety of maps — of a garden or park, town or city.

Equipment
• Papers: 300 gsm (140 lb) hot-pressed acid-free paper; tracing paper; layout paper.
• For writing and illustrations: Gouache paints; pastels; pastel fixative; automatic pen; square-edged nibs; drawing nib.
• Basic equipment.

My first step was to decide exactly what I wanted to put on the map, so I spent some time gleaning information from booklets and talking to local people. I also referred to a 150-year-old map of the village and its surroundings as I wanted to be as accurate as possible. I then had a good idea of what to feature pictorially and how much space I should leave for the words. As there is so much text I decided to split it up into blocks with subheadings to aid readability and help the overall layout. I wrote the text in gouache paints and colored in the illustrated parts of the map with pastels. I used a 300 gsm (140 lb) hot-pressed, acid-free paper.

◄ 2 The historical background
It is important to be as accurate as possible in a calligraphic piece like a map and I found that referring to photographs and other illustrations while I was working helped me to visualize the village as it was in the past.

3 Tracing the map
Once you have decided on the layout, trace the map shape from your reference on to tracing paper. It is a good idea to trace more of the area than you expect to use and then decide on the part that you will use for the map. This will help you to assess the shape and design. You will also be able to get an idea of the size of the finished piece. ►

1 Thumbnail sketches
Make thumbnail sketches to get an idea of the various layouts that could be used in a project like this.

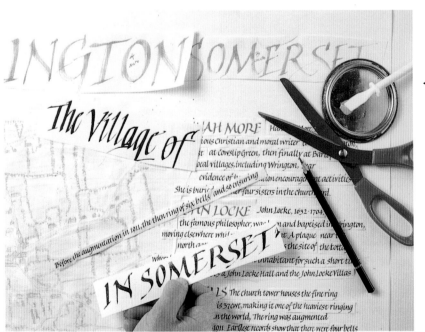

◄ 4 Writing trials
Experiment with scripts and sizes for the titles and main text on rough paper. Bear in mind the amount of text that will appear in the finished piece and the scale of the map. This is also the time to try out different colored gouache paints. In this illustration I am experimenting with grey and burnt sienna gouache for the titles which are written in capital letters with various sized nibs.

The Church is a fine building in the Perpendicular style

The Church is a fine building in the Perpendicular style

The Church is a fine

Th The Church is a fine building in the Perpendicular style

This map is based on

The Church is a fine building in the Perpend

This map is based on a tithe ma

This map is based on a tithe map of 1839. Certain additions have been made, such as the extent of the built-up areas today, and the course of the railway which came and went in that time. The school is shown, though not built until the 1850's, and the hanging tree at Branches Cross, which disappeared a long time ago.

T The Church is *All Sain* *The size and finest of the church of All Saints*

5 Writing the main text

Write out the main text in the script, sizes and color you have chosen. I decided on a fairly formal Italic script and at this stage I wrote in black ink using a No. 4 nib for the larger text and a No. 5 for the smaller lettering.

6 Preparing a rough

Do the final paste-up (see page 52). It is worth spending time moving the lettering around until you are satisfied that it complements the shape of the map. Finally, paste the lettering down in position and photocopy it. You may then want to adjust some of the text blocks — photocopying gets rid of the distracting cut edges on the strips of paper so the text blocks can be seen more clearly. This shows how some blocks were cut again and the line lengths adjusted.

moving elsewhere whilst still an infant. A plaque near the north gate of the churchyard marks the site of the cottage where he was born. Despite being an inhabitant for such a short time, the village boasts a John Locke Hall and the John Locke Villas.

HANNAH MORE Hannah More, 1745-1833, the illustrious 'Christian and moral writer' lived in Wrington, first at Cowslip Green, then finally at Barley Wood. Many local villages, including Wrington, bear evidence of her education encouragement activities. She is buried with her four sisters in the churchyard.

THE BELLS The church tower houses the fine ring of ten bells. The tenor is 37 cwt, making it one of the heaviest ringing peals of ten in the world. The ring was augmented with four trebles in 1911. Earliest records show that there were four bells in the 16th century, increasing to five in the 17th, then six in the 18th century. The oldest surviving bell is the present 9th was cast in 1712 by Edward Bilbie of Chew Stoke.

Broad street was originally ma regular market and fairs ... derableage, and many of the predominant in former years. The village ... gh, presumably not all at the same time. Of th ... st serving though considerably reduced in size

THE CROSS ... on the junction with Silver street, but was ve

7 Experimenting with color

Working on rough paper, color in the map area to get a general impression of its impact. Here I used a gouache wash in various greens which I applied with a brush. This enabled me to assess the colored area alongside the main title and underneath the titles on the actual map. I cut the title into a strip so that it could be moved around — this helped me to see how the various elements in the map related to each other.

8 Finalizing the color

The map can be colored with pastel pencils, gouache or watercolor. I decided to use the pastels as they are the easiest to handle. They also respond well to a water wash-over to give an effect similar to paint. Green is the obvious color for the map so I decided to use grey gouache for the text and burnt sienna gouache for the titles. Both go well with the green.

9 Paper trials ▶
The type of paper will affect the finished appearance of the map so it is important to carry out trials on various papers: write small parts of each element — text, title and map — on each of the different papers. I finally decided on a 300 gsm (140 lb) hot-pressed paper.

◀ **10 Tracing and ruling up**
Trace the map on to the paper and rule up (see page 60) the lines for the lettering using a sharp pencil and clean ruler. Measure the lengths of lines for the text on your photocopied paste-up and mark them on the paper. Color in the pastel background and fix it with a pastel fixative so that it does not smudge. The fixative will also help you to write over the pastel areas of the map. Finally, proofread the rough to make sure there are no mistakes.

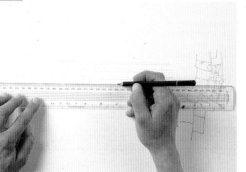

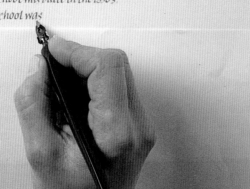

◀ **11 Practising the finished writing**
'Warm up' to do the finished writing by writing sections of the text on a spare piece of the paper you will be using. Check the consistency of the gouache colors on the same kind of paper.

▲
12 Title trials
I needed to make a lot of trials for the titles in order to achieve the freedom and texture I wanted in the final writing.

THE BELLS The church t
n bells. The tenor is 37 cwt, makin
peals of ten in the world. The r
h four trebles in 1911. Early records
the 16th century, increasing to five
in the 18th century. The oldest s
which was cast in 1712 by Edward B

AD STREET Broad street was origin
to accomodate the regular market and
e village are of considerable age, and man
ade that was predominant in former year
inns, though presumably not all at the
is the longest serving though considera

houses the fine ring of
one of the heaviest ringing
was augmented
w that there were four bells
he 17th, then six
ing bell is the present 9th,
of Chew Stoke

much wider, presumably
A number of the houses
iem bear evidence of the wool
village has boasted a
time. Of the surviving two
duced in size

GTON IN SOMERSET

15 The final touches
Use a drawing nib to put in road and field names — I used an informal Italic script — and color in details like roads, buildings, hedges, etc. Fix pastel areas as in Step 9.

Erase the pencil lines, taking care not to smudge the paint as you go round the letters. If the work is to be mounted, define its margins (see page 53) so that you can see exactly how much space will be shown around it.

◄ 13 Writing the text
Sandarac the paper, if necessary (see page 60). Plan the order of writing the sections and how long each should take. Split the text into manageable blocks. Breaking off halfway through one will show up as an inconsistency in your writing.

14 Writing the titles
Warm up as you did before doing the main text by writing the titles on a spare piece of paper.
Now write in the titles on the map. I used the burnt sienna gouache and a No. 3A automatic pen for the larger writing and a No. 0 for the smaller.

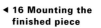

THE TOWER The outstanding feature of the church is the magnificent tower. It is in the Perpendicular style, having been built around 1450, and measures 113½ feet high. It is admired for its excellence of proportions, and is free of any elaborate embellishments. Sir Charles Barry used these proportions as the basis of his design for the Vittoria Tower when the Houses of Parliament were rebuilt in 1835

THE SCHOOL A village school was in existence from the early 16th century, though the form and location is unclear. The present school was built in the 1850's, and is one of few complete Victorian examples still in use today.

THE LOCK UP The village lock-up was built in 1824 and consisted of two cells and a constables office. No record remains of the occupants, though there must have been an urgent need as it was erected with unseemly haste. Situated in the High Street the building is used for sto

THE HANGING TREE The hanging tree once grew in the grass triangle at Branches Cross. Ju and the Bloody Assizes were responsible for the reputed hanging of three men there. A young tree now g

◄ 16 Mounting the finished piece
A framer will cut a mount to your specifications. I used a dark grey card that complements the colors I used for the words and drawings in the map itself.
A mount keeps the piece of work safe as well as showing it off to its best advantage.

This project has shown:
• How to combine titles, subheadings and main text.
• Use pastels for areas of color.
• Design a modern calligraphic map.

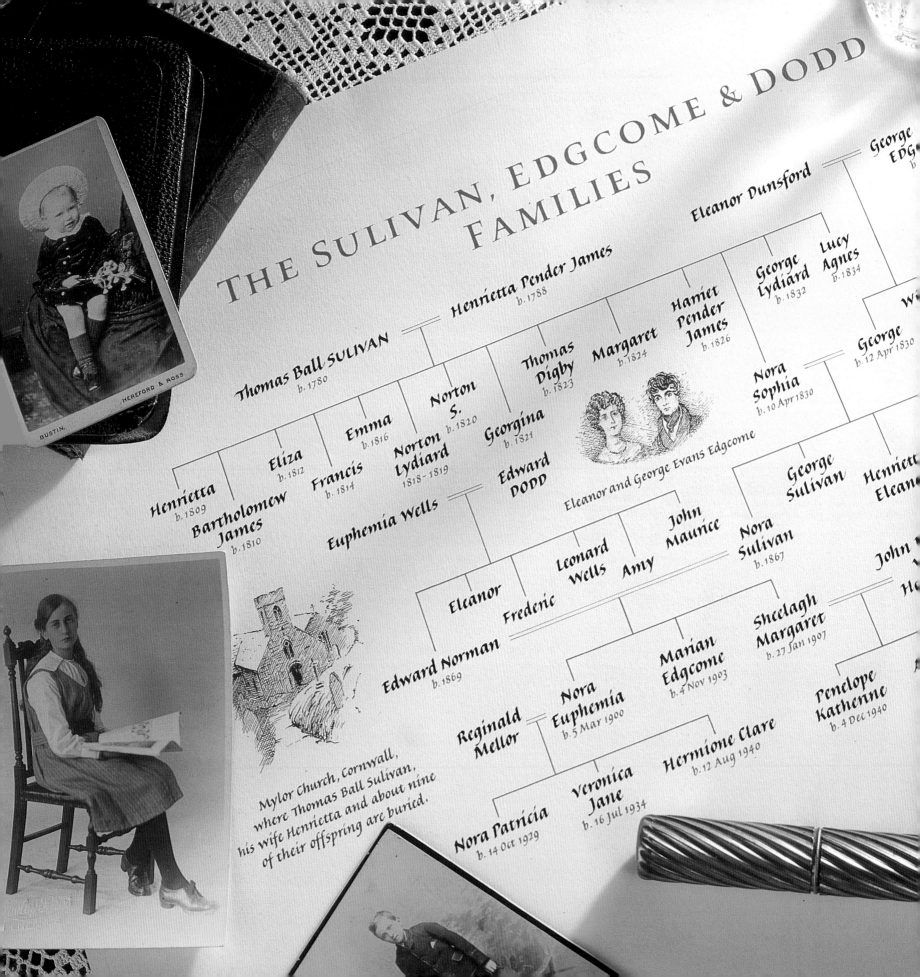

THE SULIVAN, EDGCOME & DODD FAMILIES

Eleanor Dunsford

George EDG...

Henrietta Pender James
b. 1788

George Lydiard
b. 1832

Lucy Agnes
b. 1834

Thomas Ball SULIVAN
b. 1780

Thomas Digby
b. 1823

Margaret
b. 1824

Harriet Pender James
b. 1826

W...

George
b. 12 Apr 1830

Nora Sophia
b. 10 Apr 1830

Emma
b. 1816

Norton S.
b. 1820

Eliza
b. 1812

Francis
b. 1814

Norton Lydiard
1818 – 1819

Georgina
b. 1821

Henrietta
b. 1809

Bartholomew James
b. 1810

Edward DODD

Eleanor and George Evans Edgcome

George Sulivan

Henriett... Eleano...

Euphemia Wells

Leonard Wells

Amy

John Maurice

Nora Sulivan
b. 1867

John ...

Eleanor

Frederic

Edward Norman
b. 1869

Sheelagh Margaret
b. 27 Jan 1907

Marian Edgcome
b. 4 Nov 1903

H...

Penelope Kathenne
b. 4 Dec 1940

Reginald Mellor

Nora Euphemia
b. 5 Mar 1900

Hermione Clare
b. 12 Aug 1940

Mylor Church, Cornwall, where Thomas Ball Sulivan, his wife Henrietta and about nine of their offspring are buried.

Veronica Jane
b. 16 Jul 1934

Nora Patricia
b. 14 Oct 1929

A family tree;
John Neilson
Watercolor paint on
hot-pressed paper
30.2 x 44.3 cm
(11 7/8 x 17 1/2
inches)

A FAMILY TREE: BALANCING THE LAYOUT AND USING SPACE

Everyone has ancestors and everyone's family tree is interesting, regardless of how famous or obscure its members are. The challenge to a calligrapher is that no two trees are the same. In one a single generation may have twenty-two names and the next ten; in another a married couple may both be the eldest children in their respective families. Family trees refuse to conform to a standard pattern and arranging all the parts so that the end result is clear and attractive is something that no one who likes jigsaw puzzles will be able to resist.

A number of considerations are involved before starting work on a family tree and during the development of the project:
• The letterforms to be used and their size, weight and color.
• How to design the lines of connection.
• The balance between space and text.
• How to present sequential information clearly so that it is easily understandable.
• Whether illustrations will be used.

Although there is quite a lot to do in the preparatory and layout stages of a family tree the calligraphic element is relatively straightforward and there be a comparatively small amount of text.

This project takes one couple born in the 1860s and traces their relations for two generations back and forward in time. The basic method of working shown on the following pages can be adapted to family trees of all kinds, from a simple single line of descent to huge jungles of names.

Equipment

• Papers: 300 gsm (140 lb) white hot-pressed paper; layout paper; tracing paper.
• For writing and illustrations: Watercolor or gouache paints; square-edged nibs; pointed nib.
• Basic equipment plus: Felt tip pens or colored pencils

I decided to use three colors of watercolor paint for this family tree — red for the title, lines and dates, black for the names and a brown made from a mixture of the two for the captions and for the illustrations which I drew from photographs and an old portrait. Details on the tree itself are restricted to names and to birth and death dates where they are known. However, some extra background information is given in the captions. The shape, which I decided on only after doing a number of thumbnail sketches, is horizontal. I used a 300 gsm (140 lb) white hot-pressed paper that can take the kind of fine detail that a project like this requires.

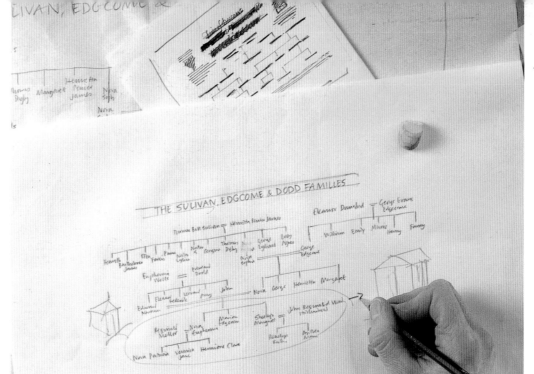

◀ 2 Thumbnail sketches
Do small thumbnail sketches of the layout. These will help you to decide whether a vertical or horizontal form is most suitable. They will also give you ideas for the title and illustrations, how any extra blocks of text or lines of information will fit in and whether borders or decorative devices would be useful to balance the design or fill awkward spaces. When you have selected a suitable sketch do a very rough pencil draft at actual size.

3 Color trials ▶
Decide on the paper you will use. It should be hot pressed, not too fibrous and able to take fine detail. Make sure it is available in a big enough sheet. It is worth buying three or four sheets of your chosen paper to allow for trials and mistakes.
Use pencils or felt tip pens to try out various color schemes on the paper.

1 Editing
Decide how much information will be included in the family tree before starting to work on the layout.

◀ 4 The focal point
The title is usually the focal point for the viewer. Use thumbnail sketches and trials with pen and ink to establish a size, weight, color and style that draws the eye in but balances with the rest of the design. I decided on red Versals made with a No. 4 nib.

◄ 5 Deciding on the illustrations
Now is the time to make a final decision about the illustrations you will be using for the tree. In this case the two side sketches are based on photographs.

6 Drawing the illustrations
Experiment on a sheet of the actual paper with different drawing techniques. Aim for a stylistic link between calligraphy and illustrations and make sure the illustrations are not too heavy. I experimented with a brush but finally decided to use a pointed mapping pen (shown in Step 5). The color is a mixture of red and black watercolors.

▶

7 Deciding on the script
Decide on the style of script. Legibility is important, so keep it simple. Foundational and Italic (which I used here) are ideal. You can use two scripts but more would weaken the design.
 Try different weights and colors by doing rough drafts of a section of the tree at actual size. Refer to your pencil draft (see Step 2). I decided on red for the title and dates, black for names and brown for captions. I used a No. 4 nib for the main text and a No. 5 for captions and dates.
 Your decisions should be guided by the feel of the piece.

◄ 8 Laying out the entries
The design of each entry must be consistent. The space between marriage lines and names is here about the same as the space between words. Vertical lines end about one x-height from the top of the names. Two- and three-line names are either centred or ranged left. The size, weight and color of all information must be consistent.

9 The paste-up
Write out all the sections at actual size on layout paper, then cut them out and do a paste-up (see page 52). Include all the elements in the family tree.
▼

THE SULIVAN, EDGCOM
FAMILIES

Thomas Ball SULIVAN — Henrietta Pender James

nrietta Eliza Emma
Bartholomew Francis Norto
James

10 Ruling the lines ▶

The lines are an essential part of the design so consider their color and thickness very carefully. Do them with a ruling pen against an upside-down ruler (which prevents the paint 'pooling'). I used the same red paint as for the title.

13 Starting the finished piece

Lightly trace the main shapes in the illustrations and skeleton forms of the title lettering on to the final sheet. Take time to position the title and to form and space the letters correctly. This is the most exposed part of the design. ▶

◀ **11 The final layout**

Stick the entries down firmly, draw in the lines of the tree (see Step 10) and assess the overall effect. Double-check all the details, spelling, etc.

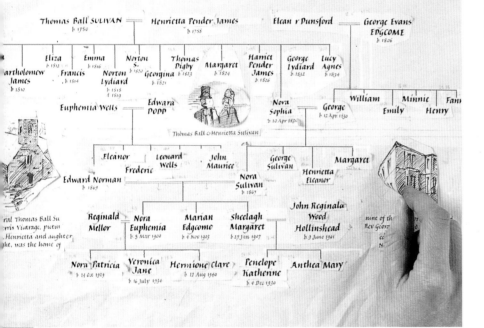

12 Transferring measurements

Mark off the 'vertical' position of each line and group of entries on to a strip of paper (or note down measurements from a ruler), working from a fixed line such as the title base line. Transfer these measurements in pencil to your final sheet, leaving plenty of margin space around the text area.

Do the same for the 'horizontal' position at the start of each entry, and transfer these line by line to your final sheet. Write in each name lightly in pencil. Rule up where the writing is to be on the tree. Measure and rule 'top lines' if necessary. ▶

14 Writing the finished piece
Practise writing on a spare piece of the actual paper and then write out the actual piece. My order of working was: all the names; dates, etc; horizontal and then vertical lines; captions and extra blocks of text; illustrations; title. You may need to make two or three attempts at the finished piece.

Correcting mistakes
It is not always necessary to rewrite a finished piece if you have made small mistakes. On some papers it is possible to slice small mistakes off the surface with a new, rounded scalpel blade. Practise first on a separate piece of the same paper.

▼

THE SULIVAN, EDGCOME & DODD FAMILIES

▲

15 The final touches
Work out the margins (see page 53) before the family tree is framed and mounted.

This project has shown:
• How to present information in a visually ordered sequence.
• Create a harmonious balance between space and text.
• Approach and carry out a large, formal piece of work.

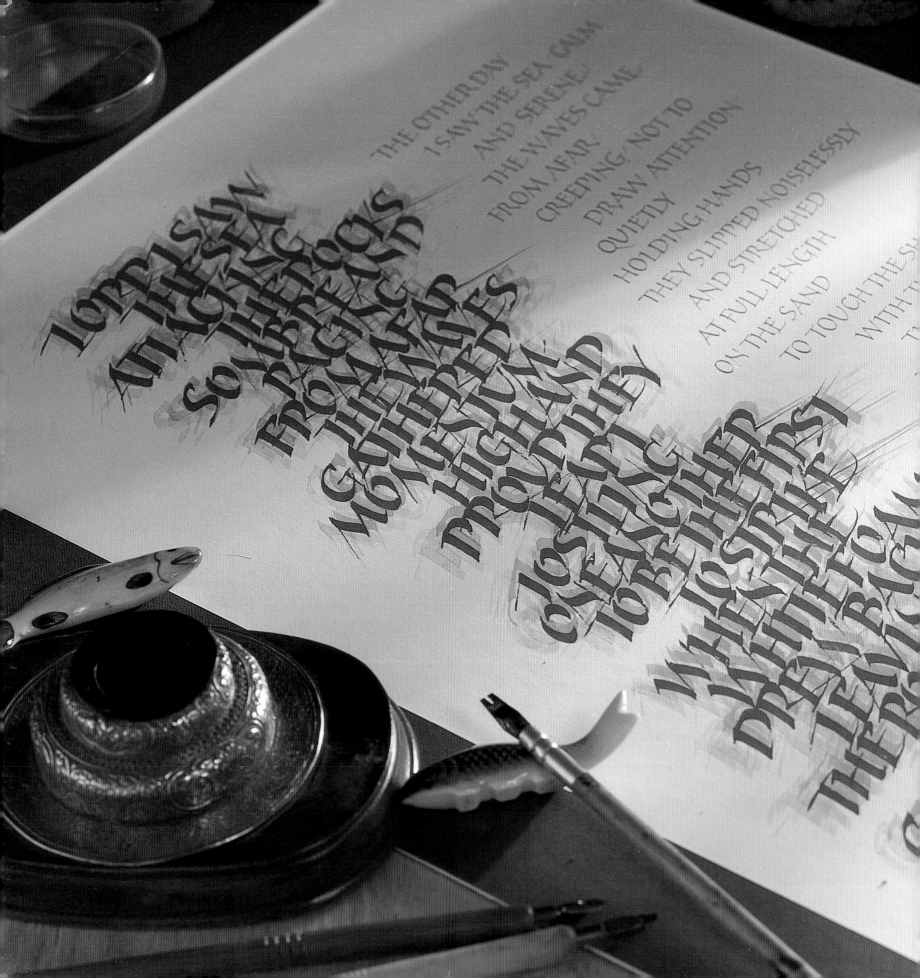

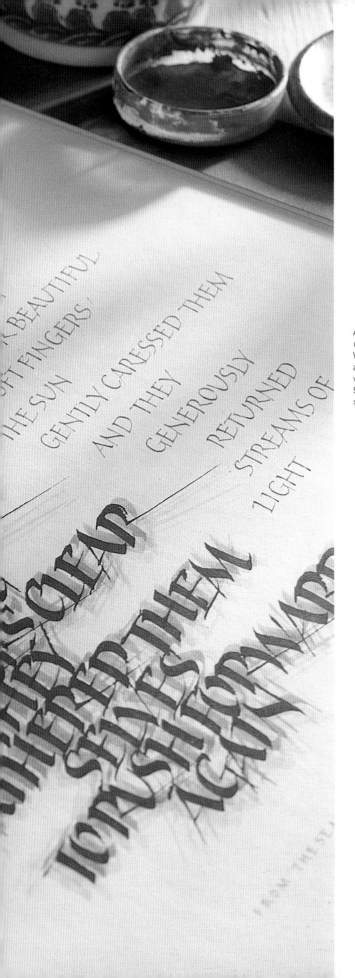

A Broadsheet: Underlaid Writing and Creating a Mood

A broadsheet;
Gillian Hazeldine
Watercolor paints
and gouache on
watercolor paper
57.5 x 37 cm (22 1/2
x 14 5/8 inches)

A broadsheet can be a relatively straightforward writing-out of a simple quotation with a title and credit but, at the other end of the scale, it can be a work that tests calligraphic skills to the utmost.

Whether a broadsheet is simple or complex, a number of decisions must be made before starting work. The first, and most obvious, is the choice of text or texts. Once this has been made the calligrapher must decide how the mood or atmosphere of the words can best be expressed. To do this he or she must decide:

- What letterforms to use.
- What materials and colors will best express the imagery in the text.
- How best to balance elements like the title and credit.
- The size and weight of the text.
- Whether illustrations are appropriate.

Any piece of work like this is, of course, inspired by the text that has been selected and the interpretation will be unique to the individual calligrapher.

The text in this broadsheet has contrast in verbal imagery, the 'angry' and the 'calm' sea, which gave me the opportunity to use visual contrast. The following pages show I used underlaid writing — putting a layer of color over other, different, colors — to build up a heavy 'angry' side, and changed the weight and scale of the writing for the 'calm' side. I used the 'spray' effect of the extended strokes on the angry writing and the overall color to link the two sides and create the mood I wanted.

Equipment

- Papers: 350 gsm (200 lb) watercolor paper; layout paper.
 For writing and illustrations: Automatic pen; square-edged nibs; black non-waterproof Indian ink; watercolor paints; gouache paints; ox gall; gum arabic; soft brush.
- *Basic equipment plus: Tissues; small, tall container.

The text in this project is the first two verses of Michael Quoist's 'The Sea' from his *Prayers of Life*. In the first the sea is angry, 'attacking the rocks', and in the second it is 'calm and serene'. This presents a possibility for visual contrast in the use of calligraphy.

My working method for this piece was experimental and depended partially on 'controlled accidents'. The 'angry' hand is in underlaid writing, written with a No. 10 automatic pen in Italic capitals with no interlinear space. I used a No. 4 nib and a free, lightweight version of the script for the 'calm' text.

Underlaid writing requires a fairly heavyweight paper so I chose a 350 gsm (140 lb) watercolor paper.

2 Experimenting with underlaid writing

It is important to experiment with underlaid writing — putting one layer of color on top of others of a slightly different color. I did two or three versions of the angry text, writing with a No. 10 automatic pen and using lighter tones for the underneath layers, positioning the words differently each time. I rejected this squareish block.

▼

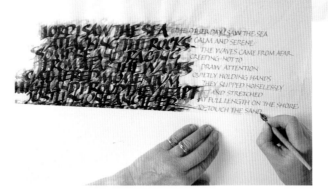

▲

3 A vertical format

The vertical format works much better than the horizontal one. I did several rough black-and-white layouts with black ink trying to improve the overall shape of the writing and achieve a 'wave-like' appearance for the angry text. I started to finalize the letterform for this side, pulling out the legs of R and K throughout into sharpened strokes.

◄ 4 Color trials

I did color trials for the angry writing, using watercolors (for transparency) for the underneath layer and made notes of the colors: dark grey and a dark green with a bit of yellow. I used gouache for the top layer. I also did some trials for the calm writing using square-edged nibs and allowing the colors — dark, bluish green and cerulean blue — to change subtly by feeding a second color in without cleaning the pen.

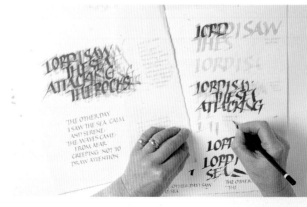

5 Starting the finished piece

I wrote directly on to the final paper without guidelines, following my rough. I used grey watercolor watered down to a very light tone on a palette and then transferred to a small but tall plastic container. I held this in my left hand and dipped the automatic pen into it. The wateriness of the paint and my sloped board meant that the pigment flooded to the bottom of the letters. As it would dry much darker I used a brush to pick off the excess pigment after writing three or four letters, wiping it on a tissue. When this was dry I used a darker tone of the same grey for the second layer (see right). I placed this writing slightly below and to the side of the first layer. ▶

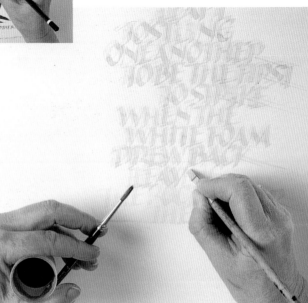

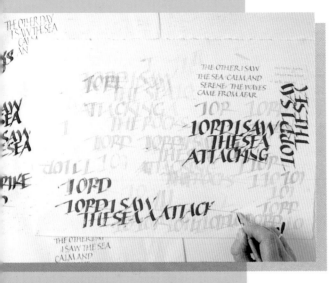

1 Experimenting with scripts

I tried out different scripts and experimented with underlaid writing. I used an automatic pen for this.

6 Applying more watercolor layers ▶

I applied a layer of dark green mixed with a little yellow, following the method described in Step 5. When this was completely dry I applied a less watery mix of the color.

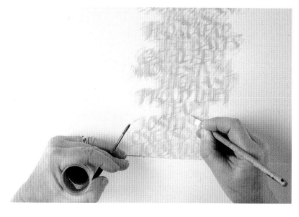

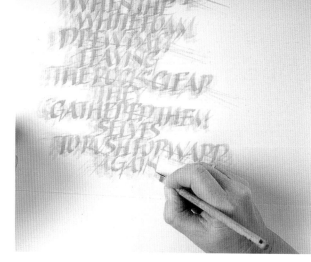

◀ 7 The final watercolor layer

The final watercolor layer is a mixture of dark green with grey. There are now five layers of watercolor. I have been picking off excess pigment with the brush throughout the 'layering' process.

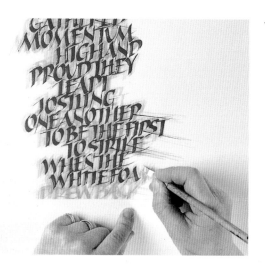

◀ 8 The top layer

I used a gouache mixture of oxide of chromium (a dark green), cobalt blue, black and white for the top layer and added a touch of ox gall, which destroys the surface tension of water, to help the flow. I wrote directly on to the paper, following my rough. A halo effect, suggesting spray, has been created by the layers, particularly by all the 'pulled' strokes on the Rs and Ks.

9 The 'calm' writing ▶

The final piece is slightly deeper than the rough so I worked out the lightweight writing on an overlaid sheet of layout paper to achieve the length and shape I wanted. I ruled only a central line for each line of text so that the letters differ slightly in size, giving a less formal effect than writing done between two lines. I wrote with a No. 4 nib and used green and cerulean blue, with a drop of ox gall and gum arabic in each. I did a few letters with one color, then fed the next color in without cleaning the nib to achieve a subtle color change.

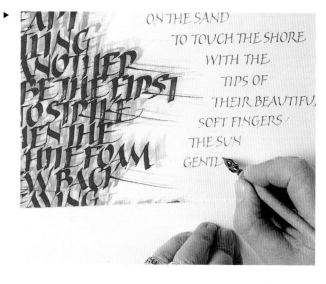

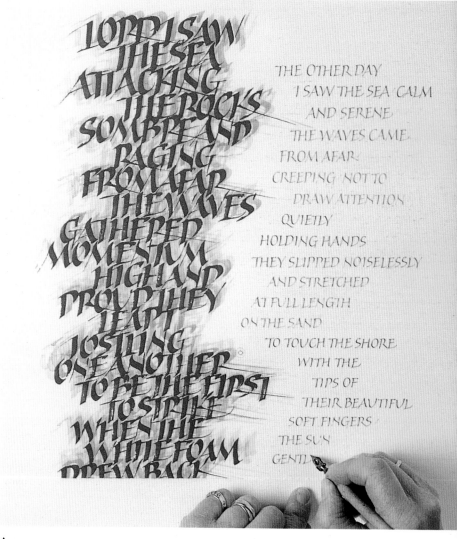

▲

10 Finishing the piece

This illustration of the layered textures and lightweight writing shows the color changes.

My final touch was to add the credit, placing it below the lefthand text so that the weight imbalance between the two verses is emphasized.

This project has shown:

• How to use different weights of lettering.

• Do underlaid writing.

• Use calligraphy to reflect the verbal imagery in a text.

TEMPLATES

FLAP

A

B

B

TOP

E

F

E

F

SIDE

BACK

SIDE

C

C

BASE

E

BASE

A

Inner base, for extra
strength. Cut 1.

Box for recipe cards
Measurement key:
A = 16.5 cm (6 1/2 inches)
B = 8 cm (3 1/8 inches)
C = 22 cm (8 5/8 inches)
D = 20.5 cm (8 1/16 inches)
E = 2.5 cm (1 inch)
F = 2 cm (13/16 or 8/10 inch)
G = 4.5 cm (1 3/4 inches)

Cut away dotted portions

D

C

E

C

A

B

SCORE + FOLD
SCORE + FOLD

Cut away dotted portions

C

A

FRONT

D

INNER
FLAP

B

A

To secure the cords
passing through the
top flap. Cut 1.

OVERLAP

B

E

G

TAB

Tabs to secure the
cords at the sides of
the box. Cut 2.

Cover of manuscript book
'Square' refers to the portion of the
cover extending beyond the text
block/book.

A = Measurement from spine to
foredge at widest point + 2 mm
(1/16 inch) for square
1 mm (1/32 inch) for folding
B = Depth of spine at widest point
C = Measurement from head to tail
+ 4 mm (1/8 inch) for square
D = Approx. 3 cm (1 1/8 inch)
E = 2 — 2.5 cm (3/4 — 1 inch)
F = A fraction more than the width
of the tapes
G = 1 cm (3/8 inch)
H = 7 — 10 mm (1/4 — 3/8 inch)
depending on how much tape is to
show on the cover

D

A

D

FRONT
COVER

C

E

E

FLA

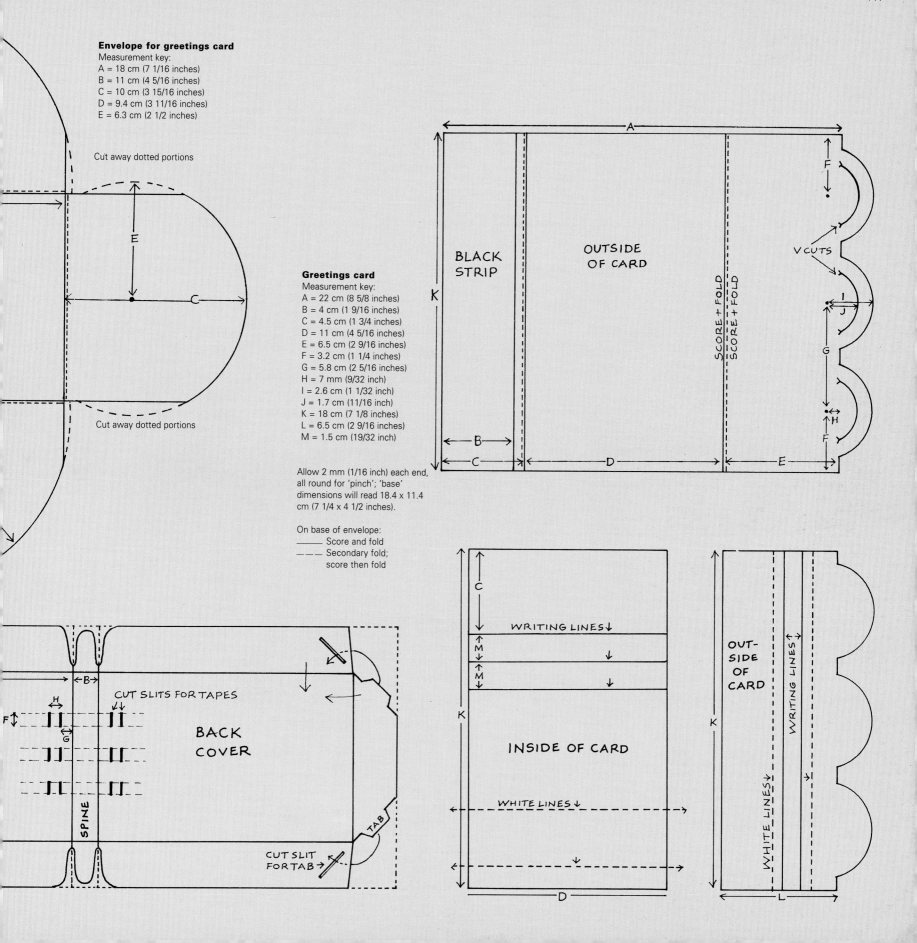

Envelope for greetings card
Measurement key:
A = 18 cm (7 1/16 inches)
B = 11 cm (4 5/16 inches)
C = 10 cm (3 15/16 inches)
D = 9.4 cm (3 11/16 inches)
E = 6.3 cm (2 1/2 inches)

Cut away dotted portions

Cut away dotted portions

Greetings card
Measurement key:
A = 22 cm (8 5/8 inches)
B = 4 cm (1 9/16 inches)
C = 4.5 cm (1 3/4 inches)
D = 11 cm (4 5/16 inches)
E = 6.5 cm (2 9/16 inches)
F = 3.2 cm (1 1/4 inches)
G = 5.8 cm (2 5/16 inches)
H = 7 mm (9/32 inch)
I = 2.6 cm (1 1/32 inch)
J = 1.7 cm (11/16 inch)
K = 18 cm (7 1/8 inches)
L = 6.5 cm (2 9/16 inches)
M = 1.5 cm (19/32 inch)

Allow 2 mm (1/16 inch) each end, all round for 'pinch'; 'base' dimensions will read 18.4 x 11.4 cm (7 1/4 x 4 1/2 inches).

On base of envelope:
——— Score and fold
– – – Secondary fold; score then fold

BLACK STRIP

OUTSIDE OF CARD

SCORE + FOLD
SCORE + FOLD

V CUTS

CUT SLITS FOR TAPES

BACK COVER

SPINE

CUT SLIT FOR TAB

TAB

WRITING LINES↓

INSIDE OF CARD

WHITE LINES↓

OUTSIDE OF CARD

WRITING LINES

WHITE LINES

GLOSSARY

acrylic
Paint that can be diluted with water but is waterproof when dry; available in tubes.

artwork
Finished original work.

ascender
Stroke, usually vertical, above the body of a letter.

arch
The curved stroke of a letter; joins or emerges from its vertical stroke.

body height
The height of x or, in typographic terms, the x-height of a letter.

bone folder
A long, thin, flat piece of bone curved at one end and pointed at the other used for scoring and folding paper.

bowl
The round or oval part of a letter.

built-up stroke
The thick part of a letter, made by lying a number of pen strokes side by side.

burnisher
A tool made from agate or haematite; used for rubbing gold that has been applied to a piece of work.

capital letter
Upper case or majuscule letter.

Chinese stick ink
Traditionally made of lamp black that is baked and compressed with a binding substance into stick form.

credit
Attribution on a piece of work: the writer, date or information about the work.

crossbar
Horizontal stroke on a letter.

deckle
Frame that holds a layer of paper pulp to make a sheet of paper.

deckled edge
The rough edge created as a result of the paper pulp lying against the deckle.

descender
The part of a letter that extends below the body height.

flourish
Decorative curved strokes that form extensions to letters, usually on ascenders and descenders.

gilding
The application of gold to a piece of work.

gouache
Non-waterproof water-based paint; usually available in tubes.

graphite paper
Used like carbon paper for transferring an image.

guidelines
Lines drawn as a guide for placing letters and words.

gum ammoniac
A liquid form of resin used in gilding a piece of work.

hairline
The finest line a pen can make.

hand
A style of writing.

Indian ink
Ground Chinese stick ink; supplied in bottles. The non-waterproof variety is best with calligraphy nibs and pens.

interlinear spacing
Space between lines of writing to keep the ascenders and descenders of minuscule letters from overlapping.

Japanese tissue
Very fine paper, usually handmade, used for delicate or repair work.

layout
A plan for a piece of work.

majuscule
A capital or upper case letter.

manuscript book
A hand-written book.

margins
The space on the paper around the edges of a piece of calligraphy.

minuscule
A small or lower case letter.

paste-up
Roughs cut into strips or portions and pasted down in a position different from the original writing.

quill
Pen cut from the flight feathers of, usually, a swan, goose or turkey.

reading line
The top third of the body height of the letters in a line of writing.

resist
Application of a substance such as masking fluid that does not mix with the wash applied over it and which is removed when the wash is dry to reveal the paper underneath.

rough
A trial piece of writing that is done to prepare a layout for the finished piece.

ruling pen
A pen made of two halves connected by a screw that can be adjusted to give lines of varying widths when the pen is loaded with ink.

script
A style of writing.

serif
The ending and beginning of a letterstroke. It may sometimes be made as a separate pen stroke across the beginning and end of each stroke.

spread
Two facing pages in a book.

stem
The vertical stroke in a letter.

straight-edge
Heavy metal ruler against which paper is cut. It may or may not be marked with measurements.

text
Main part of the poetry or prose in a piece of calligraphy.

thumbnail sketch
Small pencil sketches of ideas for a piece of work.

transfer gold
Sheets of gold on tissue backing sheet.

trim marks
Marks at the corners of a sheet of paper that indicate where it should be cut after printing.

vellum
Cowskin that has been carefully prepared to receive writing.

waisting
Making a built-up stroke thinner in the middle than at the ends in order to give it a graceful line and ensure that it does not appear to bulge in the middle as a line of consistent width can do.

wash
A thin layer of paint applied to paper with a brush.

x-height
A term for body height.